THE ORIENTALISTS

PHILIPPE JULLIAN

THE ORIENTALISTS

European Painters of Eastern Scenes

PHAIDON
OXFORD

Translated by Helga and Dinah Harrison

Phaidon Press Limited, Littlegate House, St Ebbe's Street, Oxford

Originally published as *Les Orientalistes*
© 1977 by Office du Livre, Fribourg, Switzerland

First published in English 1977
Translation © 1977 by Office du Livre

ISBN 0 7148 1780 5

Printed in Switzerland

Contents

List of Illustrations

8

To Prince Hassan Aziz Hassan,
In memory of our outings in Cairo

Preface and Acknowledgements

Books dealing in one way or another with Orientalist painters would fill a vast library – *Le Tour du Monde* collection, various publications on the Salon and the Royal Academy, the biographies, letters and diaries of numerous painters. But there are only two general works, neither very recent, devoted solely to French artists, *L'Orient et la Peinture française au XIXᵉ siècle* by Jean Alazard (1930), and *L'Exotisme dans l'Art et la Pensée* by Roger Bezombes (1953). I have adopted the method of the latter by using quotations from poets and travellers to comment on the pictures. First I shall define the Orientalist movement and fix its geographical and temporal boundaries before discussing its masters and their sources of inspiration. After having analysed the themes the Orientalists preferred, I shall undertake a trip through their world from Spain to Turkey, passing through North Africa, and follow them as far as India.

In the following paragraphs, I particularly want to thank all the people who helped me and to mention the other sources on which this study is based. I have found valuable information on the English artists in *The British in the Middle East* by Sarah Searight, and in Rose Macaulay's *The Pleasure of Ruins*. I have consulted articles on various aspects of Orientalism in art reviews. The catalogues of four exhibitions have been particularly helpful – those of *Le Salon imaginaire* in Berlin, 1968, of *Le Musée du Luxembourg en 1874* in Paris, 1974, of *L'Orient en Question* at the Cantini Museum in Marseilles, 1975, and of *Mahmal et Attatichs* at the Galerie Soustiel, 1975–76, which contains an extensive bibliography. Jean Soustiel and Lynne Thornton have generously allowed me to use the material they had collected for that catalogue. Miss Thornton has also kindly read through the manuscript and pointed out errors and omissions.

In London, my friend Giles Eyre put at my disposal the documents used by the Hartnoll and Eyre Gallery for its catalogues on the painters of India. In London, too, Mr. Rodney Searight has – with as much erudition as humour – taken me over his collection several times. In Paris I should like to thank M. Gérard Seligmann, the Galerie Tanagra, M. Philippe Leroux, Mme Prat, M. Francis Duchene and Princess zur Lippe-Biesterfeld, Sotheby's representative, for furnishing documents and interesting suggestions. M. Neagu told me about photographs taken at the former Luxembourg Museum and now kept in the photographic archives. M. Jean-Louis Gaillemain has advised me on aspects of German Romanticism and Orientalism, and Mme Legrand, keeper of the Musée d'Art moderne in Brussels, has drawn my attention to Evenepoel's Algerian works.

The Orient
before the Orientalists

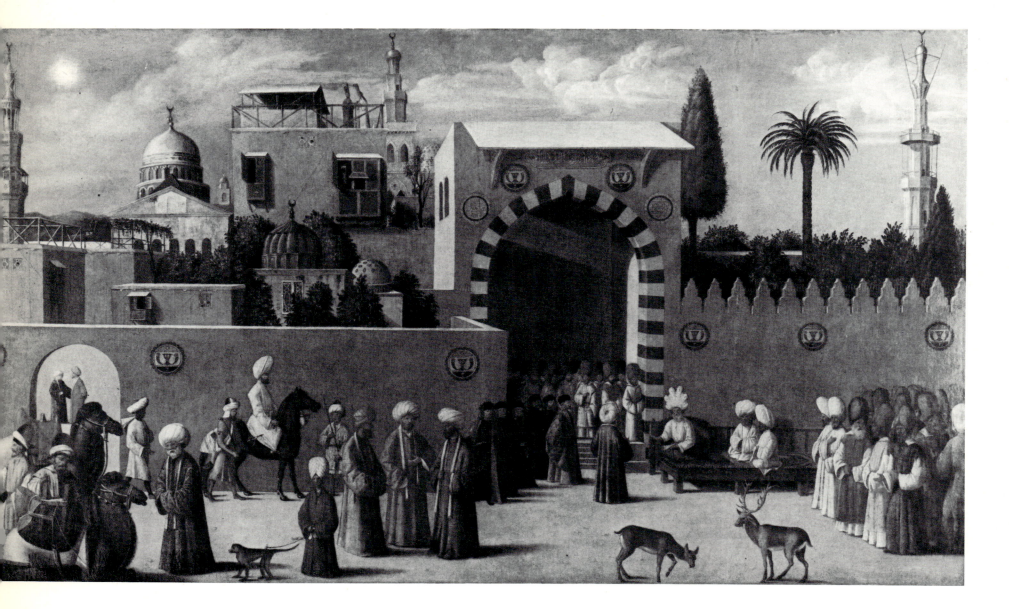

Gentile Bellini: The Reception of the Venetian Ambassador in Cairo. *Oil, 118×203 cm. Musée du Louvre, Paris. – Very accurate picture of Egypt at the time of the Mamelukes.*

Orientalism is only a phase in the cult of the Exotic; we must define its position in time and space before we can undertake an inventory of its riches.

The yearning for the exotic was felt as early as Roman times, and the Romans yielded to it by importing Egyptian and Persian decorative styles together with the cults of Isis and Mithras; the reign of Heliogabalus was a Syrian carnival. But the Romans were no more Orientalist than was Gauguin, although he went to the Antipodes to search for glimpses of paradise. While there were exotic animal and plant features in early cathedral sculptures, the preoccupation with authenticity and the desire for a different environment that characterize Orientalism came later. In the Middle Ages, Salome's dance was a subject frequently depicted, but it was set at the court of a Frankish *seigneur*. Yet the Crusades had made the Middle East known in Europe.

The dawn of Orientalism dates from the moment that artists began to deck their models in turbans and fluttering belts. Lucas van Leyden's *Daughters of Lot* and the Bathshebas in the tapestries and miniatures of the end of the fifteenth century were the first *almahs* (dancing-girls) to be imported. The elaborate costumes of the Three Kings came either from Byzantium, as in the fresco Ghirlandaio painted for the Medici; or from Turkey, for the fall of Constantinople in 1453 brought the East deep into Europe. The conquerors' dress, arms, and architecture became known first through wood carvings; very soon turbans, kaftans, and scimitars became as familiar as the more or less ancient clothes beginning to be used in pictures of saints and heroes. Dürer was so fascinated by these novel features that he incorporated them in his bizarre painting of *The Martyrdom of the Ten Thousand*. The turban came to be identified with fabulous wealth as much as with evil.

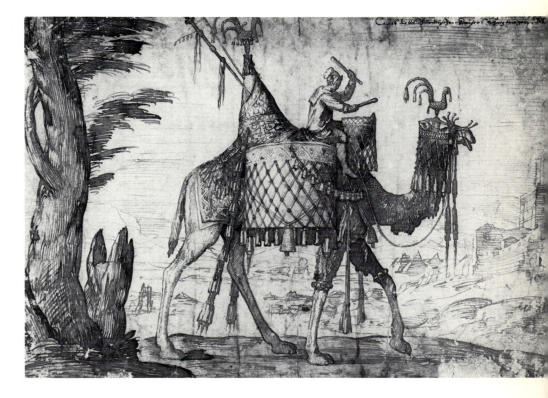

Melchior Lorck: Camel, 1557. Drawing, 33.1×47.1 cm. Musée du Louvre, Cabinet des Dessins, Paris. – One of the earliest drawings executed in Turkey, by a Danish artist.

Right up to the Romantic era, the East began in Venice: senators in damask robes received turbaned ambassadors, whose janissaries bristled with outlandish weapons; slaves in golden necklaces rolled out Smyrna carpets under the feet of Caterina Cornaro as she approached her kingdom of Cyprus. Gentile Bellini probably went to Constantinople and to Egypt, for his *Portrait of the Sultan* and his *Reception of the Venetian Ambassador in Cairo* are exact in every detail. A more fanciful picture of the splendours of the Egypt

of the Mamelukes is found in Carpaccio's *Saint Stephen Preaching in Jerusalem* and also in many elegant figures in his other paintings. The Venetian editions of Marco Polo's work were illustrated with increasing authenticity, although no sources farther afield than Turkey were used. For a long time artists took the details they needed from Melchior Lorck's *Turkish Customs and Costumes,* a collection of engravings published at the end of the sixteenth century; the author was a Dane who accompanied one of the Emperor's embassies to Suleiman II.

War even more than diplomatic contacts made the Turks known throughout Europe. Their westward progress was halted at the eleventh hour by two Christian victories — considered miraculous at the time — the battle of Lepanto in 1571, and the relief of Vienna in 1683. Both events became favourite subjects for painting. The Turks in Tintoretto's paintings, shown either as torturers or as captain-pashas, were absolutely true to life. Writers, too, soon began to draw on Oriental tales, borrowing their genii and sorcerers — Tasso in *La Gerusalemme liberata,* Ariosto in *Orlando Furioso.* Armida is a sultana, her enchanted pavilion the kind of summer-house found in the gardens of the Seraglio. The exotic passages of these poems contain a wealth of often cruel descriptions that have their parallel in the countless baroque paintings of *Judith and Holofernes* and in the turbaned Sibyls — though here they are veiled in mystery — painted by Dosso Dossi (Giovanni de Lutero), who, like Ariosto, came from Ferrara.

In France, Antoine Galland translated *A Thousand and One Nights* (1704—08), and La Fontaine skilfully adapted Indian fables. The King carried on a correspondence with the Great Mogul, and embassies were sent by Persia. In this period, the East reciprocated, and the palaces of Isfahan had "Occidental" decoration. Turkish characters appeared in the setting of Versailles and in Lebrun's *Battles*, while Monsieur Jourdain in Molière's *Le Bourgeois Gentilhomme* received the Mufti to strains by Lully. From the beginning of the seventeenth century there had been Turkish dances in the ballets given at the court of the Grand Duke of Tuscany, for which Stefano della Bella, who had been to Egypt, designed the costumes.

The English showed a very early taste for Oriental costumes: Van Dyck painted Sir Robert Shirley (1609) as a picturesque Persian in an enormous turban. For his Magi, Rubens transformed Flemings into pashas, perhaps with a hint of the Polish in the fur-lined coats and fur caps.

But it was Rembrandt who painted the first Orientalist pictures in which the subject was simply an excuse for rich materials and unusual architecture. The models for his Davids, Josephs, and Prodigal Sons were sensual, melancholy Jews covered with necklaces, draped in turbans, and posed beside props borrowed from synagogues. Besides, Rembrandt copied Mogul miniatures and collected Turkish weapons and Persian fabrics. He had all the characteristics that were to distinguish the Orientalist, but he also had one quality they lacked completely — a feeling of reverence.

At the beginning of the eighteenth century, the Turkish style remained decorative: there were Turkish characters in Watteau's drawings and on the panels painted by Lancret, including the famous *Turc amoureux,* but it was all rather fun, a kind of fancy-dress ball. The most famous Turkish "event" was the masquerade put on by the pupils of the French Academy in Rome, whose costumes were depicted by Vien and Barbault; we find a similar lavishness, one hundred and fifty years later, in the drawings of Bakst. In this ornate genre, the Turkish embassies painted by Joseph-François

Charles Amédée Philippe van Loo: A Sultana Dressing, *1774. Oil, 320×380 cm. Musée du Louvre, Paris. – Also known as* The Marquise de Pompadour in Turkey. *No effort at accuracy in the setting.*

21

Jacques-André-Joseph Aved: Portrait of Saïd Pasha, Ambassador of the Porte, 1742. Oil, 238×161 cm. Musée de Versailles. – Note the accuracy of the costume, the carpet, and the firman on the table.

Parrocel are more authentic. The Pompadours disguised as sultanas painted by Boucher and van Loo are no more genuinely Oriental than the sultanas of Diderot's *Bijoux Indiscrets;* although the costumes are fairly faithfully reproduced, they are made from European fabrics. *Chinoiserie,* which is a subject for a separate book (done admirably by Hugh Honour), remained chimerical, an imaginary world, a kind of rococo planet, inspiring Jean Berain's and then Boucher's tapestries, as well as Voltaire's *Orphelin de la Chine.* Nobody would have dared take such liberties with the Near East after the publication, in 1712, of "A Hundred Prints Showing the Different Nations of the Levant" by J.-B. van Mour (1671–1737), "painter-in-ordinary to the King of the Levant". Van Mour, a Fleming from Valenciennes, also set a fashion in painting two subjects that recur again and again, a sultana bathing and a rebellion, the latter against Ahmed II. We must also mention the works of Antoine de Favray, a Knight of Malta (1706–91): views of the Bosphorus, scenes from the lives of the ladies in the Greek quarter of Constantinople, and illustrations for the *Voyages littéraires en Grèce* by Guys (1771). Voltaire's *Orosmane* shows a preoccupation with local colour that is lacking in Racine's *Bajazet:*

> *Au fond d'un sérail inutile*
> *Que fait parmi ses icoglans*
> *Le vieux successeur imbécile*
> *Des Bajazets et des Orcans…*

["What is the senile heir of the Bajazets and Orcans doing in his useless seraglio amidst his icoglans…?"] "Icoglans" were handsome slaves destined for a career as soldiers.

The Genevese painter Liotard (1702–89), who went to the Levant from 1734 to 1743, fits more obviously into the

category of "Orientalist", that is, someone who paints authentic Oriental scenes for a European public. He lived in Smyrna, grew a beard, and dressed in Turkish fashion. His pastels of Levantine women owed their tremendous success to their authenticity. Jean-Baptiste Hilaire made more concessions to fashion, but his stay in Constantinople gave him the material for charming pictures. Like his, André Chénier's Louis XVI-style Orient is somewhat lacklustre, but in his poem *La Circassienne* he was the first to describe one of those harem favourites whom so many painters tried subsequently to portray:

"The Ganges spun the gold for the silken net imprisoning her black hair. Golconda has lavishly scattered pure emeralds and rubies over her rich belt, the narrow circle that gently caresses her ... On her lovely bosom, full of youth and love, pearls rise and fall gently ... and another strand of pearls entwines her bare arms...."

One of the earliest French Orientalist paintings took its inspiration from India, the *Portrait of an Indian Woman of the Kingdom of Tanjore* in the costume and ornaments of her country, shown at the Salon of 1767 and still known, thanks to a sketch by Saint-Aubin in the margin of the catalogue, to which he added: "There are gold bracelets on the arms and legs, a gold belt and gold chain, also on the toes." It was a description of an Indian dancing-girl. Fortunately the delightful Indian woman painted by Francesco Rainaldi, who exhibited at the Royal Academy in 1777–98, has been preserved.

The Venetians made a speciality of the most authentic Turkish ornaments. The older Guardi painted 46 scenes from Turkish life and views of Constantinople for Marshal von der Schulenburg, who had fought on the banks of the Danube. It was also common for officers in the army in

Jean Barbault: Priest of the Law, *1748. Oil, 66×49 cm. Musée du Louvre, Paris. – The costume, used in the procession of the students of the Academy in Rome, combines an accurate rendering with theatrical splendour.*

Africa to buy Algerian scenes. Tiepolo, who often used turbaned figures and colourful Negroes in his frescoes, did not really depict the mysterious Orient except in his engraved the *Capricci,* in which sibyls and necromancers were grouped round antique ruins.

The English in India commissioned painters such as Zoffany and Tilly Kettle to portray them on their plantations with their slaves; they trained local artists, the "Company painters", to paint the landmarks of their new empire. In the first instance, the model was European, but the second type of painting was really a glorified picture postcard. It was not until Zoffany produced his two great paintings, *The Tiger Hunt* and *The Embassy from Hyderabad to Calcutta,* that we have the first truly Orientalist pictures. At the end of the century, the landscapes and ruins by Thomas and William Daniell (uncle and nephew), which were already in the Romantic style, enjoyed a great success at the Royal Academy. We must also mention George Wilson's (1741–97) portraits of Maharajahs. Inspired by these pictures, George Stubbs, the animal painter, painted a sepoy with a cheetah on a leash, which was also acclaimed. We shall see what a great part animals played in Orientalism.

As the eighteenth century progressed, carefully illustrated travel books became more and more numerous and one of them, by C. de Bruin, a Dutchman, was translated into several languages. The English, with their particular fondness for ruins, published *Ionian Antiquities* in 1747, and the *Antiquities of Athens* in 1782, after the drawings by William Pars. In these engravings Turkish costumes enliven the melancholy classical ruins. There were yet more ruins in the beautiful aquatint collections published in 1799 after drawings made by the Daniells in India. For a long time,

Eastern Costumes, engravings by Francis Smith published in 1763, remained a standard work of reference.

In France, too, travel books appeared: the fine *Voyage pittoresque en Grèce* by Choiseul-Gouffier in 1792, the Comte de Volney's romantic *Ruines* (1791), and in 1787 *Le Voyage en Egypte et en Syrie,* with engravings by L.-F. Cassas, and A.-L. Castellan's albums on Turkey. The illustrations in these books fall into three categories: buildings, which were generally engraved after amateur drawings, costumes done more accurately after miniatures, and picturesque ruins with Turks posed among them. The contrast between an elegant architrave and the fierce janissary leaning on it to smoke his Turkish pipe, as drawn by William Pars, became a recurring theme in the following century. All the nineteenth-century armchair Orientalists made use of these engravings; Ingres took the architecture and props for his *Turkish Bath* from them and even the attitudes of the slaves.

Neo-classicism, which was philosophical and markedly heroic, regarded the East – until the Egyptian campaign – as exclusively the domain of the decorators. However, we must mention the authentic costumes drawn by François Gérard for *Bajazet* in Didot's edition of Racine. Then, suddenly, the sphinx, Isis, vases, canopies, and obelisks became part of an aesthetic language, so that Egypt came to be called the China of neo-classicism. Napoleon's victories gave meaning to this setting. When conquerors and Egyptologists returned, they had fallen under the spell of Cairo, where they had found a new Arabian Nights, both fabulous and sordid, sensual and farcical. Dominique-Vivant Denon, a very accurate and lyrical watercolour artist, published his delightful *Voyage dans la Basse et la Haute-Egypte;* the *Description de l'Egypte* appeared between 1809 and 1820, with the famous

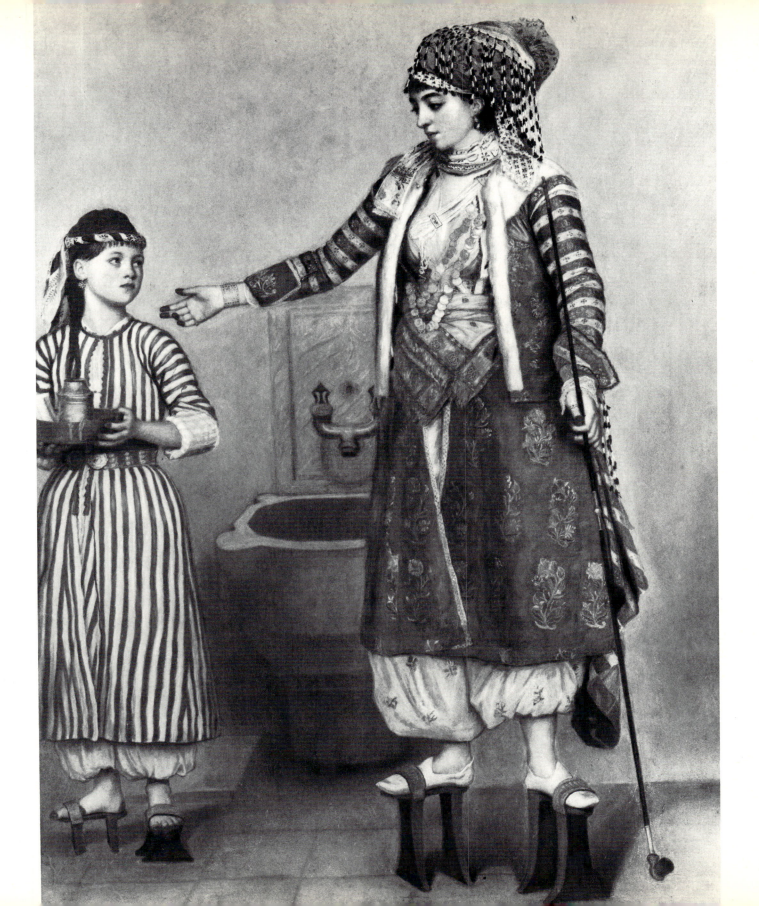

*Jean-Etienne Liotard:
A Turkish Woman and
her Slave, c. 1742–43.
Pastel, 71×53 cm.
Musée d'Art et d'His-
toire, Geneva. – The
almost photographic
accuracy of the cos-
tumes and the snapshot
quality of this bathing
scene (pattens were
worn in the Turkish
bath) were unique in
the eighteenth century.*

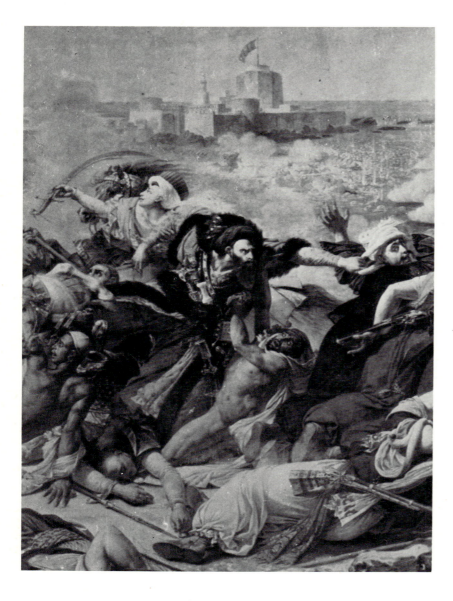

Antoine-Jean Gros: The Battle of Aboukir *(detail), 1806. Oil, overall 578×968 cm. Musée de Versailles. – This famous painting contains the germ of all French Orientalism.*

engravings that showed as much of the Pharaonic ruins as of the Islamic buildings. Caraffe exhibited Egyptian scenes at the Salons of 1799 and 1800, and Cassas had a painting of the Seraglio at the Salon of 1804.

With the help of all this material, A.-J. Gros painted his enormous *Battle of Aboukir* (1806), in which he contrived to herald Romanticism in an exemplary neo-classical composition. Here we find all the future paraphernalia of the Orientalists: flags, richly coloured costumes, beauty threatened in the form of the pink-clad page-boy *(icoglan)* who holds out his master's sabre to Murat, sumptuous Negro nudes; the violence expressed by the thrashing horses, the wounded desperately striving to get one more blow at their enemies. What pleasure they derived from painting these gorgeous fabrics stained with blood! The youth in pink was the forerunner of countless sultanas, dancing-girls and *almahs;* the mameluke was soon to engender a crop of Bashi-bazouks, Arnauts and janissaries eager for bloodshed and rape. Three years later we find the same characters and the same costumes in Girodet's *Revolt in Cairo,* although here they are undisguisedly equivocal, for the handsome boy is swooning in the superb arms of a completely naked Moor. We may take these two great compositions as the starting point of French Orientalism, in which violence played such an important part; the somewhat gentler English variety begins with the canvases painted by Zoffany for the rich colonists in India.

The Germans and Italians got to know Oriental subjects through operatic stage sets. Orientalism had less appeal for the Germanic countries, where Romanticism was based on national myths. To a lesser degree this is also true of England, whose painters were often inspired by the Arthurian legends. As a result of the success enjoyed by Chateau-

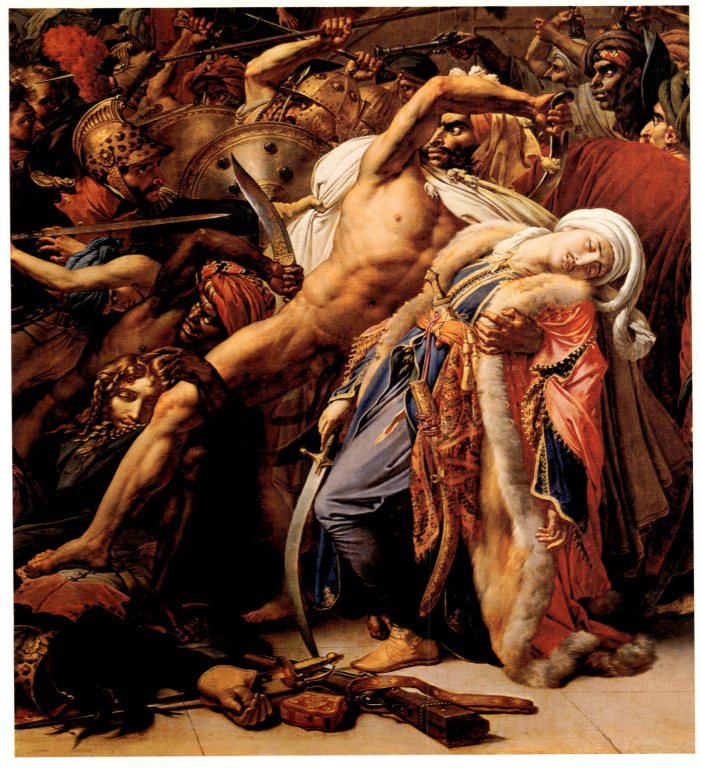

Anne-Louis Girodet de Roucy Trioson: Revolt in Cairo (detail), 1810. Oil, overall 365 × 500 cm. Musée de Versailles. – Here the colour range and many of the subjects of the first Orientalists can be seen twenty years before their time.

briand's *Itinéraire de Paris à Jérusalem* in France and the popularity of Byron's poems in England, the number of Oriental subjects shown at the Salon and the Royal Academy increased considerably. But in spite of this, Orientalism was essentially a French genre and remained so throughout the whole of the nineteenth century.

Orientalism is a form of Romanticism just as it is a new way of painting history, with which it is often closely linked. The artists found fresh inspiration in political events. Between 1820 and 1830, the independence of Egypt, the liberation of Greece, and the conquest of Algeria brought the Near East and the Middle East increasingly into the mainstream of European affairs. In the two decades that followed, travel became easier and quicker. But the success of this sunlit genre had deeper roots. In the century of coal, whole cities lay under a mantle of drabness. An Orientalist picture in a Victorian drawing room was a kind of escape. To our great-grandparents these canvases were not only a reminder of a different world, of something picturesque and heroic, but they hinted at pleasures that were often taboo in Europe and titillated a secret taste for cruelty and oppression. In this way the genre lasted far beyond the thirty odd years that were dominated by Romantic painting, and it contributed a bright and lively – if not particularly original – note to the Academic style that reigned supreme at the Salon until the end of the century.

In the reign of Charles X, the Orientalists achieved recognition as genre painters, in the same way as the painters of landscapes or seascapes. The Algerian campaigns and a revived interest in the Holy Places increased their influence, and their numbers grew. Between 1840 and 1880 an Orientalist stood a good chance of getting rich. The most famous painters might be called Orientalist at some point of their career: for instance, Delacroix in France, Makart in Austria, Bryulov in Russia, Holman Hunt in England, and Fortuny in Spain. After 1880 the growth, with the Impressionists and then the Symbolists, of a modern style in opposition to the Academic school undermined the prestige of the Orientalists. The more bizarre among them, such as Rochegrosse and Lévy-Dhurmer, went on exploiting the Orient until 1910, and the colonial painters emulated them. Orientalism declined when the development of transport increased contacts between Europe and Asia. It is perhaps significant that the splendid Orientalist exhibition at the Cantini Museum in Marseilles limited its choice to works executed before 1875. We shall add another thirty years to cover the period of the genre's decline, so that our closing date coincides almost exactly with the end of the nineteenth century.

We must also fix the geographical boundaries of Orientalism, and consider only those countries that European artists were able to visit. Most of them did not go beyond the Mediterranean Near East; their inspiration was primarily Islamic, their fantasy world that of the *Arabian Nights*, their poetry Persian, and their idea of the picturesque based on Cairo and Constantinople. It was very difficult to travel through Persia, and Arabia was inaccessible; the Moslem north of India was a source of ruins and sumptuous props rather than actual subjects. China, except for Hong Kong and Macao, where the charming Chinnery was painting, remained closed to the outside world. Although the opening up of Japan had a decisive influence on the decorative arts, painters, apart from Whistler, did not gain much from it. The fact that Van Gogh copied Japanese prints has nothing to do with Orientalism.

In the Islamic Mediterranean East, Egypt made the greatest contribution, then came Turkey and its depen-

dencies, Syria, Lebanon, and the Holy Land, the last-mentioned being particularly important for the English, who went there Bible in hand. Greece, even after its independence, provided genre scenes, as did the former Turkish provinces in the Balkans. For the French, Algeria provided an Orient that was heroic at first, then sensual. There is also a northern Orient, bordering on Russia; an Orient of furs, Turkestan and Georgia. The Orientalists in countries such as Poland and Hungary, which had long had contacts with the Turks, used local subjects or the picturesque Orient surviving in the Jewish ghettos.

We shall come back to these fringe regions after going all round the Islamic Mediterranean, country by country, to assemble an album of pictures with captions taken from writers who visited these countries: Byron will help us understand Delacroix, Gautier Decamps, and Loti will explain the work of Lévy-Dhurmer. Before undertaking this journey, we had to read the poets from whom our painters drew their inspiration: Ariosto and Heinrich Heine, André Chenier and Anna de Noailles. We had to read the accounts of the travellers whose tales fired their imagination and in whose footsteps they often followed. The reaction of the public is best seen in the reviews of the Salon, where this genre was so well represented, for these tell us more than the "impressions" of the Royal Academy or the Vienna exhibitions, although there, too, the Orientalists were present.

Confined by the time, space, and culture of last century, Orientalism as an art form is more difficult to define, for it transformed all the traditional genres. So many battle scenes in Algeria, nudes in harems, Bosphorus seascapes, ruins in the desert, still lifes in the shade of *moucharabiehs* ... Above all, the Orientalist picture is a genre painting either openly exotic, as in the *Dance of the Almahs* and the *Call of the*

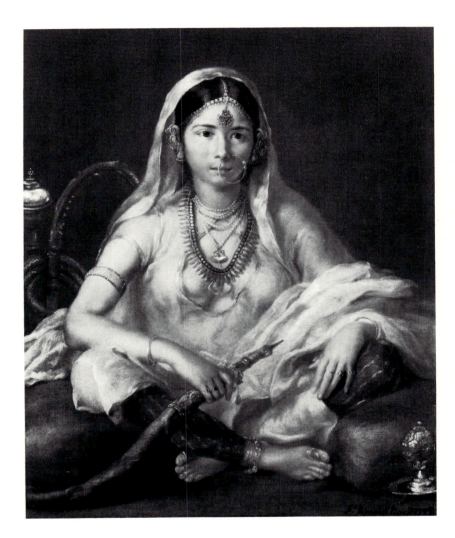

Francesco Rainaldi: Portrait of Princess Mashim Oudh, 1787. Oil, 70×56 cm. Private coll. — Indian women introduced a new kind of seductiveness into England.

Muezzin, or – though in a more authentic guise than in the previous century – depicting scenes that might just as well be set in Passy or Kensington, such as the *Visit to the Harem* or *Shopping in the Bazaar.* We must distinguish between painters who had been to the East and brought back a personal vision and those who simply exploited a fashionable style. Of course, we shall deal only with the first kind, but even among these there were many, like Delacroix, who went to the East for only a short time and spent the rest of their lives drawing on the memories of a brief stay.

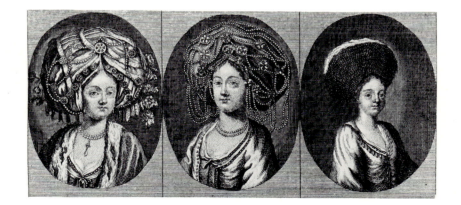

Turkish Head-Dresses, *Engravings from Cornelis de Bruin's* Voyage au Levant…, *1700.*

The Influence of Musicians, Travelling Poets and Writers

32

Romanticism drove many poets from their own countries, where only the past was still interesting; the industrial revolution created a sordid environment and offered only a drab future. It became essential to leave home. Governments were increasingly bourgeois and discouraged adventure in the mother country, but welcomed it in countries that were strategically or commercially important even though they no longer counted politically. There were not only Orientalist artists and writers, but also soldiers, engineers, priests, and countless adventurers. From the end of the Napoleonic Wars, the East symbolized easy riches and an untrammelled freedom to some, mystery and passion to others. Western poets fed their avid public marvellous pictures of the East, drawn more from a sketchy knowledge of Oriental poetry than from personal experience; and those who had not been to the East at all took their material from actual travellers, whose numbers were constantly growing. Of the four most fervently Orientalist poets, two – Byron and Chateaubriand – actually went there, while the two others, Victor Hugo and Heinrich Heine, only dreamt of it. Like the catalogues of the Salons, we could accompany each picture in this book with a quotation from one of these poets.

Byron was the poet who wielded the greatest influence. In 1809 he visited Spain and pushed on through Greece as far as Constantinople. In 1824 he died in the cause of Greek independence. His poems, which are mostly disguised autobiography, always feature Eastern heroes. *The Corsair* tells of an abduction from the seraglio; *Childe Harold's Pil-*

Richard Parkes Bonington: Eastern Scene, 1825. Watercolour, 24 × 19 cm. Wallace Collection, London. – Reminiscent of Mogul miniatures.

grimage deals with the cruel, brave Pasha of Janina, tyrant of Northern Greece; *The Giaour* is the fatal hero for whom women escape from the harem at the risk of their lives. Leila, the heroine of that harem, soon meets a rival in Zuleika, the *Bride of Abydos*. All the heroines and their adventures are met again in the episodes of *Don Juan*, in Greece with Haidée, in Turkey with a Sultana. The *Hebrew Melodies* combine the sensuality of the *Song of Songs* with the despair of the *Book of Job*, and one of the poet's least successful works, the tragedy *Sardanapalus*, was to inspire Delacroix's greatest masterpiece.

Byron's East, sensuous to the brink of perversity, cruel and mysterious, was the only place where the dandy still had a chance of becoming a hero. It certainly had plenty of local colour of a flowery, but somewhat conventional kind. When the mediocre translation of Byron's poems was published in 1822, his young French readers, who had just been learning to draw from the coldest neo-classical models, were fired with enthusiasm; friezes of sultanas and janissaries, inspired by Byron, soon chased the nymphs and heroes from the Salon. The struggle of the Greeks against the Turks gave an added ardour to this fashion, though, to tell the truth, the artists were far more interested in the picturesqueness of the Turks than in the sufferings of the Greeks.

With Byron, we must mention Thomas Moore's Indian poem *Lalla Rookh*, which inspired many painters and musicians and Samuel Taylor Coleridge's *Kubla Khan*, a dream that took the reader as far as Marco Polo's China. In his view of the mysterious East, Byron was influenced by *Vathek*, written in 1786 in French by William Beckford. Echoes of this fantastic, cruel and farcical East are found also in Count Potocki's *Manuscript Found at Saragossa*. Another, popular source of Orientalism in English poetry

Sir William Beechey: Thomas Hope. Oil, 221 × 167.7 cm. National Portrait Gallery, London. – An art connoisseur painted in a Turkish costume of the kind subsequently made popular by Lord Byron.

was Shakespeare. Desdemona, Cleopatra, and Portia all were turned into sultanas by their Romantic illustrators.

Like the poets, the novelists who visited the East remembered it with a kind of golden glow. Disraeli, who went to the Levant in 1830, used it for his historical novels, *Contarini Fleming* and *Alroy:* "The meanest merchant in the Bazaar looks like a Sultan in an Eastern fairy tale." The best book on Syria is Alexander William Kinglake's *Eōthen* (1844). Some Englishmen became so thoroughly "Arabized" that their imitations, their pseudo-translations, re-translated into Turkish and Persian, were tremendously successful, like James Morier's *Adventures of Hajji Baba* in Persia and Thomas Moore's *Lalla Rookh* in India. Robert Louis Stevenson wrote *The New Arabian Nights* (1882). But the most famous work was the translation, or rather the re-writing, of the *Rubáiyát of Omar Khayyám* by Edward Fitz-Gerald (1859); such was its success that Burne-Jones left the Knights of the Round Table long enough to draw Persians in the margin of William Morris's copy.

The most delightful of the armchair Orientalists, inspired by poems as well as miniatures and engravings in travel books, was Richard Parkes Bonington. He never went farther than Venice, but his watercolours have strikingly faithful colouring and a truly Persian delicacy. He showed them first in 1826, next to Delacroix paintings, at an exhibition organized in aid of the Greek patriots. He had a great deal of influence on French watercolour artists. A generation later, Edward Lear, the author-illustrator, went to Greece in 1849, to Egypt in 1854, and to India in 1875. Best known for his limericks, which have a surrealist absurdity, Lear was a splendid topographic artist, and the delicate tints of his watercolours make his views of the Nile and the Holy Land

John Frederick Lewis: The Siesta, *1876. Oil, 88.6 × 111.1 cm. The Tate Gallery, London. – A Circassian woman shaded by a lattice. Here this popular subject is treated with particular elegance.*

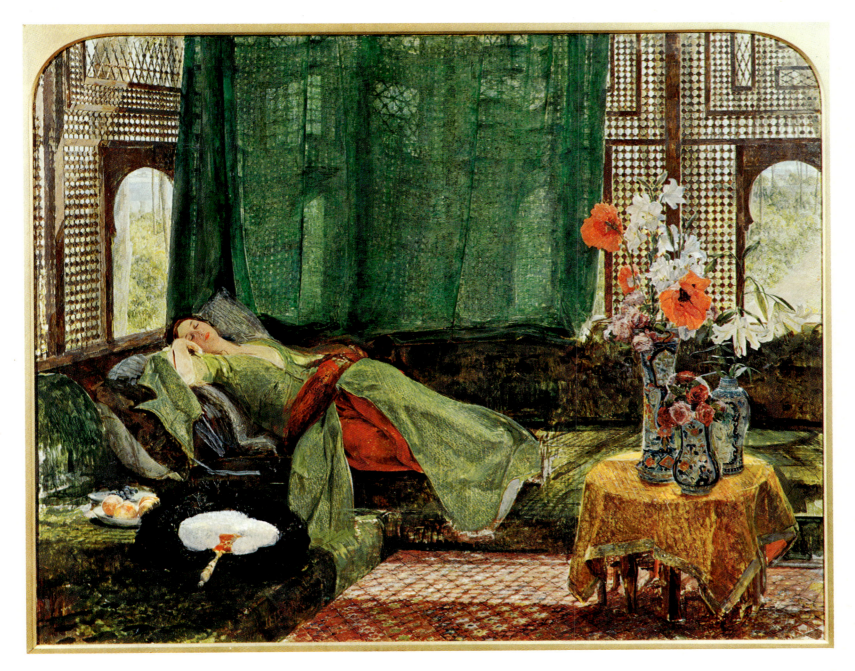

Edward Lear: The Oasis. *Drawing, 31.7×52.7 cm. R.G. Searight Coll., London. – Sketch by a poet who was also a great traveller.*

real masterpieces in a genre cultivated by all the English ladies who went on the earliest Cook's Tours.

From his journey through Spain in 1807, Chateaubriand brought back a hero, in *Les Aventures du dernier Abencérage,* who provided fresh material for the painters and lithographers, for china and clock manufacturers. His *Itinéraire de Paris à Jérusalem* became a model for travellers, who had until then been interested chiefly in antique ruins. Now their enthusiasm was aroused by mementos of the Bible; and the Holy Land, which had been completely neglected, became a place of pilgrimage. But Cairo was almost equally sacred to the admirers of Napoleon. That, after all, was the very spot where he had been tempted to emulate the conquests of Alexander the Great and a place where he left his mark.

Baron Denon's two volumes and the wonderful series of plates in the *Description de l'Egypte* stirred the memory of those who had been there and the imagination of the armchair travellers: Casimir Delavigne produced *Les Messéniennes* and Victor Hugo *Les Orientales,* published in 1829 and such an immediate success that some of his verses became as current as folksongs:

> *Elle eut beau dire: Je me meurs!*
> *De nonne elle devint sultane …*
> *Dans la galère capitane*
> *Nous étions quatre-vingt rameurs.*
> (VIII Chanson des Pirates)

[It was no use her saying, I am dying, from a nun she became a sultana; there were eighty of us oarsmen rowing the leading galley.]

Or again:

> *Il faut au Sultan des Sultanes;*
> *Il faut des perles au poignard!*
> (XII La Sultana favorite)

[The sultan needs sultanas, the dagger must have pearls.]

The refrains of these often sinister songs were inspired by the cruelty of the Turks:

> *Ma dague d'un sang noir à mon côté ruisselle.*
> *Et ma hache est pendue à l'arçon de ma selle.*
> (XV Marche turque)

["The dagger at my side is dripping with black blood, and my axe is hanging from the pommel of my saddle."]

Hugo's drawings were inspired not so much by mosques as by towns; he liked to do sweeping washtints of the desert showing the dome of some *marabout* or a ruined arch left

standing above a mass of rubble, all that remained of a town after the Jinns had passed.

Musset must have been making fun of the Oriental picturesque in *Namouna:*

Si d'un coup de pinceau je vous avais bâti
Quelque ville aux toits bleus, quelque blanche mosquée,
Quelque tirade en vers d'or et d'argent plaquée,
Quelque description de minaret flanqué
Avec l'horizon rouge et le ciel assorti…

["If I had, with a stroke of the brush, built you some blue-roofed town, a white mosque, a string of verses inlaid in silver and gold, some description of a minaret against a red horizon, with the sky to match…."]

In 1832 Lamartine and his wife and daughter set off for Jerusalem in Chateaubriand's footsteps. "The ladies will bring back some charming watercolours for their albums," Madame de Girardin wrote to him, but it was he who brought back the finest pictures, though they were marred by his determination to give them a biblical serenity.

"All my life, the East has been the dream that filled the dark days in my foggy home. As a child I read so much of the Bible and pored over the magic engravings in it, the tents of the patriarchs, the dogs, the camels, the vines, the sweet resounding names of that first family…."

Lamartine's aristocratic East matches Chassériau's, Byron is inseparably linked with Delacroix, and Hugo inspired mainly illustrators and painters of the picturesque. Lamartine travelled in the style of a nobleman, with a large escort, and was received by the pashas.

Gérard de Nerval, when he stayed in Cairo in 1849, lived very simply, often like an Egyptian. He then went to Constantinople by way of Syria. His East is accurate in its detail

but clouded by his love of the fantastic, which is laid over a colourful scene like a dark glaze. He was too introspective and it was inevitable that he should be disappointed by the reality when he saw the East. He certainly could have written the *Erythréa Sonnet* without going through Egypt and Syria:

Colonne de saphir, d'arabesque brodée,
Reparais! Les ramiers pleurent cherchant leur nid,
Et de ton pied d'azur à ton front de granit
Se déroule à long plis la pourpre de Judée…

["Sapphire column, ornate with arabesques. Come back! The doves are crying as they search for their nest, and the purple of Judaea falls in long folds from your granite top to your azure foot…."]

Théophile Gautier will be encountered all through this book for, between 1830 and 1870, he was tireless in praising the Orientalist painters and encouraging the public to buy their works. Many of the poems in *Emaux et Camées* written between 1848 and 1850 are about their pictures:

J'ai ma petite chambre
A Smyrne, au plafond d'un café;
Les Hadjis comptent leurs grains d'ambre
Sur le seuil, d'un rayon chauffés.
 (Ce que disent les Hirondelles)

["I have my little room in Smyrna, above a café; on the threshold, the Hajjis count their amber beads warmed by a ray of sun…."]

Gautier went to the East several times, first to Algeria, where he was sent by Louis-Philippe, then to Turkey; he travelled through Russia and finally followed the Empress Eugénie to Egypt. Even his *Voyage en Espagne* (1845) can be called Orientalist, for when he went to Andalusia he was constantly longing for the Islamic world.

Alexandre Dumas, who also travelled in the East, wrote *Un Mois au Sinaï*. He went as far as the Caucasus and came back with superb costumes and some splendid yarns. Didn't Monte Cristo live like a sultan with a mysterious woman captive?

Flaubert's grand tour of the East with Maxime Du Camp from 1849 to 1851 was marked by melancholy. From Alexandria onwards, he had a "heavy, anxious feeling as soon as his foot touched the ground." Later he noticed "a melancholy and sleepy sensation, you are already aware of something vast and pitiless in whose midst you are lost." This melancholy alternates with descriptions of farcical obscenity or bedazzlement. "The liquid light seemed to flow beneath the surface into the core of things." "They covered themselves with colour, not with cloth." "Two negresses stood leaning against the railings in poses that would make Veronese weep for joy." Flaubert returned from these adventures sick and misanthropic, but they provided him with the setting for the *Tentation de saint Antoine* and *Salammbô*. His Orientalism was both glittering and mystical, a little turbid, and even sinister; it had a tremendous influence on the Symbolists. Rochegrosse illustrated, almost caricatured, it; and Gustave Moreau, who never illustrated the work of the novelist, expressed it in his countless Salomes and in hundreds of watercolours. To obtain the texture and the colouring of "the purple shrouds in which the dead gods sleep" (Renan), Moreau studied Persian and Indian miniatures, and copies of Assyrian and Sassanid bas-reliefs, and read the works of Oriental story-tellers, poets and philosophers. He and Flaubert were kindred spirits.

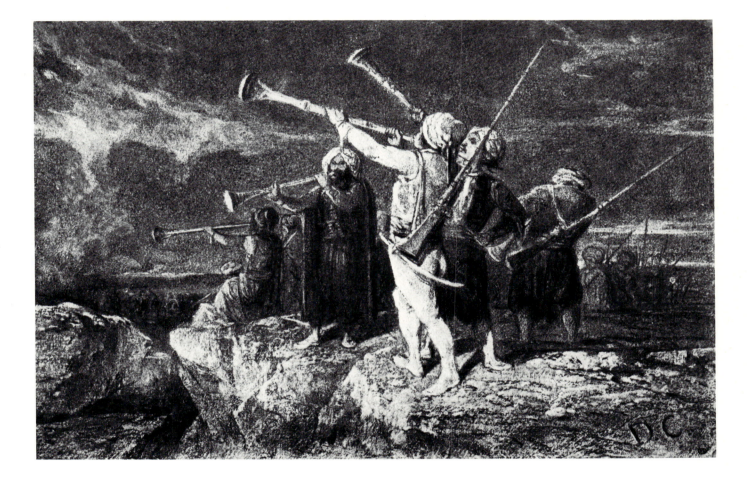

Gabriel-Alexandre Decamps: Hunters Blowing the Trumpet, *c. 1835. Charcoal, 31.1×47.2 cm. Musée du Louvre, Cabinet des Dessins, Paris. – Here the fantastic outstrips the picturesque.*

Fromentin, too, was melancholy: his books *Un Eté dans le Sahara* 1857, and *Une Année dans le Sahel,* 1859, immediately became classics. A little peeved at being mixed up with the picturesque Orientalists, the painter wrote: "The East is extraordinary, it gets away from conventions, it upsets the age-old harmonies of the landscape. I am not speaking of a fictitious East, I am talking of that dusty, whitish country, rather crudely coloured when it does have colour, with rigid shapes, generally broad rather than lofty, unbelievably clear with nothing to soften it, almost without an atmosphere and without distance."

The desolate East had been launched, the land of deserts, of ruins, ruled by fatalism. We find it in many passages of Gobineau's *Nouvelles asiatiques,* between disillusioned humour and local colour. This was the East near Central Asia about which the Russians wrote, Lermontov in *A Hero*

of *Our Times*, Pushkin in *The Fountain of Bakhchisarai* and Tolstoy in *The Cossacks*.

Sadder still, but more picturesque, was the tottering Turkish Empire which provided the setting for Pierre Loti's love affairs in *Aziyadé* and *Les Desenchantées*. The novelist, who filled his house in Rochefort with an incredible collection of Islamic bric-à-brac, delighted in half-tones like those in certain pastels by Lévy-Dhurmer, the last exponent of Orientalism. It is as clear now as it was to Loti that after 1900 the Orient of the painters, and poets existed only in the imagination; colonialism had enslaved it, progress had disfigured it, and the only picturesque thing left was the odd bazaar for travellers, now become tourists. A final poetic gleam is found in some verses by Anna de Noailles and in some Kipling stories. We might have dated the end of the East of the Orientalists as 10 May 1869, the inauguration of the Suez Canal, which laid Asia open to swift commercial conquest, if it were not for the fact that the painters, long condemned for being leading lights at the Salons that rejected the Impressionists, continued to send fascinating canvases to the Salons for another twenty years or so.

Puvis de Chavannes finished his large *Marseilles, Gateway to the East* just at the time when the Suez Canal was opened. There were various figures on the deck of the boat arriving in Europe, the Continent that was to rob them so soon of all poetry – a Persian, a Maronite priest, and a beautiful, somewhat sad Levantine woman. Lascars are busy with the tackle, but there is no fuss, no garish excess. Puvis, who had never been to the East, here achieved the *tour de*

Leopold Karl Müller: Today's Sphinx, c. 1880. Oil, 66.3×40 cm. Österreichische Galerie, Vienna. – The painters of the time liked to rediscover the ancient Egyptian "type".

40

William Holman Hunt: Afterglow in Egypt, 1854–63. Oil, 185.4×86.3 cm. The Southampton Art Gallery, Southampton. – *The mystic sensuality of the Pre-Raphaelites.*

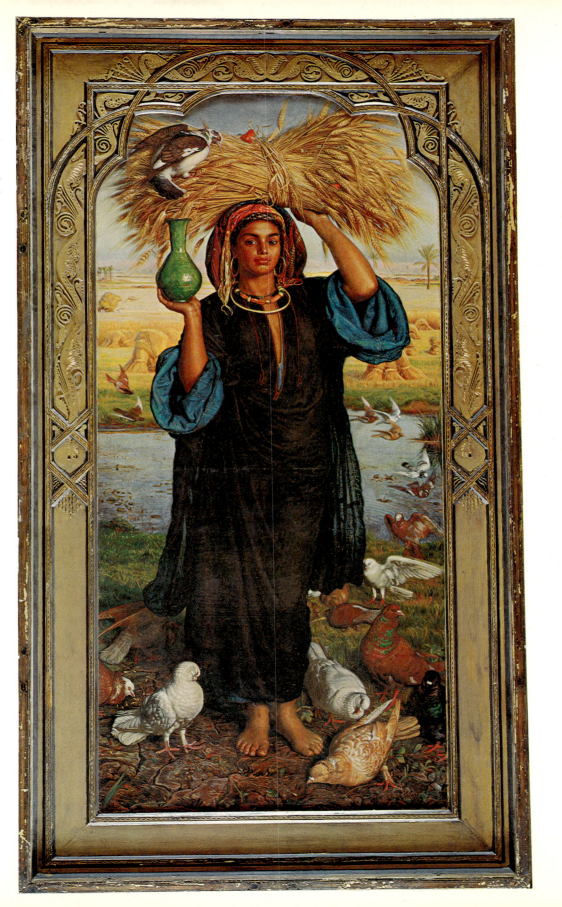

force of being a cold, precise Orientalist who made no concession to the picturesque. There are dozens of studies of costumes, many taken from material brought back by his friend Léon Belly. It is a skilful, harmonious composition, lacking in poetry, but reminiscent of Renan, who also returned from the Levant via Marseilles after his archaeological missions in Palestine. Corot, too, dreamt of the East in his poetic fashion and was happy to dress a good-looking model in a grey-blue embroidered kaftan or place a Grecian cap on a fair head.

We shall not discuss the metaphysical East that was so important to such painters as Odilon Redon and Gustave Moreau, the East of Schopenhauer and Wagner, who thought of Parsifal as an incarnation of Buddha. Sâr Peladan advised painters to find a new inspiration in the East, but the Symbolists – apart from Lévy-Dhurmer – did not listen to him and went no further in that direction than Byzantium.

In Germany, Goethe was the first to succumb to the East; his *West-östlicher Divan* is a collection of imitations of Persian poetry, which Théophile Gautier described in these terms:

> *Pendant les guerres de l'Empire*
> *Goethe, au bruit du canon brutal*
> *Fit le* Divan *occidental*
> *Fraîche oasis où l'Art respire.*
> *Pour Nisami quittant Shakespeare,*
> *Il se parfume de santal*
> *Et sur un mètre oriental*
> *Nota le chant qu'Hudhud soupire.*

["To the sound of the brutal cannon during the Imperial wars, Goethe made the *Western Divan* a fresh oasis for Art. Leaving Shakespeare for Nisami, he perfumed himself with sandalwood and gave Hudhud's song an Oriental metre."]

Many poems in the *Divan* recall Persian miniatures. This is the same East as Bonington's, primarily graceful, sometimes very equivocal, as in the *Book of the Cup-Bearer*. Many an Orientalist who had painted a rather too seductive slave or page-boy might have said like Goethe: "Neither the immoderate longing for a half-forbidden vice nor the tender feeling for the beauty of an adolescent could be left out of the *Divan*; but the subject must be treated with complete purity in keeping with our ethics."

In 1827, Heinrich Heine began to write about Spain in *Almansor,* which takes place in a dilapidated Alhambra, and until 1851, when he wrote *Romanzero,* this Jewish poet never ceased to extol the superiority of the Islamic countries. He himself never went there, but his friend Prince Pückler-Muskau went in his place. He even brought a gorgeous black slave girl back from Egypt, but she promptly died of consumption. Heine easily adapted the images of the *Song of Songs* and of the Persian poets:

"The rose bloomed sixteen times and faded sixteen times, and the nightingale sang to it and fell silent sixteen times. And during that time the poet remained seated night and day at his loom of thought and wove the vast fabric of his poem."

The East was brought to Germany by writers rather than by painters and often, as in Goethe's work, in an equivocal manner. Count August von Platen published four series of sonnets inspired by the Persian poet Hafiz, which he called the *Ghazels* and dedicated to the handsome young men of his circle. Later, towards the end of the century, Karl May, the novelist, took his readers to an imaginary East illustrated by Sacha Schneider in a Symbolist style. The Germans contributed to the Orientalist fashion in literature and philosophy more than in art.

42

The most highly regarded Orientalist scholar was a Viennese, Baron Hammer-Purgstall. He wrote histories of several Moslem countries, which began to appear at the end of the eighteenth century. He was a tireless and prolific translator of poems such as the *Divan* by Hafiz which was the basis for Goethe's *West-östlicher Divan*. Balzac, who was one of his admirers, dedicated *Une Passion dans le Désert* to him to thank him for providing the Arab inscription for his *Peau de Chagrin*.

Wrubel, a Russian visionary haunted by legends of evil, was deeply moved by Lermontov's poem *The Demon*, which conjures up a whole Eastern phantasmagoria. His accursed seraphim came from Byzantium, and his sirens and black angels from the Central Asian plains, whose solitude engendered the most extraordinary myths. He was also haunted by Rimsky-Korsakov's *Sadko*, a legend in music.

After pointing out the links between poetry and the more or less imaginary East of the Romantic painters, we must turn to the influence of music, or rather of opera: an increasing authenticity was expected of operatic sets, whereas the costumes remained subject to the current fashion. When Delacroix was painting *The Death of Sardanapalus* he asked Eugène Ciceri, the famous decorator, for material; and Roberts was designing the scenery for Covent Garden. It is interesting to see that in the theatre, too, stage sets became increasingly authentic with the spread of Orientalism. Mozart's *Seraglio*, Gluck's *Les Pélerins de la Mecque*, Boïeldieu's *Calife de Bagdad*, and even Rossini's *Italian Girl in Algiers* were presented as "*Turqueries*". Works already well known, like Cherubini's *Les Abencérages* (1813), and Donizetti's *Zoraide di Granata* (1822) acquired much more realistic sets. Sanquirico's antique Eastern sets for Rossini's *Semiramide* created a public demand for more authentic and

Karl Blechen: The Oriental Conservatory at the Potsdam Palace. *Oil on paper, 64 × 56 cm. Kunsthalle, Hamburg. — By an excellent painter of romantic buildings.*

exotic décors. Moore's *Lalla Rookh* inspired several of Spontini's works, including an opera; and Felicien David's opera in 1862 had admirably authentic sets and was highly successful because for the first time the score contained Oriental tunes. The same is true of Léo Delibes's *Lakmé*

(1883, Indian setting), Bizet's *Pêcheurs de Perles* (1863) and his less well known *Djamileh* (1872). In *Aïda*, commissioned for the opening of the Cairo Opera House in 1869, Verdi made no concession to local colour except in the sets.

Biblical subjects were popular and there were stage reconstructions of the Temple of Solomon and views of Jerusalem and the Nile. The performance of Gounod's *Reine de Saba* (1862) and Saint-Saëns's *Samson et Delila* (1877) gave the public a chance to see glittering Orientalist tableaux on the stage. In Russian music, Glinka's *Russlan and Ludmila* (1842) also has echoes of the East. The Arabic dances in Tchaikovsky's *Nutcracker Suite* and Rimsky-Korsakov's *Scheherazade,* composed in 1888 and performed in Paris over twenty years later, led to a revolution in the plastic arts and a complete renewal of Orientalism. *Scheherazade* dealt a death blow to the Orientalists of the Salon, whose dancing girls, compared with Diaghilev's ballet dancers in costumes by Bakst, looked like shop-worn mannequins. Many subjects dear to these painters, like the Bedouin's Daughter and the Persian Market, soon began to look equally hackneyed.

William Holman Hunt: Illustration for Tennyson's poems, Recollection of the Arabian Nights, *1857.*

Three Masters

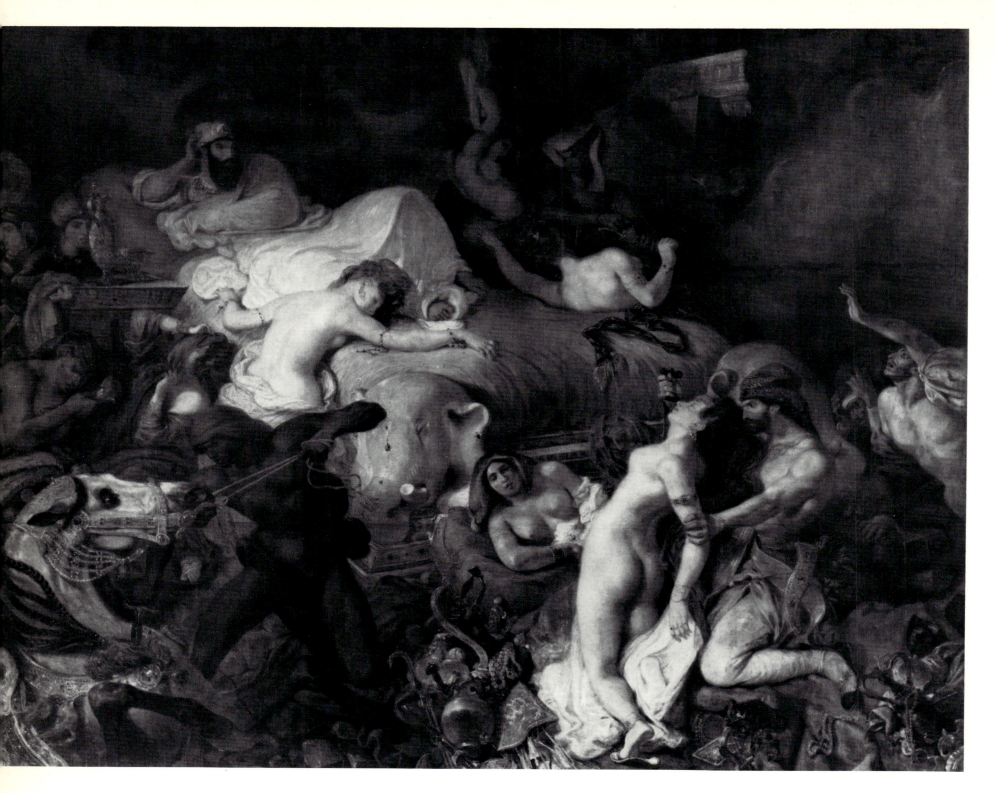

46

"There is more interest in the East nowadays than there has ever been. Never before have Eastern studies made such progress. In the age of Louis XIV everyone was a Hellenist, now they are all Orientalists. Never have so many fine minds, at one and the same time, delved into the abyss that is Asia.... Everywhere the East has come to preoccupy the mind and imagination.... Everything there is large, rich, and fertile." These lines by Victor Hugo in the preface to *Les Orientales* could have been written by many other European poets. "The whole Continent is leaning towards the East," the writer concluded.

Aesthetically, Orientalism was spread very unevenly. No other country gave so much space to it in its exhibitions as France. English painters who felt drawn to the East settled in the country of their choice and adopted its clothes and often its customs. The Germans usually went as tourists and did not specialize in a genre. The Italians often went to live in the East, where they found a more generous clientele than at home. But none of these painters was, like the French, an official figure, a sort of Ambassador of the Exotic accredited to the Académie des Beaux-Arts.

Three painters – one a genius, the second a great painter, and the third a very good painter – secured the foremost place for Orientalism in French art so that between 1825 and 1875 it became as important a genre as historical painting. The first of these painters, Eugène Delacroix, found in Morocco the colour he sought and an inexhaustible source of inspiration. The second, Théodore Chassériau, discovered

Eugène Delacroix: The Death of Sardanapalus, 1827. Oil, 392× 496 cm. Musée du Louvre, Paris. – All the themes of literary Orientalism are combined in this work.

the East that suited his temperament in Algeria, which also provided subjects for Eugène Fromentin, the third, who made numerous stays there. Delacroix and Chassériau spent only a few months in Africa.

For the Salon of 1824, Delacroix, who was very familiar with the Egyptian paintings by Gros and Girodet, painted *The Massacre at Chios,* inspired by Byron's poems on Greece. A friend of his, Mr. Auguste, a distinguished connoisseur, had brought back weapons and costumes from Turkey and lent him the requisite accessories. The *Turk on Horseback* has all the cruel elegance of a Byronic hero. But his victims, as Alexandre Dumas pointed out, were too like those in A. J. Gros's picture of *The Plague-Stricken at Jaffa* (1804). "I'm afraid I've washed Gros's palette badly," Delacroix admitted. He was more himself when illustrating the fight of *The Giaour and the Pasha* after Byron. And *Greece Expiring on the Ruins of Missolonghi* was just the kind of heroine that Byron loved to sacrifice in his life and works.

In *The Death of Sardanapalus* at the Salon of 1827, Delacroix was more Byronic than Byron himself. Here we find all the Orientalist paraphernalia, a cruel, bejewelled prince, ravishing victims, a naked black male slave, a thoroughbred foaming at the mouth, and, spread on muslin, Golconda's treasures mingled with carved weapons. This painting – perhaps one of the finest of nineteenth-century works – was inspired by three ideas: the East, history, and death. We learn from the painter's diary that he used Indian material for the props. In this sadistic apotheosis Delacroix certainly identified with the tyrant. Baudelaire made no mistake when he compared Delacroix with "one of those Hindu princes who, in the midst of the most sumptuous feasts and splendours, have a kind of unsatisfied hunger, an inexplicable yearning, deep in their eyes...."

In spite of the extreme care Delacroix took to collect authentic material, his conception of the East was too far from reality to withstand the shock of a trip to Morocco in 1832. And what the painter actually discovered there was simplicity. "The white draperies, the half-naked riders… antiquity has nothing more beautiful," he wrote to a friend. "They are closer to nature in a thousand ways, their clothes, the shape of their footwear, and everything they do is a source of beauty…."

On the way back, the painter and his companion, the Comte de Mornay, stopped at Algiers. As a result he painted the *Women of Algiers* (Salon of 1834), a masterpiece of genuinely experienced Orientalism, whereas *Sardanapalus* had been the masterpiece of an imaginary Orientalism. These women are like pink and white peonies: they remind us of Baudelaire's *L'invitation au Voyage:*

> *Les riches plafonds,*
> *Les miroirs profonds,*
> *La splendeur orientale…*
> *Luxe, calme et volupté.*

[Rich ceilings, deep mirrors, Eastern splendour…. Luxury, calm and sensual pleasure.]

In the later version at the Montpellier Museum, the pleasure in painting gives way to a sense of staleness and the sensuality remains latent and unfulfilled. From then on, Delacroix sent a Moroccan scene, lion hunts, fighting horsemen, or variations on the *Women of Algiers* to practically every Salon. A certain pedantry finally dimmed the freshness of his memory, but in such pictures as the *Jewish Wedding,* with its bright greens and clear whites, he recaptured all the immediacy of the watercolours actually done during the journey. These harmonies of greens and reds, so common in Morocco, were not always successful in a painting, and the *Convulsionaries of Tangiers,* for instance, is simply garish. Back in France, Delacroix wrote: "Paris bores me to death; since my journey I have seen things and people in a different light." The natural physical intensity of Moroccan life showed up the artificiality of Romantic intensity.

Delacroix, Chassériau, and Fromentin discovered Antiquity in the Maghreb. "Rome is no longer in Rome," wrote Delacroix, and Chassériau, who stormed out of the Villa Medicis, banging the doors behind him, compared the classical city to a tomb. Fromentin wrote to Gustave Moreau: "I challenge anyone to show me an antique that is better draped, more finely proportioned and more scrupulously beautiful than a Bedouin, any Bedouin picked at random in the market, the café or the street." This love of antiquity restrained these painters from running riot with colour. Delacroix's portrait of *Sultan Abd ar-Rahman,* whom he glimpsed at Meknes, is a model of sobriety. It has more dignity than colour, perhaps to avoid the pitfall of using the kind of props dear to G.A. Decamps and his pupils. Fromentin, who saw the painting at the Salon of 1845, wrote: "Grey, this is the accession and triumph of grey, from the cold grey of the walls to the hot powerful grey of the ground and the scorched vegetation." At the same Salon, Chassériau exhibited a rather similar portrait of the *Caliph of Constantine* with his suite, on horseback, a sparkling, elegant picture, reminiscent of Géricault. But Chassériau had not yet been to Algeria.

Throughout his life Delacroix drew on his memories of Morocco, either doing variations on his most famous paintings, the *Sultan* (1849) and the *Convulsionaries* (1851) — one

Théodore Chassériau:
Esther Dressing, 1841.
Oil, 45.5×35.5 cm.
Musée du Louvre,
Paris. – In the tradition
of the Venetian masters,
but with echoes of
Algiers.

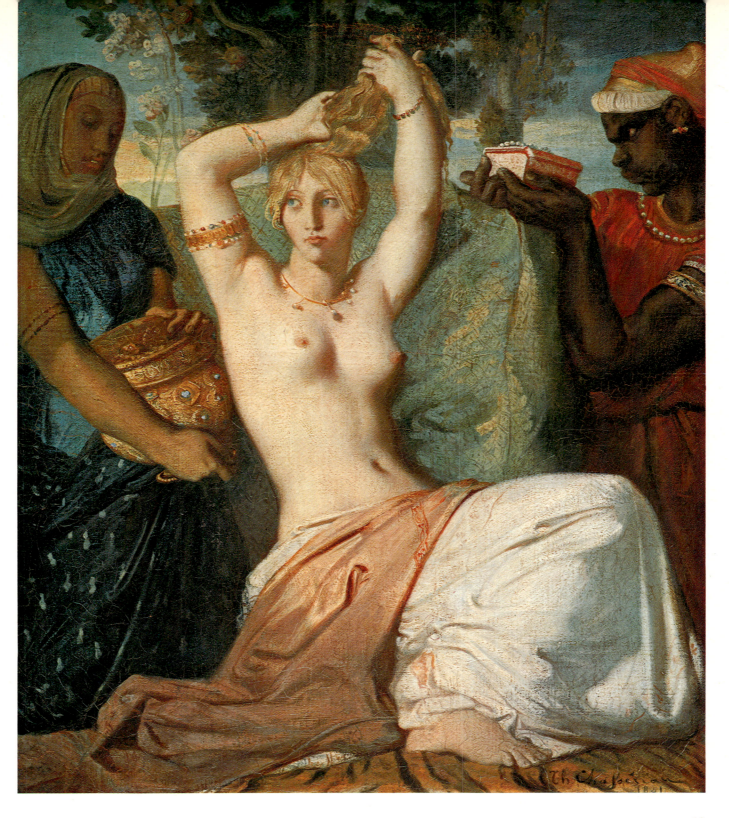

of his last paintings was the *Collection of Taxes* — or inventing lion hunts and horse fights which owed at least as much to Rubens as to Morocco. In the large works of decoration that occupied his old age, he managed to revert to a robust antiquity with nothing academic, such as he thought the Moroccans incarnated. "Men dressed in white passed in the distance among the trees, horsemen who tamed steeds rode along a narrow path, half naked, without saddles, who had, we felt, something Thessalian about them." These are the Moroccan shepherds seen in the background of the fresco *Jacob Wrestling with the Angel* in the Church of Saint-Sulpice.

On 23 December 1860, three years before his death, Delacroix wrote in his diary: "Subjects from the *Arabian Nights:* Sultan Shariar, coming back to say goodbye to his wife, finds her in the arms of one of his officers. He draws his sabre, etc.... The king of the Black Isles (in the fisherman's story), enraged by his wife's feelings for her black lover, whom he himself had wounded and who is lying at his feet, draws his sabre to kill her: she stops him with a gesture and turns him into half man, half marble. The story of the first dervish.... After the dervish has taken refuge with his uncle, they search the tomb together: they come into a large underground hall where they find a bed, its curtains drawn, with the two burnt bodies of the son and his sister. Columns, lamps, provisions, cisterns, etc."

None of these pictures was even sketched out. Before the coming of the Ballets Russes, the fantasies of the *Arabian Nights* tempted only very few painters. Perhaps they feared to veer too close to the kind of vignette illustrating that book, done by second-rate artists whose imagination tended towards fairy-tale spectaculars.

Much in Théodore Chassériau's background caused the East to appeal to him. His father, after being an inspector of revenue with the expedition in Egypt, had married a Creole at Santo Domingo. Chassériau, who looked like a Persian prince, was attracted by biblical scenes from the start of his career. His *Susannah Bathing* is draped in a sari, and in the foreground is a still life of Eastern objects. The portrait of his blonde mistress between two Negro women was based on another biblical ablution (a popular subject with Orientalists). Admittedly, he was influenced by Delacroix, but even more by Girodet's numerous Eastern portraits and by Géricault. One of his models was the Negro who had posed for *The Raft of the Medusa*. The actress Rachel's Jewish beauty delighted him; her looks and gestures reminded him of the Jewish women who had posed for him while he stayed in Constantinople in 1845, at the invitation of the caliph of the region. The caliph, an ally of France, must have been very attractive if we are to judge from his portrait and the painter's description of him: "Those terrible, gentle eyes, sad yet blazing, which seem turned inward and yet look right through you, gazelle eyes, yet lion eyes, which have made many Parisian women thrill and blush in the depth of their *loges*."

All Chassériau's work was marked by his short stay — one spring — in Algeria. Like Delacroix, he painted lion hunts, slaves, and Moorish chiefs preparing defiantly for combat. His masterpiece, which was saved from pedantry by a genuine melancholy, was *Arab Horsemen Taking Away Their Dead after the Battle* (1850). In Algeria he developed, like Delacroix, a passion for Arab horses; again like Delacroix, he covered notebooks with sketches, drawings and notes: "Remember the towns of the south have satin tones in their shade and radiant light. The sky a burning blue, green, grey. Reddish tones next to greys, like Roman palaces. To

warm the large quiet areas of wall it needs just a touch of gold in a few places."

Baudelaire was unfair when he accused Chassériau of "robbing" Delacroix. He had less power, less depth. He was narcissistic, and all the people he painted looked like him. The difference between them is very noticeable when we compare Delacroix's Arabs in the Palais Bourbon and those in Chassériau's paintings in the Cour des Comptes. Delacroix's are sturdy Romans, Chassériau's graceful Indians. The same is true of the fresco in the Church of Saint-Roch *Saint Philip Baptizing the Eunuch of the Queen of Ethiopia.* Their contemporaries were right. Arsène Houssaye wrote in *L'Artiste* in 1848: "Chassériau is an artist of the East who has visited the court of the Queen of Golconda. The Indian sun shines on his palette." Critics with the most divergent views were charmed by Chassériau's work. Thus Thoré praised it at each Salon, but less enthusiastically than Gautier, who said of the last, unfinished picture: "Two women in brilliant costumes are lolling on the cushions of a divan in weary, languid poses, gesturing with that nervous boredom that comes from being shut in a harem." During the last years of his life, Chassériau had a young Rumanian companion, Princess Cantacuzeno, who looked like his models.

While Chassériau was a great painter influenced by the East, Fromentin was a great Orientalist. A native of La Rochelle, like Chassériau, he was an educated, sensitive bourgeois, easily discouraged, sufficiently solitary by nature to be able to endure a month in the desert. Friendship meant a great deal to him: that of Gustave Moreau, in the Fifties, was paramount. Of the two, Moreau was the guiding spirit, gave practical advice on such matters as how to speckle horses' rumps, and was able to comfort and reassure. Free from money worries, Moreau helped Fromentin, who was

Théodore Chassériau: Ali ben Hamed, Caliph of Constantine, Followed by his Escort, *1845. Oil, 320×261 cm. Musée de Versailles. – The caliph, a great lover of France, invited Chassériau to stay and inspired one of his foremost works.*

51

rather poor, to sell his paintings, either at exhibitions organized in Bordeaux by their friend Dauzats or by the dealer, Beugnet. Not only Fromentin, but other Orientalists frequented Moreau's studio, for instance Belly and Berchère, who, wrote Moreau, "came back jet-black" from a long stay in Egypt in 1856. Indeed, they seemed to do Moreau's travelling for him while he stayed at home and assimilated their experiences. He wrote ironically in 1856: "The artistic caravan of the Nile, Gérôme and Company, is continuing on its way." Fromentin was not spared Moreau's irony either. The margins of his friend's books are covered with caustic notes.

Like Moreau, Fromentin was a delightful talker, full of ideas and interested in philosophy. He was modest, too, and did not take his very numerous paintings for works of genius, even after Baudelaire wrote: "To me these luminous canvases breathe a heady vapour that quickly condenses into desire and regrets. I find myself unexpectedly envying these men who are stretched out in blue shades, neither awake nor asleep, whose eyes, if they express anything, express the love of calm and the contentment that comes from immense brightness."

Fromentin frequently stayed in Algeria and often took friends with him, like Narcisse Berchère, Charles Labbé, the author of *Fumeurs de Kief*, Auguste Salzmann, an archaeologist draughtsman, and Alexandre Bida, who, he said, "handled black and white like a palette." Fromentin pushed far on into the Sahara; his stay with a Bedouin tribe "would

Eugène Fromentin: Study of a Horseman for the "Falcon Hunt". *Drawing. Private coll. – This splendid drawing emphasizes the links between Moreau and Fromentin.*

Eugène Fromentin: Arab Horsemen Halting in a Forest, *1868. Oil, 54.5×64.5 cm. Musée du Louvre, Paris. – This canvas is clearly influenced by the Dutch landscape painters with whose work Fromentin was so familiar.*

deserve a religious record". He wrote two books on his experiences, one on the Sahara, in which he gives a good description of its overwhelming impact and of the mirages, and the other on the Sahel. About this green region round Algiers he also had interesting things to say. His prose described his canvases: thus he wrote in 1867 of the *Arabs at Prayer:* "In a historical setting of innocence, majestic figures draped in black and white...." George Sand was very fond of these books and became a close friend of his; and Pierre

Loti must have been influenced by their way of changing from the picturesque to the melancholy. His masterpiece, *Dominique* (1863), was the very opposite of picturesque. Fromentin, like all the literary painters, was even better at drawing than at painting. His heads of Moors and his horses are splendid: in this he comes very close to Moreau.

We shall encounter these three masters again among their imitators – they had no disciples – at the Salon, where the Orientalists occupied a more important place each year.

Francis Philip Stephanoff: The Embassy of the Flower. *Drawing-Room Book, 1852.*

The Salons

Paul-Louis Bouchard: The Intrigue, *1880. Oil, 40×26.5 cm. Galerie Tanagra, Paris. – A typical Salon picture of the kind the Egyptians loved at the end of last century.*

It was common to quote poets, novelists and travellers in the – often lengthy – reviews of Orientalist pictures in the catalogues of the Salon. Thanks to Gros, Girodet and Vincent, the painters of the Egyptian campaign, Orientalism was accepted by the Establishment, which confused it with history, and in some cases with antiquity: it smacked of "higher painting"; with the years, Orientalism became a genre. When Delacroix exhibited his *Massacre at Chios, Greece Expiring on the Ruins of Missolonghi,* and *The Death of Sardanapalus* at successive Salons, there could be no doubt that these paintings, or at least the first two, belonged to a great genre based on noble sentiments.

The Salon had often accepted Delacroix's contributions rather reluctantly, so it was not until Théophile Gautier had gained sufficient authority that his paintings found a fervent defender in papers like *L'Artiste,* where they were often reproduced as lithographs.

The French Orientalists can be divided into three generations: those who created the genre under Louis-Philippe, picturesque, keen on local colour, like Decamps and his disciples, Horace Vernet, and the military painters; a second generation of neo-classicists, clustered round Chassériau and Fromentin, concerned more with elegance and the expression of feelings; then, during the Third Republic, we have painters like J.-L.-L. Gérôme, J. J. A. Lecomte du Noüy and G. A. Rochegrosse, to whom Orientalism seemed the last hope of "higher painting". They were superbly skilful but sometimes vulgar and unconsciously funny, which has made them popular with lovers of kitsch. The first generation included painters like Callande de Champmartin, who imitated Delacroix as best he could, Adrien Dauzats, who was excellent at architectural features, Emile Lessore, a pupil of Decamps, J.-A.T. Gudin, a battle painter dear to

Narcisse Diaz de la Peña: Turkish Assembly, *c. 1845. Oil, 24.5×33 cm. P. Leroux Coll., Paris. – A charming example of the "Turqueries" of the Louis-Philippe period.*

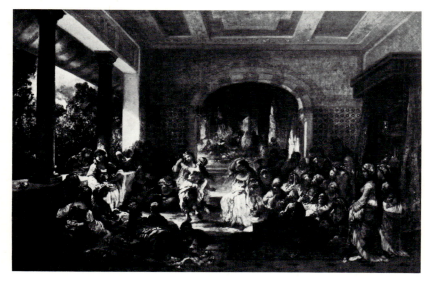

Louis-Philippe, and Alfred Dorzon, who deserves greater recognition for his sense of colour.

One Orientalist whom Gautier constantly encouraged, G.-A. Decamps, was soon to become the model for all Orientalists for two generations. Even the greatest did not escape his influence. After he had exhibited the *Algerian Dancers with Kerchiefs*, the Salons of 1848 and 1849 followed with Delacroix's *Arab Comedians*, Chassériau's *Dancers with Kerchiefs*, the *Moorish Feast* by Benjamin Roubaud, and Adolphe Leleux's *Dance of the Djinns*. Decamps set out for the East in 1828 with his friend Garneray, a seascape painter, and settled in Smyrna, which he used as a centre for touring Asia Minor. From 1837, when he first exhibited the *Torture with Hooks* and *Coming Out of a Turkish School* at the Salon, he was immensely successful. In 1839 in *La Presse*, Gautier wrote about the *Turkish Café*: "There is a white wall with stone pillars, and the eye looks between them into a cool transparent shade, in which the Turks are smoking opium in an attitude of such exotic idleness that the most active of men must envy them. Above the wall are full rounded cupolas, like marble breasts, minarets tapering into the serene air, and the blue sky shining through the dark green leaves of the carob trees and cypresses; white puffs of doves are flying overhead." His enthusiasm was still unabated in 1860: "His strange dreamlike figures, whom travellers remember with the dazzlement of a vanished mirage, while those who stayed in Europe do not know them."

Narcisse Diaz de la Peña: Harem Scene, *c. 1845. Oil, 53×80 cm. Claude Bernard Haim Coll., Paris. – It would have been impossible to witness this charming scene in an Islamic country: boudoir Orientalism.*

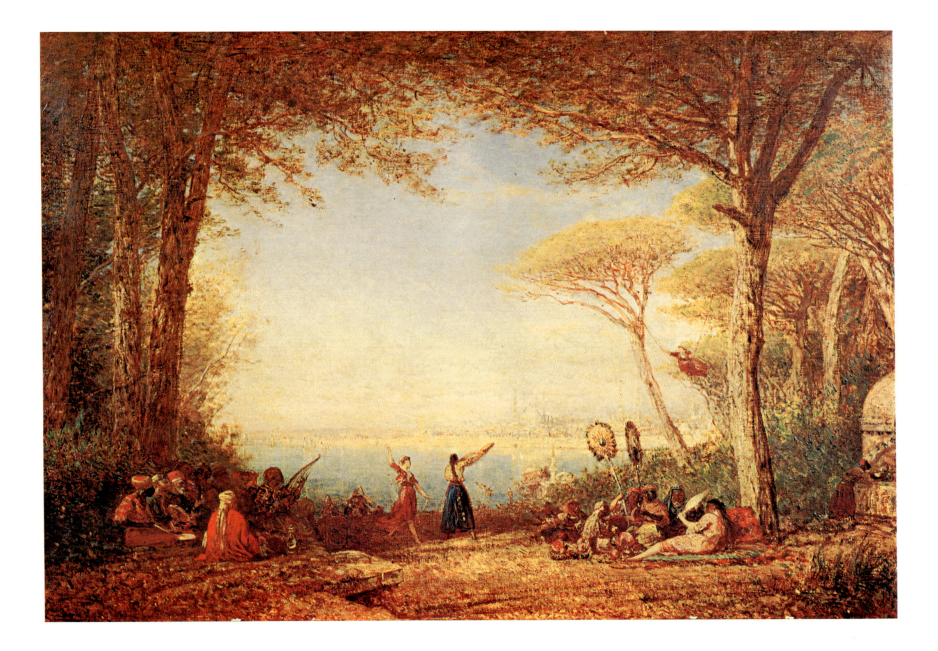

Félix Ziem: The Clearing. Oil, 85×115 cm. Private coll. — *The Sweet Waters of Asia with Constantinople in the background: a backcloth for an opera.*

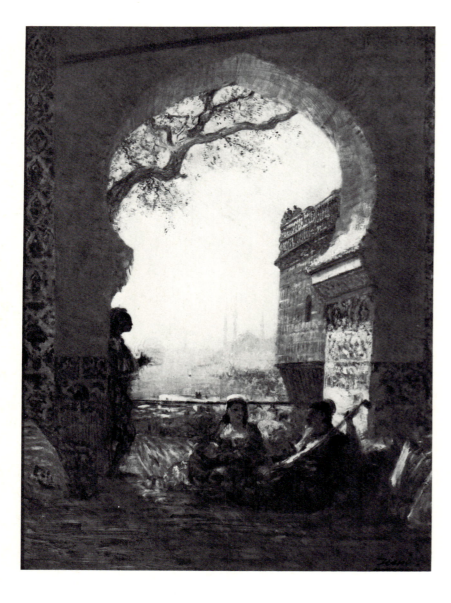

Félix Ziem: On the Terrace, c. 1875. Oil, 74×54 cm. Private coll. — An example of Orientalism painted from memory.

Decamps had intense admiration for Rembrandt, but the pictures he painted under his influence, like *The Mocking of Christ* at the Louvre, are very bad. His small, lively, meticulous figures and his interest in the life of the common people were really much closer to van Ostade, although he took his local colour from Turkey. *Coming Out of a Turkish School* is one of the most charming pictures painted in the reign of Louis-Philippe, and its desert landscapes are not without grandeur. The conventional colouring and the rather contrived composition were too obviously done in the studio, where Decamps churned out his contributions to the Salon with a somewhat mechanical verve. Delacroix, who had admired him at first, finally said: "It's hackneyed, it's hard, even stringy, it's yellowed like old ivory."

Decamps soon found imitators, like G.-Fabius Brest, and L.-Amable Crapelet. Edmond About described Crapelet's *Floods in Cairo*, Salon of 1857, "as if cooked up in Decamps's kitchen… skies mixed with sulphur and saffron." His shades were not so black, his *impasto* not so thick as those of the master. The number of Decamps's imitators finally wearied the more discerning members of the public. Adrien Dauzats and Charles de Tournemine, and later Théodore Frère,were more original. The brilliancy of their colours earned them the name of neo-colourists.

Prosper Marilhat and E.-A.-Alfred Dehodencq, two excellent painters, produced less picturesque but much more authentic Orientalist paintings than Decamps. Between 1831 and 1833 Marilhat accompanied Baron von Hügel all over the Near East. One of the painter's letters to his family shows the sporting side of Orientalist painting:

"We would stop at an inhabited or wild place, always in the open; we would put down our mattresses, have the mules unloaded, and the cook would light his fire. If it

Théodore Frère: Desert Halt near Cairo, c. 1870. Oil, 25×40 cm. Private coll. – One of the most successful of the Orientalist paintings prompted by the opening of the Suez Canal.

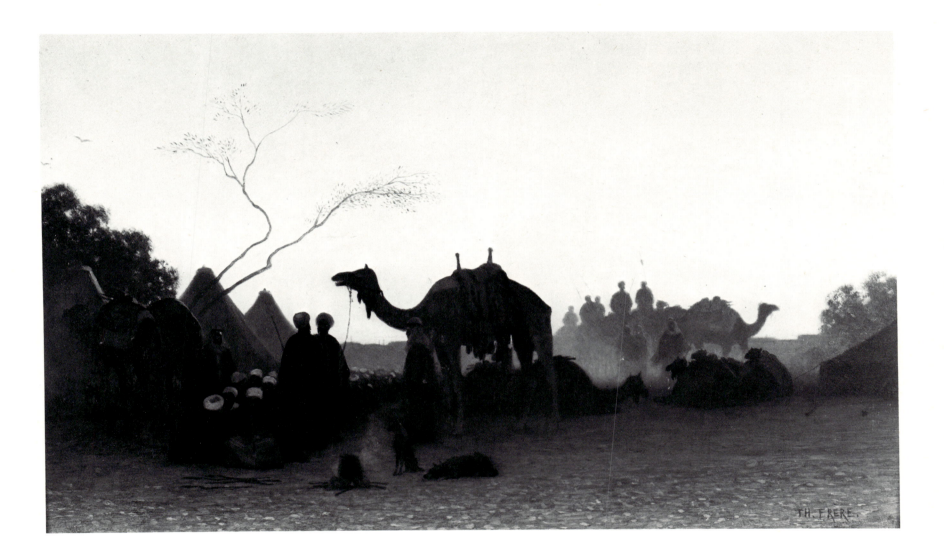

wasn't dark yet, I went off to make a few sketches.... On top of a heap of luggage mixed up with saucepans, mattresses, and donkey saddles, wherever we stopped, the baron sat perched, writing; around him two or three hundred Arabs from the caravan were busy watching him. When I came back with my portfolio on my back, we would find the table

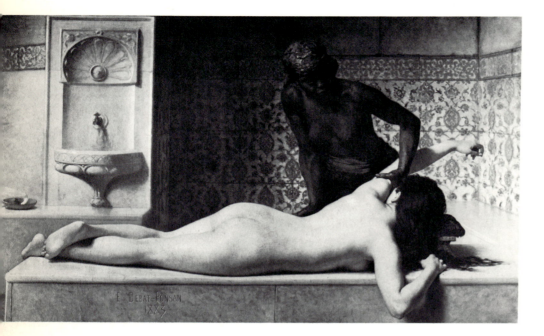

Edouard-Bernard Debat-Ponsan: The Massage, *1883. Oil, 170×
200 cm. Musée des Augustins, Toulouse. – Typical of successful Salon
art.*

set on a mat, with mattresses as seats, like a Roman ban-
quet; in the middle a huge dish of rice; then boiled chickens
and pots of sour milk to round off our meal."

Marilhat never went back to the East and continued to
send rather severe but beautifully coloured landscapes and
townscapes to the Salon. He also painted a few historical
pictures. He himself adopted an Oriental life style; Gautier,
who thought he had "the look of an icoglan or Zebek," was
wild about his pictures. He wrote about *Recollections of the
Bank of the Nile:* "The violet shades of evening are begin-
ning to mingle with the limpid blue of the sky, on which the
moon is curved like a silver sickle. Turquoise and pale lemon

tones bathe the distant stretches of the horizon, and standing
out against it is the black of the slim columns and the elegant
capitals of a palm forest planted on a river bank that forms
the dividing line between the sky and the water, an exact
mirror reflecting its colours. A swarm of cranes is flying
across the sky in V or delta formation. You could not dream
up anything calmer, more reticent, or more mysterious."

After a stay in Andalusia in 1849, Alfred Dehodencq dis-
covered Morocco: he went back to Tangiers regularly until
1863. A better draughtsman than painter, he produced
masterly sketches of the life of the common people, mostly
violent ones. His large historical canvas, *Boabdil's Farewell
to Granada,* has a fine fire, but studio colouring. He died,
forgotten, in 1882. The public had been tired of romantic
Orientalism for twenty years: in 1866, Charles Blanc wrote
in the *Gazette des Beaux-Arts:* "Ethnic interests have some
good in them as long as they aren't abused to the point
where the nude is replaced by costumery and draperies by
tawdry finery. Nowadays trips to the East have created a
speciality that exempts artists from solid study and produces
a facile school of painting with ready-made compositions
and picturesque effects." Facility of travel led to facility in
painting.

But it was Chassériau who made the deepest impression
on Gautier, perhaps because they had the same taste in
women. Their women had "something immobile, myste-
rious, disturbing.... Their beauty is veiled by an incurable
melancholy;" both loved the antelope- or gazelle-like move-
ments of these beautiful creatures who remained untouched
by modern civilization. Gautier wrote of the *Susannah*
(Salon of 1839), painted when Chassériau was twenty:
"Never had the painter succeeded more fully in achieving his
ideal of exotic beauty, which he felt so deeply." In 1847,

when the jury of the Salon refused a very large canvas by Chassériau, *Sabbath Observance in the Jewish Quarter of Constantine* (now lost), Gautier protested, then organized his triumphal comeback at the Salon in the following year.

Fromentin's canvases showed a less picturesque East than that of Decamps and his fellow artists. His Algerian landscapes at the Salon of 1847 were widely noticed. They showed the influence of Marilhat – the tendency to idealize from the basis of very exact drawings. There is really no trace of Delacroix, whom he admired more than anyone, except in the *Arab Tailor's Workshop*, 1852. His *Lion Hunt* is not very good. In other pictures he imitated the kind of riotous colour found in Narcisse Diaz (*Moorish Burial*, Salon of 1853). Like the Barbizon painters, about whom he wrote so well, Fromentin was close to such Dutch painters as Cuyp or Wouwermans, but later his blue tones heralded Impressionism. Baudelaire admired his "broad and supple imagination" at the Salon of 1859, at which five of his paintings, including *The Audience with the Caliph* and *Bab-el-Ghardi Street at El Aghouat* set the seal on his success. The critic in the *Gazette des Beaux-Arts*, Paul Mantz, singled him out among the numerous Orientalists of that Salon – Bida, with his *Preaching in the Lebanon*, Devilly with the *Battle of the Marabout of Sidi Brahim*, Boulanger with a *Portrait of Alexandre Dumas* dressed in costumes brought back from the Caucasus, several Ziems, and Berchère's *Simoun*. Mantz praised his "Eastern gravity, his moving serenity." Gautier wrote in the *Salon de 1861:* "Fromentin

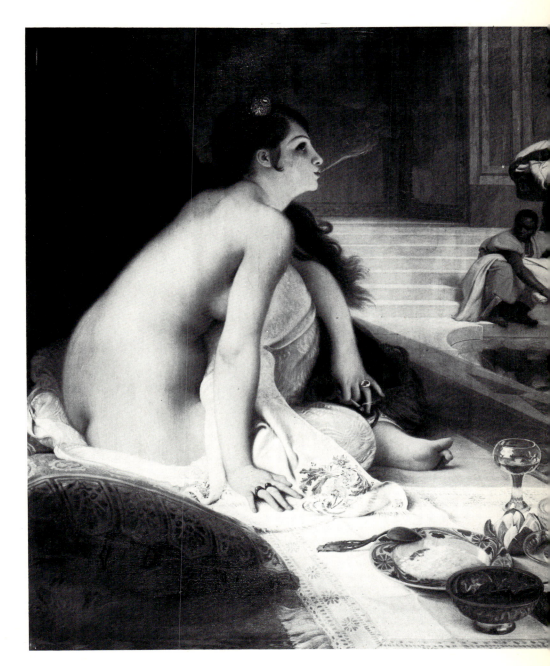

Jean-Jules-Antoine Lecomte du Noüy: The White Slave, 1888. Oil, 146×118 cm. Musée des Beaux-Arts, Nantes. – A Circassian of the Batignolles quarter of Paris.

has definitely taken the lead in the Oriental caravan. His painting has the swift dazzlement of something seen at the gallop.... Sometimes we find his good taste excessively delicate for Africa." After travelling through Upper Egypt with the Empress's party, Fromentin exhibited works based on his memories of the Nile until his death in 1876. He unsuccessfully tried mythological scenes, perhaps as a stepping-stone to the *Académie des Beaux-Arts*. His talent as a writer won him eight votes in the French Academy.

Fromentin loved greys, pale greens, the copper colour of horses' rumps and the elegance of Arab noblemen. He practically never painted a woman. When he tried to be dramatic, he was simply lugubrious, as in *The Land of Thirst,* which was such a success at the Salon and which, with unconscious irony, hung for a long time in the drawing room of M. Martell, the cognac-dealer.

The paintings dearest to the rich bourgeoisie of the second half of the nineteenth century were usually the work of the indefatigable Félix Ziem. He quickly acquired that easy manner suitable for the heavy gilt frames of his perennial views of Venice; he had made a very good start. In his *Salon de 1859* Paul Mantz gave him a warning: "M. Ziem paints seascapes as one might paint flowers or jewellery; van de Velde would be astonished at these pictures with all their glitter of rubies, diamonds and topazes: he would find it a bit difficult to understand all these structures with vast perspectives, the gold and silver vessels, that sea where everything is capricious, and the bright flags waving in a crazy light. The painter of *Damanhour* and *Gallipoli* is sliding down a dangerous slope and would benefit from a little moderation."

Ziem's admirers soon turned to a wonderfully gifted young painter, Henri Regnault, who had won the Grand Prix of Rome in 1866. When Gautier saw his *Salome,* a kind of fancy-dress gipsy, he waxed enthusiastic: "Here is some promise of a major painter, a successor to Delacroix."

The *Summary Execution under the Moorish Kings of Granada* confirmed that judgement. But a critic hostile to the revival of Orientalism accused Regnault of "indulging in paint-brush orgies, in the pomp and chichi of Oriental painting and its garish colouring. He stifles the idea with tawdriness." After a stay in Spain, where he learnt more from Velazquez than from his teachers at the Villa Medici, Regnault decided to settle at Tangiers. He returned to France when the Franco-Prussian War broke out in 1870 and was killed soon afterwards. Regnault's robustness may seem a little vulgar, but his craftsmanship and verve might have made him into a French Makart.

Despite the protests of critics like Castagnary, who favoured realism, Orientalism was still doing well at the Salon of 1869, as Théophile Gautier noted with satisfaction:

"Fantasia, by Fromentin, a real gem. In front of a large tent, an Arab tribe is doing a fantasia [a kind of wild cavalcade].... Riders, horses, costumes, caught as they fly past with dazzling speed, run riot, swirl and glitter, all shown with a luminosity of colour and a lightness of touch that enchant the eye...."

"Gérôme: *The Cairo Pedlar* selling his Eastern bric-à-brac retains a rare dignity and could easily be a patriarch in a biblical picture. The *Harem Outing* shows a boat rowed by ten oarsmen cutting through the waters of the Nile; the mysterious beauties, hidden in a cabin on the deck, can be glimpsed behind the curtains, and a musician squatting in the stern is singing one of those nasal chants that are so penetratingly charming to barbarian ears, and accompanies himself on the *guzla....* The boat threads its way through the

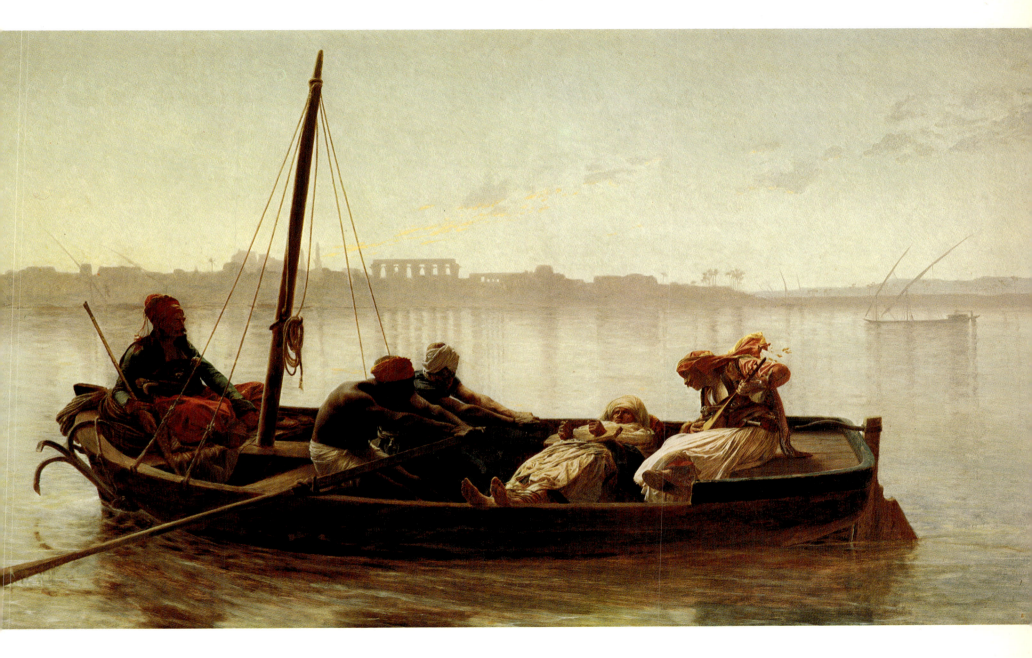

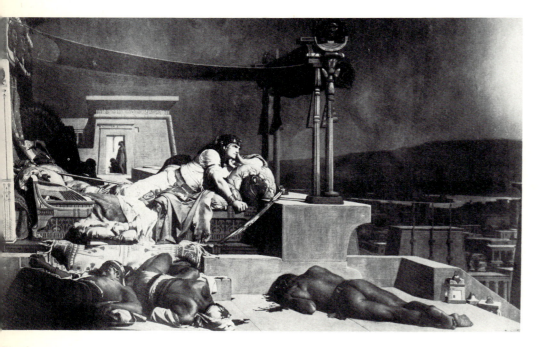

Jean-Jules-Antoine Lecomte du Noüy: The Bearer of Bad Tidings, *1871. Oil, 74×121 cm. Ancien Musée du Luxembourg, Paris; now at the Ministry of Cultural Affairs, Tunis. – This long-famous picture illustrates an episode from the* Roman de la Momie *by Théophile Gautier.*

clear transparent water along the hazy bank in a kind of luminous mist that has a magic effect."

"Guillaumet: *The Famine in Egypt,* which is a little reminiscent of Delacroix's *Massacre at Chios;* M. Huguet: *The Women of the Ouled-Nail Troupe,* a painting of brilliant light; M. Belly: *Religious Festival in Cairo;* Berchère: *Towing on the Dyke of the Menzaleh Canal;* Brest: *Sweet Water Fountain in Asia* and *On the Bosphorus.* Tournemine has left Asia Minor and taken refuge in India: instead of pink flamingoes he is painting elephants. The caravan is

continuing on its way. We hope it won't leave too many camel corpses in its wake."

Among the neo-colourists exhibiting under the Second Empire, there are some artists whom we shall encounter in the countries where they chose to set up their easels. Théodore Frère, of whom Baudelaire said after the Salon of 1845 that he had "a fine and firm execution," was one of the best official Orientalists. He exhibited between 1834 and 1882, travelled a great deal, and had the honour of accompanying the Empress to Egypt. Charming Charles de Tournemine with his white and blue tones was the Ziem of the more discerning. Emile Lessore was the heir of Decamps; Charles Girardet earned a modest fame through his precision. Narcisse Diaz de la Peña was the most successful of all when he abandoned his pleasant fanciful pictures of the surroundings of Barbizon to do equally fanciful and even more lustrous Moorish scenes; Adolphe-Joseph Monticelli, like Diaz, never went to the East but painted it in just as charming a light.

To some extent Jean-Léon Gérôme took the place that would have been better filled by Regnault. For thirty years his pictures were the star turn of the Salon, whether he painted scenes from Roman life, historical anecdotes or Orientalist canvases; the last were by far the best. A pupil of M.-G.-C. Gleyre, an excellent Swiss painter, he made a trip to the East in 1837 and afterwards was able to imbue neoclassical subjects with great poetry. He has been rediscovered in the last few years, especially in the United States, after being despised by art historians because of his hostility to the Impressionists. An impeccable draughtsman but poor colourist, he impressed his contemporaries by the breadth of the subjects he treated and the morals he pointed out. The history lesson was often pedantic and his mind not unlike that of Flaubert's M. Homais, as in that tête-à-tête between

a lion and the sun in the *Two Sovereigns of the Desert*. But Gérôme often went beyond the picturesque and achieved real poetry, as in *The Prisoner,* which inspired Hérédia's sonnet:

Assis, jambes en croix, comme il sied aux fumeurs,
Le chef rêvait, bercé par le haschisch étrange
Tandis qu'avec effort faisant mouvoir la cange,
Deux nègres se courbaient, nus, au banc des rameurs…
(Les Trophées)

[Sitting cross-legged as smokers do, the chief dreamed, lulled by strange hashish, while two naked Negroes rowed the Nile craft, bent painfully over their oars.…]

From 1855 Gérôme travelled regularly in the Near East and spent whole winters on a Nile barge in Cairo. He made a careful study of buildings and props: at the Salon of 1857 alone he exhibited *Egyptian Recruits, Albanian Chief at Prayer,* and the *Colossi of Memnon;* in 1866, *Door of a Mosque* and *Turkish Butcher* sold for the enormous sum of 5000 Francs.

Gérôme had many imitators, the best of whom was J.-J.-A. Lecomte du Noüy, whose *Janissaries Sleeping at the Entrance of the Seraglio* caused a sensation at the Salon of 1877: "Mohammedanism still has its followers, and the sun of the picturesque East still rises on Parisian art. The *Door of the Seraglio* is imbued with our anecdotal, sharp wit. The execution is perhaps too obsessed with detail, but let's hope that the black guards wake up. The dawn is sneaking over their glistening skin."

Lecomte du Noüy is also responsible for one of the most famous paintings of last century, *The Bearer of Bad Tidings* after an episode in Gautier's *Le Roman de la Momie.* A Pharaoh is ordering the death of a black messenger who lies prostrate at his feet after announcing the defeat of his armies.

Benjamin Constant and then G.-J.-V. Clairin dealt with subjects similar to Gérôme's, Constant with a certain heaviness, Clairin without much substance but with the charm of attractive colouring; after all, he had been Regnault's best friend. He worshipped at Sarah Bernhardt's feet, which accounts for the theatrical side of his paintings and his love of props. He often went to Morocco and Egypt and was one of the pillars of the French *Salon de la Société Orientaliste.*

Luc-Olivier Merson: The Flight into Egypt, c. 1890. Oil, 74 × 130 cm. Manoukian Coll. – This canvas furnishes a good example of the religiosity prevailing at the turn of the century, a contrast between the indifference of the ancient gods and the religion of love.

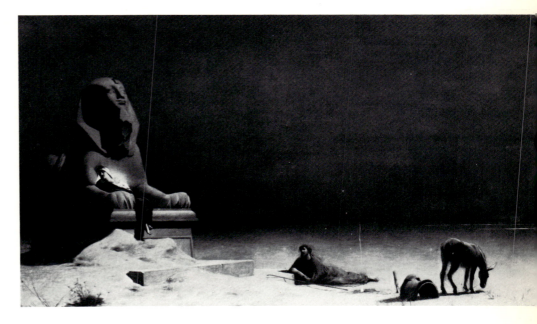

John Frederick Lewis: The Halt of the Duke of Northumberland in the Sinai Desert, *1856. Gouache, 65×134 cm. Private coll. – The Arabs were dazzled by such ostentatious expeditions.*

One hardly dares mention Gustave Moreau in the same breath as these painters, but his finest works were permeated by a wholly literary Orient. He showed sensuousness in his many versions of *Salome,* whose setting was taken from the Alhambra, and mysticism in the *Conquest of Alexander the Great.* His view of Greek myths was also very Oriental. Helen, Sappho, and Cleopatra were *almahs* like Salome, naked under their jewels. In reaction to these sumptuous pictures, a new generation of painters – following Dehodencq – painted another side of Algeria, the poverty and wretchedness. The best of these artists was G.-A. Guillaumet, who lived for a long time at Bou Saada. He has been called an exotic Millet, for unlike Fromentin he painted only women and children, in whom he saw a biblical simplicity.

His lugubrious picture, *The Desert,* was tremendously successful at the Salon of 1867. He wrote the rather interesting *Tableaux Algériens.*

The East, or rather the Eastern cast-offs which had inspired Corot to do some pencil sketches of odalisques, did not interest the Impressionists very much. Lebourg painted with no concessions to the picturesque; he heralded Marquet. Renoir paid a long visit to Algiers in 1879; he had exhibited an *Algérienne* at the Salon of 1870 which Arsène Houssaye compared with Delacroix. But these Algerian women could as easily have been painted in his Montmartre studio, just like that delightful little girl in pink muslin holding a hawk, or the *Odalisque* now in Washington. But the light and flowers fascinated him, and he painted the Jardin d'Essai in Algiers several times.

The Orientalist fashion was far from over. Not satisfied with their success at the Salon, the Orientalists wanted their own exhibition. It was held at the time of the first retrospec-

tive of Islamic art at the Palais de l'Industrie in 1893. Beyond the rooms in which arms, costumes, porcelain and pottery were shown, there was a real Salon devoted to the East, with works by artists such as Pascal Dagnan-Bouveret, Charles Cottet, Alexandre Lunois, Armand Point and Victor Prouvé, who might differ in the genre they had chosen but who had all made the journey to Algeria which, as Gautier had said thirty years earlier, had replaced the journey to Italy.

There were also a good many picture-postcard Orientalists, poor imitators of Gérôme, producing their versions of the *Corsairs Capturing a Ship* and *Idling in the Seraglio,* which hung on the walls in doctors' waiting-rooms or were

69

Rudolph Ernst: The Rose Harvest, *between 1880 and 1900. Oil, 79×92 cm. Private coll. – India and Egypt are mingled in the kind of fanciful Orientalism much prized towards the end of the century.*

exported to the countries that had inspired them. Rich Levantines and Egyptian princes simply adored the Orientalists.

Orientalism was given its last *éclat* at the Salon and the Société des Orientalistes français by G.-A. Rochegrosse. He was a terrible painter when he tried to depict the great moments of history (as in *The Last Day of Babylon,* in which the remains of Sardanapalus are dragged in by ballet dancers from the Bals de Quat'z Arts), but he could be charming when he painted Algerian women in their homes or Theodora's boudoir. At the Salon, the most highly approved contributions were those that recalled the most vivid descriptions in Flaubert's *Salammbô.*

Towards the end of the great era of the Salon, two of the stars of Orientalism were Austrians, Ludwig Deutsch and Rudolph Ernst. Their works are extremely competent and so alike that they can easily be confused, and they enjoyed a great success at the Royal Academy. They were Meissoniers in Cairo, as accurate as a photograph, but not without charm. Deutsch came from Vienna to work with Jean-Paul Laurens. He obtained the gold medal at the Salon of 1892; he was even made an officer of the Legion of Honour. His work fetched high prices: in 1893 his *Nubian Dancers* sold for Fr. 13 360 and his *Arabs at Prayer* for Fr. 12 800. Ernst, a pupil of Feuerbach, exhibited in Vienna and Munich from 1875, in Paris at the exhibition of 1889 and after that regularly at the Salon. He won a bronze medal in 1900. He was rated highly by the Americans who patronized the Salon to buy something to hang on the walls of their huge houses. But the prices paid for his pictures were not excessive: in 1906, 330 dollars for *The Lotus of the Sacred Lake,* in 1907 460 dollars for *The Light of the Harem,* and in 1909 300 dollars for *The House of Roses.* He was attracted by the religious aspect of Islam, by mendicants and meditations on the Koran. Sometimes he painted dark temples swarming with beggars and idols, not unlike those of Marius Bauer, the Dutch painter.

The East that tempted the Symbolists was mystic above all. Buddhist India inspired Odilon Redon. In Turkey and Morocco, Lévy-Dhurmer found the material for his rather mediocre picturesque scenes and for his splendid pastels of white and mauve towns, which he exhibited until 1935 at the *Société coloniale des Artistes français.* The fact that the word "colonial" has now been replaced by "Orientalist"

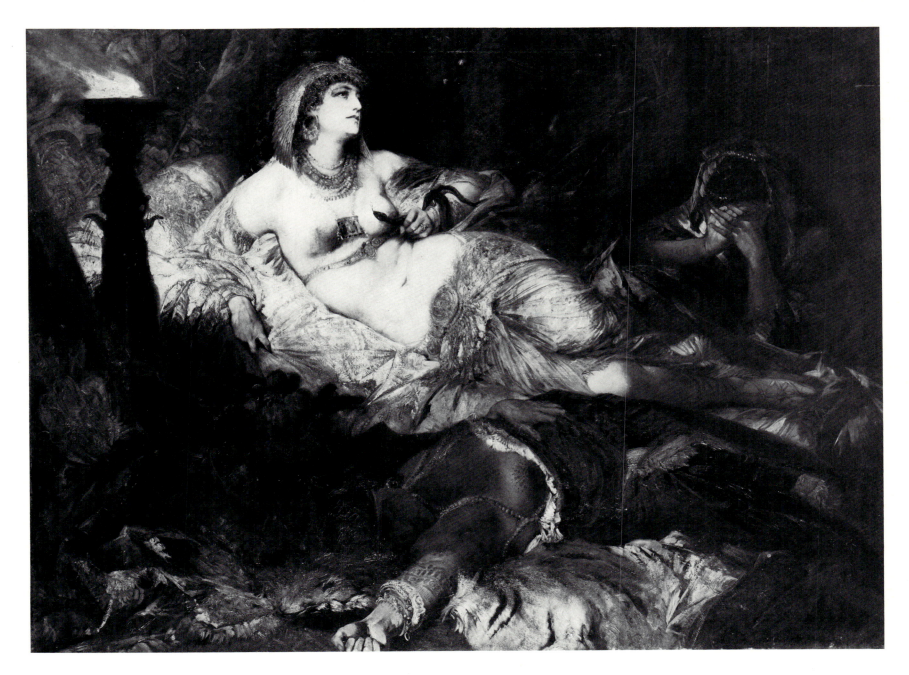

illustrates that this exotic school of painting became a means of extolling the ephemeral French Empire. The State encouraged these belated heirs of Decamps and Marilhat, who abandoned the Near East and went to the heart of Black Africa or to Indochina; their works embellished Ministries, Embassies, the palaces of Residents-General, colonial exhibitions and large ocean liners.

The Orientalists who exhibited annually at Burlington House were a little less numerous than their Salon counterparts, and their works less picturesque, and they never sank to the vulgarity of some of the French painters. John Frederick Lewis, who exhibited first at the Watercolour Society and then at the Royal Academy when he started painting in oils, had the most imitators. His large watercolour of *The Halt of the Duke of Northumberland in the Sinai Desert* was noticed by Ruskin in 1856. In a splendid tent, surrounded by servants, the noble tourist in Arab dress is receiving a sheik, whose proud simplicity contrasts with his host's sumptuousness. Henry Wallis, who was very close to the Pre-Raphaelites and famous for *The Death of Chatterton,* was much better. Between 1854 and 1893, also at the Watercolour Society, he exhibited views of Cairo and meticulous still lifes of Persian objects. Carl Müller's watercolours had a ready success in 1840 and continued to do so for a long time.

The last of the English Orientalists, Frank Brangwyn, was born in Bruges. He was an Imperialist painter who exalted anyone – sailors, soldiers, even workmen – who contributed to the glory, and even more to the wealth, of the Empire. His stays in Morocco and Constantinople had taught him the effect of red sails against bright blue skies, of the tanned torsos of oarsmen against a violet sea. The treasures of India were inadequate for the opulence of Brangwyn's great compositions. He might be compared with another artist who worked for the glory of capitalism, J. M. Sert y Badia, a Catalan, who painted, on a background of gold, a crowd of turbaned figures laden with precious goods and huge ornaments. He decorated a number of great houses, including those of the Sassoons and the eastern Rothschilds, and the Wendel mansion in Paris.

The exhibitions in Vienna also contained a fair number of exotic canvases and, as we have seen, many Orientalists grew up in the shadow of Makart before seeking commissions and medals abroad. In Vienna, most of the subjects were taken from the folklore of the neighbouring Lower Danube region and the Balkans. It was well known that the East started in the Prater. Leopold Karl Müller was the most famous Orientalist, and Adolf Schreyer a skilful imitator of Fromentin.

There were at least two Orientalists in Turin, Carlo Bossoli and Alberto Pasini, who were rated highly not only in Italy, but throughout Europe. Pasini – between trips that took him as far afield as Persia – exhibited regularly from 1859 to 1899. He was a Chevalier of the Legion of Honour and his pictures sold at around 10 000 Francs. His horses were as good as Fromentin's; his Constantinople townscapes are both accurate and poetic. Today he is greatly sought after in Italy.

With painters like Anton Mauve and Jozef Israëls, who were close to Millet and poetic realism, Holland had regained an honourable place in the kind of art that goes through the Salons and ends in museums. It also had an excellent Orientalist, Marius Bauer, who went to Constantinople in 1888 and ten years later to India and Egypt. His small figures in front of huge buildings, the banners they display, the processions of elephants and palanquins are more successful as etchings than as engravings: he some-

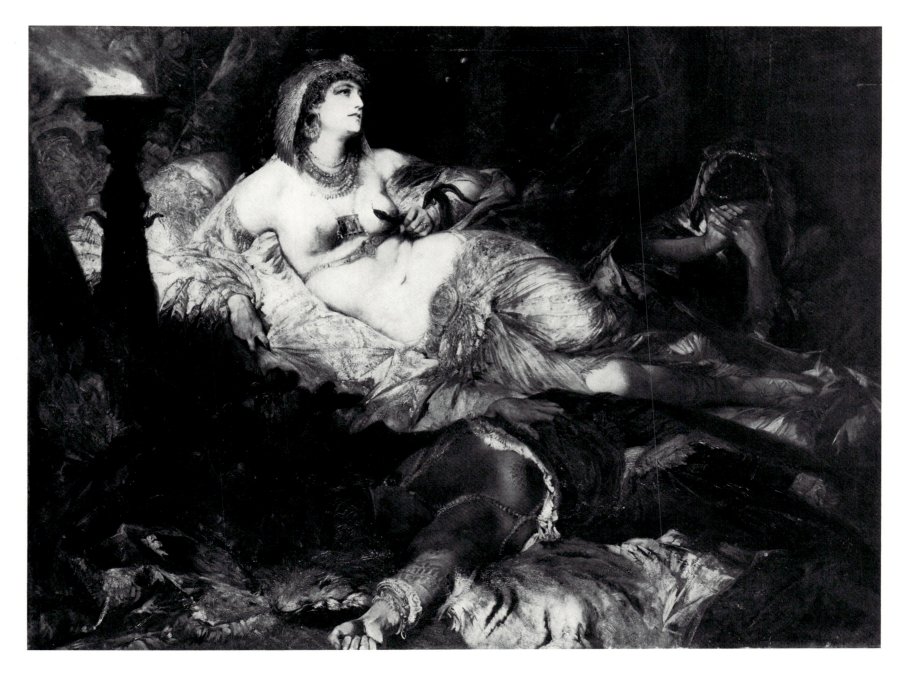

illustrates that this exotic school of painting became a means of extolling the ephemeral French Empire. The State encouraged these belated heirs of Decamps and Marilhat, who abandoned the Near East and went to the heart of Black Africa or to Indochina; their works embellished Ministries, Embassies, the palaces of Residents-General, colonial exhibitions and large ocean liners.

The Orientalists who exhibited annually at Burlington House were a little less numerous than their Salon counterparts, and their works less picturesque, and they never sank to the vulgarity of some of the French painters. John Frederick Lewis, who exhibited first at the Watercolour Society and then at the Royal Academy when he started painting in oils, had the most imitators. His large watercolour of *The Halt of the Duke of Northumberland in the Sinai Desert* was noticed by Ruskin in 1856. In a splendid tent, surrounded by servants, the noble tourist in Arab dress is receiving a sheik, whose proud simplicity contrasts with his host's sumptuousness. Henry Wallis, who was very close to the Pre-Raphaelites and famous for *The Death of Chatterton,* was much better. Between 1854 and 1893, also at the Watercolour Society, he exhibited views of Cairo and meticulous still lifes of Persian objects. Carl Müller's watercolours had a ready success in 1840 and continued to do so for a long time.

The last of the English Orientalists, Frank Brangwyn, was born in Bruges. He was an Imperialist painter who exalted anyone – sailors, soldiers, even workmen – who contributed to the glory, and even more to the wealth, of the Empire. His stays in Morocco and Constantinople had taught him the effect of red sails against bright blue skies, of the tanned torsos of oarsmen against a violet sea. The treasures of India were inadequate for the opulence of Brangwyn's great compositions. He might be compared with another artist who worked for the glory of capitalism, J. M. Sert y Badia, a Catalan, who painted, on a background of gold, a crowd of turbaned figures laden with precious goods and huge ornaments. He decorated a number of great houses, including those of the Sassoons and the eastern Rothschilds, and the Wendel mansion in Paris.

The exhibitions in Vienna also contained a fair number of exotic canvases and, as we have seen, many Orientalists grew up in the shadow of Makart before seeking commissions and medals abroad. In Vienna, most of the subjects were taken from the folklore of the neighbouring Lower Danube region and the Balkans. It was well known that the East started in the Prater. Leopold Karl Müller was the most famous Orientalist, and Adolf Schreyer a skilful imitator of Fromentin.

There were at least two Orientalists in Turin, Carlo Bossoli and Alberto Pasini, who were rated highly not only in Italy, but throughout Europe. Pasini – between trips that took him as far afield as Persia – exhibited regularly from 1859 to 1899. He was a Chevalier of the Legion of Honour and his pictures sold at around 10 000 Francs. His horses were as good as Fromentin's; his Constantinople townscapes are both accurate and poetic. Today he is greatly sought after in Italy.

With painters like Anton Mauve and Jozef Israëls, who were close to Millet and poetic realism, Holland had regained an honourable place in the kind of art that goes through the Salons and ends in museums. It also had an excellent Orientalist, Marius Bauer, who went to Constantinople in 1888 and ten years later to India and Egypt. His small figures in front of huge buildings, the banners they display, the processions of elephants and palanquins are more successful as etchings than as engravings: he some-

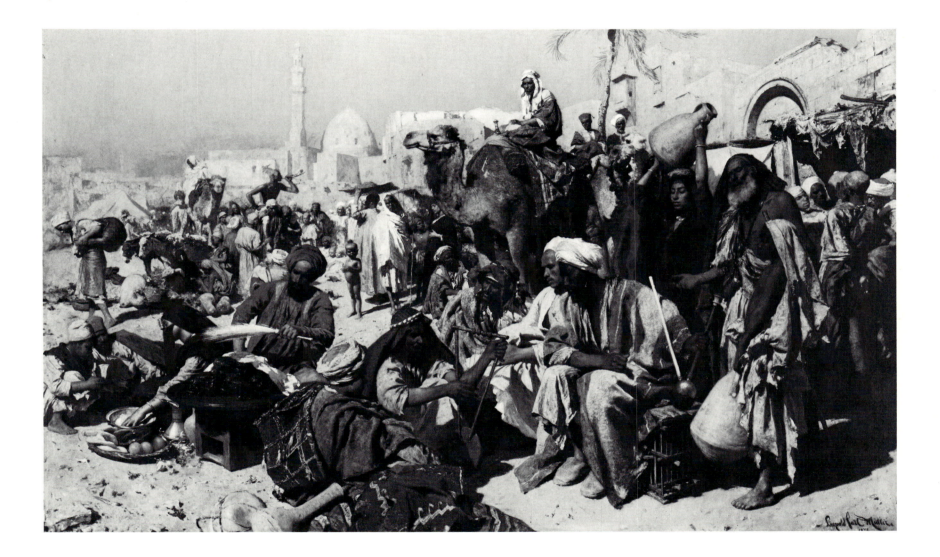

times thought he was Rembrandt in Benares. All his works, painted in the studio, recreated a sumptuous legendary East. Bauer knew the *Arabian Nights* almost as well as Scheherazade and covered the margins of the French translation by J.-C.-V. Mardrus with very lively watercolours. He was very expensive in his day, and may well become so again.

The exhibitions at Moscow and St Petersburg always had a contingent of painters who inclined towards the East,

many of them mystics like N.N.Ge, whose *Christ in the Garden of Gethsemane* is notable for its effect of bluish darkness, and Vasily Vereshchagin. National legends, too, often had an Oriental colouring, as in Victor Wasnetzov's famous *Three Princesses*.

At the time when their Empire was at its peak, the Germans had very few Orientalists, for they had no ambitions in the exotic countries. They had no colonies. Bismarck told them, "We must let the Gallic cock scratch in the sands of the desert" and this helped France to its short-lived colonial power. After the humiliation of 1870, exotic conquests were a source of prestige to the French. Even if the Orientalists did little to illustrate these conquests (only Algeria inspired painters of any worth), they evoked distant shores where the French flag was flying. The customers at the Salon bought exotic paintings out of an unconscious patriotism as much as out of sensuality and love of colour. The Italians, whose eyes were turned to Africa, also produced many Orientalists.

These painters were often very expensive, but their value declined with the decline of Salon painting, which began just over fifty years ago in France. Their works decreased in price, but less so than the nudes by Bouguereau's pupils, the works of the quarrelsome imitators of Detailles, and the paintings of cows. Like the bibulous cardinals, the *almahs* still found customers, in Texas, in America, in Argentina and in Egypt. Now, when money is flowing into the Middle East, dealers manage to repatriate them, for the oil magnates have a high regard for works that recall a former Islamic civilization or hark back to a picturesque and legendary past. It is quite possible that Salon Orientalism will fill the museums of Isfahan and even Abu Dhabi a few years hence. The large sales of Orientalists held in London recently were extremely successful and attracted buyers from the Middle East.

Célestin Nanteuil: Illustration for La Gerusalemme liberata, *1841.*

Why the East?

Constantin Egorovich Makovsky: The Return of the Holy Carpet to Cairo, *1875. Watercolour, 32×48 cm. Jean Soustiel Coll., Paris. — Study for a painting exhibited with great success in St Petersburg and reproduced in* L'Illustration.

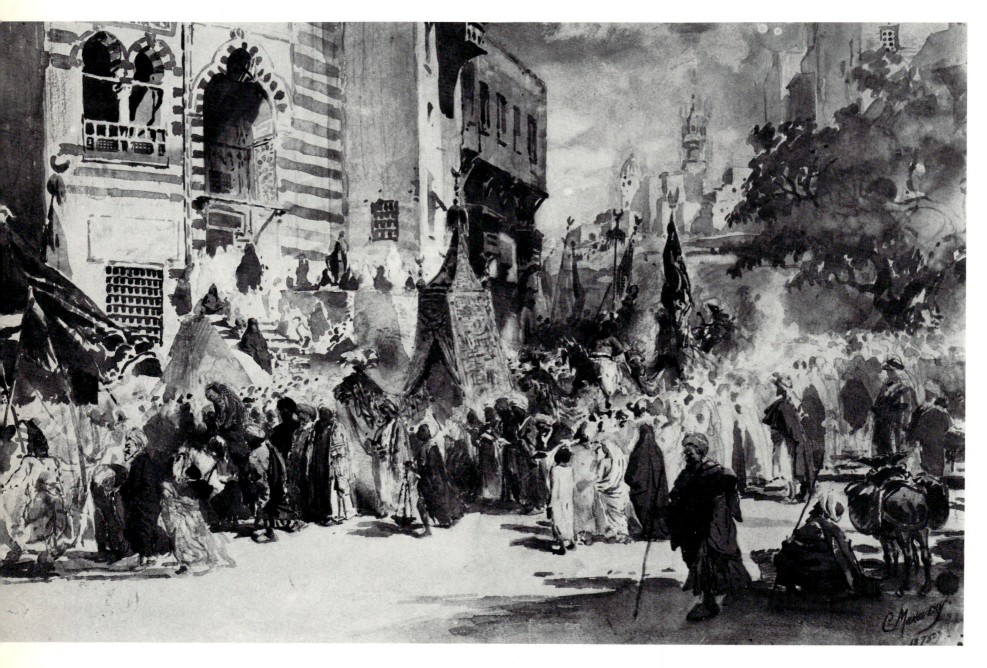

76

For almost a whole century Orientalist paintings found a ready market. Who actually were the people who bought them? First of all, the rich bourgeoisie who loved the glittering canvases by Diaz de la Peña, Ziem, and then Rochegrosse, hung in gilt frames on their crimson damask walls. Serious collectors found that these pictures looked well in a mixed setting. Decamps's best customer was the Marquis of Hertford (Wallace Collection); Prince Demidoff loved Vernet. Governments, particularly the French government, chose Orientalist canvases at the Salons to hang in national museums; there were a great many at the Luxembourg Museum. The State also commissioned large compositions to celebrate colonial victories. Armchair travellers, who subscribed to the *Journal de Voyages,* to which the painters sent numerous sketches, had lion hunts and mosques in their smoking rooms. More or less lascivious dancing girls were found on the walls of smart bachelor flats, fantasias in the homes of former officers, like the Duc d'Aumale, views of the desert embellished the houses of Suez Canal shareholders. Regular opera-goers often bought canvases that reminded them of works such as Leo Delibes's *Lakmé* or Bizet's *Pearl Fishers;* but we cannot call Degas an Orientalist simply because he painted Miss Fiocre in Circassian costume in the Delibes ballet *La Source.* International Exhibitions, especially that of 1867 with its Egyptian Pavilion and that of 1889 with its "Cairo Street", contributed greatly to maintaining the interest in the East, which had originally been simply a feature of Romanticism.

Orientalism soon became a piquant sauce to which clever painters adapted established genres, such as history, the nude, narrative, and even townscapes; they used trappings to flatter their clients' chauvinism and to help them forget the industrial cities in which they were living and dream of sunlit countries where pleasures were easy to come by.

There were four deep-seated reasons for the popularity of these paintings. First of all, after the decline of neo-classicism, they satisfied the romantic feeling for the picturesque and for local colour. Secondly, the Napoleonic Wars had aroused a patriotism that launched France, England, and later even the young Kingdom of Italy on colonial conquest. Thirdly, the East stood for an easier and richer satisfaction of sensual desires which could not be indulged in Europe, where Victorian morality was not confined to England. And finally, these pictures responded to a longing for mystery which could no longer be stilled by Catholicism, and even less by Protestantism. We shall try and see which paintings appealed to each of these feelings, but all of them have a starting point in *The Death of Sardanapalus,* the masterpiece of Orientalism, in which Delacroix applied the lessons learnt from the works of Gros and Girodet, but far beyond anything that might be called imitation.

Henry Wallis: Mosque near the Goldsmiths' Market in Cairo, *c. 1880. Watercolour, 51×35.5 cm. Joseph Soustiel Coll., Paris. – The precision and vivid colouring of this painter's works ensured their constant success at the exhibitions of the Watercolour Society.*

With these words the tradespeople of Marrakesh attracted tourists into the narrow shops where they sold slippers, copper trays, weapons, brightly coloured silks, everything that delighted the European of c. 1830. To seduce Mérimée, George Sand received him in Turkish slippers and baggy trousers. Théophile Gautier liked to put on a fez with a silk tassel; Balzac disguised duchesses and tarts as sultanas. From the earliest days of the French Empire, women's fashions revealed the Oriental influence: many a turban shaded lesser brows than Madame de Stael's, and the cashmere shawl became a favourite wedding gift. The painters who had been to the East brought back fascinating bric-à-brac, the first being Monsieur Auguste, followed by Decamps. Théophile Gautier joyfully undertook the inventory of Chassériau's studio:

"The *yataghans*, the *kanjars*, the Persian daggers, the Circassian pistols, Arab rifles, old nickel-plated strips of damask with verses from the Koran, weapons decorated with silver and coral, all that delightful barbarian luxury was arranged in trophies all round the walls. Carelessly slung over pegs, the *gandouras*, the Arab cloaks, the *burnouses*, the kaftans, and the silver- and gold-embroidered jackets were a feast of colour for the eye; they helped the artist forget the drab shades of our sombre clothes and seemed to have retained the rays of the African sun in their crushed shiny folds."

Much later, in 1872, when speaking of one of Regnault's watercolours, he described another of the Orientalist studios such as were now found between Montmartre and Monceau; nothing was omitted except the stuffed lion and potted palms: "You see nothing but curtains and door hangings in which the art of the East has exhausted itself, splendid fabrics, carpets from Smyrna, Babylon and Turkey, nothing

Carl Spitzweg: A Turkish Café, *c. 1860. Oil, 41.7 × 52.7 cm. Bayerische Staatsgemäldesammlungen, Munich. — Here this witty Bavarian genre-painter has imitated Decamps.*

but inlaid trays, gem-studded weapons, hookahs from Khorassan, and there is something terribly sad about all this accumulation of treasures. This room could serve as the setting for a scene of jealousy and murder; bloodstains would not show on these dark purple carpets." Such interiors made prospective customers shudder deliciously and enchanted the others.

Exotic words went to Gautier's head like hashish fumes. In Decamps's *Turkish Bazaar* he saw "a marvel of modern painting." This "charming variety of types and costumes.

What powerful colours, what familiarity. Such fine representatives of all races, talking about their business with an Oriental gravity, standing in the narrow streets or squatting on the threshold of shops, while scraggy dogs stray about their feet, and the pedlars scrape past with their packs, all bathed in an amber light, full of sun, a thousand mottled colours on a background of fabulous painted houses, true to life, yet fantastic like a hashish dream...."

Byron, in *Childe Harold's Pilgrimage*, had already enjoyed making similar inventories:

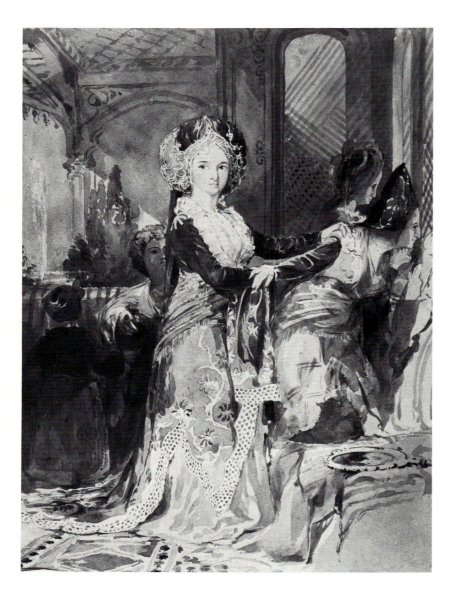

The wild Albanian kirtled to his knee,
With shawl-girt head and ornamented gun,
And gold-embroider'd garments, fair to see;
The crimson-scarfèd men of Macedon;
The Delhi with his cap of terror on,
And crooked glaive; the lively, supple Greek;
And swarthy Nubia's mutilated son;
The bearded Turk, that rarely deigns to speak,
Master of all around, too potent to be meek....
(Canto II, 58)

The religious festivals with their gaudy processions and their wild music were the climax of this expatriate culture. Thus Gérard de Nerval was in Cairo for the procession of Mahmal, in which a sacred carpet was brought back in a special litter from Mecca: "You couldn't imagine anything more hirsute, more prickly and untamed than the immense crowd of Maghrebians.... You could tell the brotherhoods of Muslim monks and dervishes by the way they screamed their love chants interspersed with the name of Allah. Flags of a thousand colours, all manner of emblems and arms carried on staffs, and here and there emirs and sheiks in sumptuous clothes, on caparisoned horses...."

Two excellent colourists, Makovsky in 1875 and Deutsch in 1909, did dazzling pictures of this ceremony. They might have written like Flaubert, "In the towns this always dazzles us like the colours of a vast fancy-dress ball." That is, a Monticelli or a Diaz. Thus the label neo-colourists, applied to the first generation of Orientalists, seems fully justified.

Thomas Allom: Turkish Ladies, c. 1850. Watercolour, 29.2×22.2 cm. R.G. Searight Coll., London. – By a charming Englishman who lived in Constantinople for some time.

Adolphe Monticelli: Oriental Scene, Turks at the Mosque, c. 1878. Oil, 43×60 cm. Musée des Beaux-Arts, Marseilles. – This oriental fantasy is probably based on a scene from a comic opera.

When we look at Delacroix's *Women of Algiers,* we can see how an artist who started from the picturesque came to achieve a masterpiece by combining a lively range of new colours in unexpected ways. Where watercolour did not give him the exact tone, he noted in the margin: "For the scarf: delicate blue, green, golden yellow. For the shirt: mauve violet on the sleeves, lake violet on the shoulders, and the body striped delicate violet. Pants: Indian red silk." He found out the names of the garments: the *mhanna* was the head-scarf; the *ghilo* a kind of gold-embroidered bolero with a light satin lining; the *hayma,* the silk belt tied rather low on the hips.

Sixty years later, when Signac was studying the *Women of Algiers,* he analysed the alchemy of colour, which went beyond the sheer joy of painting. "The green trousers of the woman on the right are dotted with a small yellow pattern; the green and yellow blend optically and create an area of yellowy-green which has the softness and sheen of silk. The orange bodice is set off by the yellow of the embroideries; a yellow scarf, enhanced by red stripes, blazes in the centre of the picture, and the blue and yellow faience in the background blends into an indefinable green of rare freshness." A little of the same joyfulness is found in the watercolours Signac did fifty years later at Constantinople, and even in Clairin's charming masquerades. Fromentin was better at colourful writing than painting. His description of an *attatich,* a sort of litter put on the back of camels, has an exuberance that is rarely found in his paintings. "…Imagine a collection of all kinds of precious materials, yellow damask, with black satin stripes and with gold arabesques on a black ground, and silver flowers on the lemon background; a whole array of scarlet silk with two strips of olive; orange beside violet, pinks crossed with blues, delicate blues with cold greens, then half-cherry, half-emerald cushions, more soberly coloured carpets of thick wool, crimson, purple and garnet-red, all this put together with the imaginativeness that comes naturally to Orientals, the only true colourists in the world."

At a time when masters like Ribot and Bonnat were painting in sombre colours, the East introduced cheerfulness without shocking the public. Regnault, for instance, had some delightful pink and red harmonies in the *Summary Execution under the Moorish Kings of Granada.*

Eugène Delacroix: Women of Algiers, *1834. Oil, 180×229 cm. Musée du Louvre, Paris. – The pleasure of painting with a fresh range of colours has never been better expressed.*

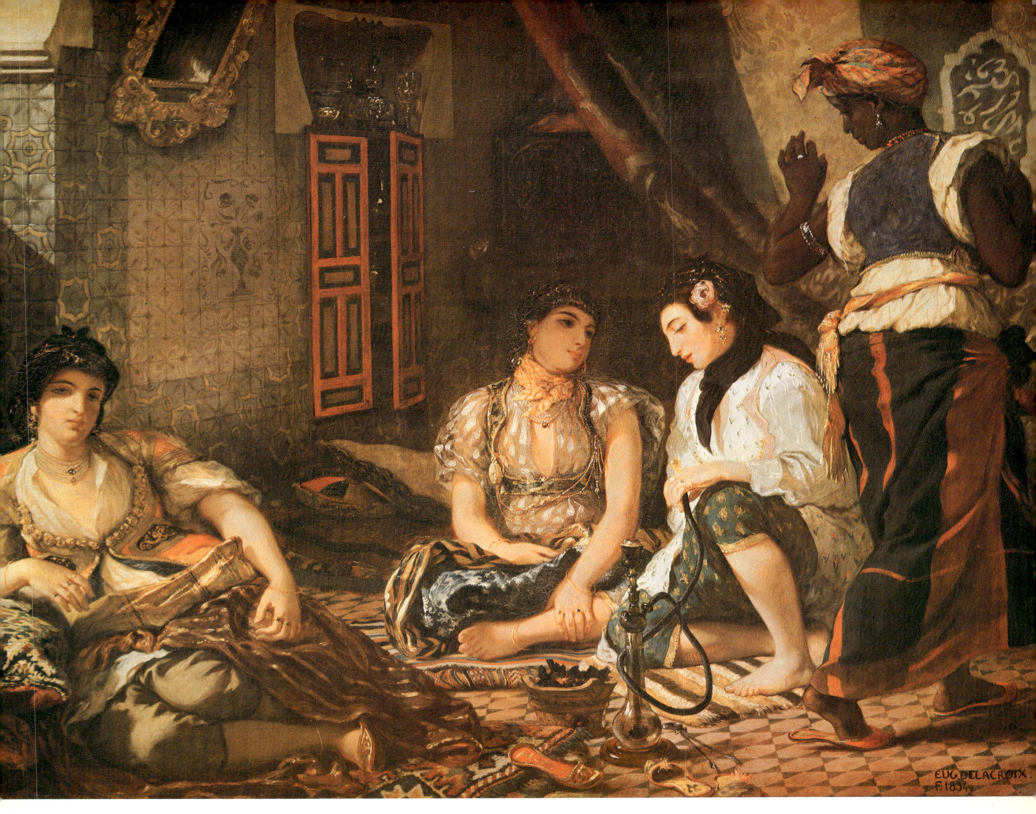

Western imagination has always associated the idea of treasure with the regions where the sun rises. The glitter of the rising star is inseparable from that of gold. History has justified that association: there were the treasures of Nineveh, of Persepolis, then of Byzantium, and finally all the gold from India which accounted for much of England's glory. But it is easier for a writer to describe a treasure than for a painter to show a picture of riches that dazzle; Delacroix alone succeeded in *The Death of Sardanapalus*. Like Delacroix, Chassériau took notes to try and fix the intensity of sunlight on his palette: "Make the gold sparkle on the cloth and the bells, a silvery gold tone for the back of the saddle, silky stripes for the cloak, mauve with gold arabesques for the *gandoura*."

In his *Romanzero*, in 1850, Heinrich Heine enumerated the presents sent by the Shah to Firdausi [Firduzi], the poet:

"...(Load) rare and splendid objects, valuable garments and household utensils of sandalwood and ivory,

Gold and silver trinkets, delicately wrought flagons and goblets, leopard skins with generous markings,

Carpets, shawls and rich brocades such as are manufactured in my empire —

And don't forget to pack gleaming weapons and saddlecloths, and jars of all manner of food and drink, as well as sweetmeats and almond cakes and all sorts of gingerbread."

Nothing could be more evocative than Baudelaire's,

"Mais les bijoux perdus de l'antique Palmyre,
Les métaux inconnus, les perles de la mer...."
[But the lost gems of ancient Palmyra, The unknown metals, the pearls of the sea... (*Bénédiction*)].

We are also reminded of the treasures given by Herod to the dancer in Oscar Wilde's *Salome*, those fabulous cabo-chons on the delicate skin of the dancing girl Gustave Moreau painted so often. For these gems alone Moreau must be considered an Orientalist, and he was practically the only one who could convey their symbolic splendour, though Rochegrosse and Clairin, and even Mucha, sometimes managed in the fake light of the theatre to paint equally fake gems with a mysterious brilliancy. The gold of the East was also conveyed in Ziem's sunsets, in the gold embroidery on the tunics of Lewis's dancing girls, and in the flashing sabres of Gérôme's janissaries.

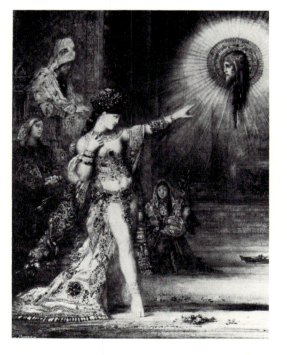

Gustave Moreau: The Apparition (detail), 1876. Watercolour, 105×72 cm. Musée du Louvre, Cabinet des Dessins, Paris. — The architecture comes from the Alhambra, the musician from India, the executioner from Egypt, the king from Judaea, and the jewels from Carthage.

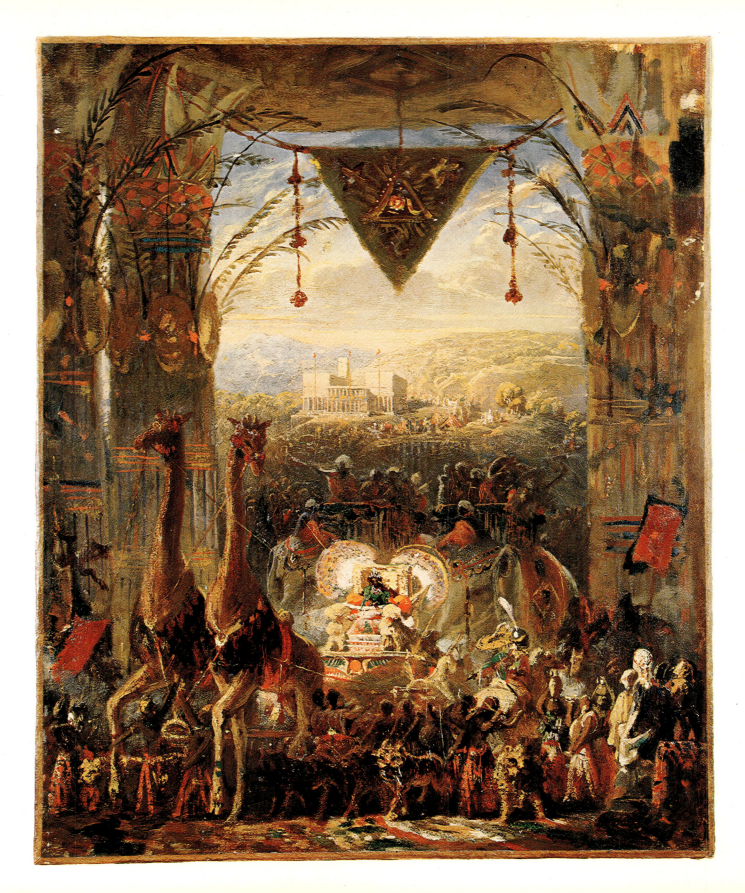

Marc-Gabriel-Charles Gleyre: The Queen of Sheba, *c. 1838–39. Oil, 54×43 cm. Musée cantonal des Beaux-Arts, Lausanne. — A sketch that anticipates Flaubert's visions in* The Temptation of St Anthony.

After gold, blood; blood readily spurts from the loved one's bosom and from the horse's withers in *The Death of Sardanapalus*. The Negroes, who almost invariably symbolize death (e.g., Delacroix's flag-bearer dominating the ruins of Missolonghi), brandish curved blades and gem-studded daggers. They are the offspring of the dark Mamelukes painted by Girodet and Gros, the progenitors of the superb executioner in Regnault's *Summary Execution under the Moorish Kings of Granada*.

Muhammad Ali's massacre of the Mamelukes in Cairo in 1805, and twenty years later that of the janissaries in Constantinople, fired the imagination. They were invested with a glory that was missing from the massacres of the French Revolution. Whereas the West was beginning to have doubts about the death penalty with hangings and guillotinings in prison courtyards, from Morocco to Persia an execution was a solemn event, a sort of public festival. Dehodencq painted several. Decamps painted heads exhibited on town walls, and in *Les Orientales* Victor Hugo visualized,

> *Livides, l'œil éteint, de noirs cheveux chargées,*
> *Ces têtes couronnaient, sur les créneaux rangées,*
> *Les terrasses de rose et de jasmin en fleur.*
> (*Les Têtes du Sérail*)

[Livid, the eye lightless, these dark-haired heads on the battlements crowned the rose and jasmine blossoms of the terraces.]

Assassination, too, gave an opportunity for fine colour effects; for Judith's killing of Holofernes, Horace Vernet placed the Assyrian general, looking like Abd-el-Kader, in front of a red curtain and dressed the heroine in Turkish clothes. It was a huge success.

Delacroix always has a parallel in Byron. Sardanapalus, the sinister rajah, might well be thinking the thoughts of the Pasha in *The Corsair*:

> Within the Haram's secret chamber sate
> Stern Seyd, still pondering o'er his Captive's fate;
> His thoughts on love and hate alternate dwell,
> Now with Gulnare, and now in Conrad's cell;
> Here at his feet the lovely slave reclined
> Surveys his brow – would soothe his gloom of mind;
> While many an anxious glance her large dark eye
> Sends in its idle search for sympathy,
> *His* only bends in seeming o'er his beads,
> But inly views his victim as he bleeds.
> (Canto III, 5)

Russian painters, like Vereshchagin, showed cruel emirs resembling the enemy of Michel Strogoff, Jules Verne's hero.

Violence was present in the fights between horsemen, which Chassériau loved to paint, after Delacroix. Flying manes, red and green leather saddle-cloths, and turbaned grooms had long been popular. Monticelli abandoned his costumed festivals to try his hand at them, with success.

Then there was the violence of the barbarians who invaded the palaces of decadent despots: Rochegrosse's *Last Day of Babylon*, a vast canvas where women and slaves are waiting pell-mell for some terrible act of violence in the midst of scattered treasures. Henri Regnault, describing one of these watercolours, emphasized the connexion between cruelty and pleasure: "A severed head is nailed to the boat like a trophy; but the heads of the obscure warriors have been cut off and nailed to the walls and gates of the captured city. The women will be half-naked, they have been strug-

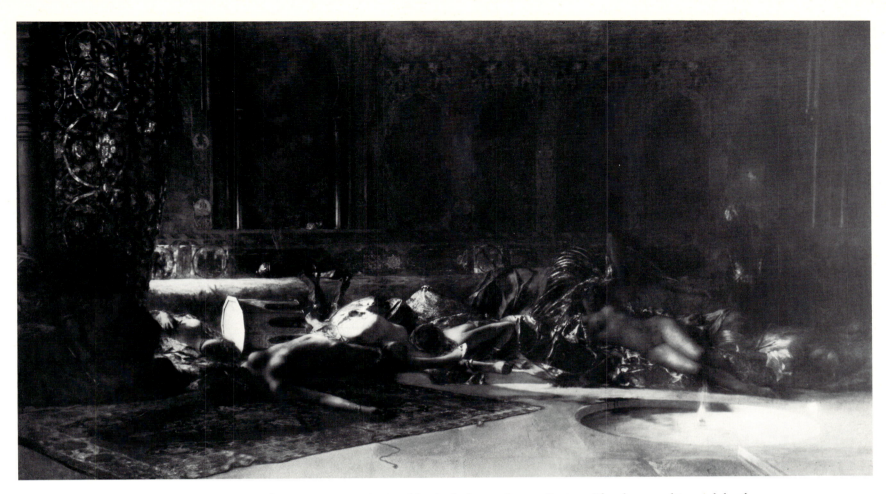

Benjamin Constant: The Sharif's Justice. *Oil, 374×630 cm. Ancien Musée du Luxembourg, Paris. – Blood, sensuality, and death.*

gling: the master's eye has to be drawn by the glint of white young flesh, etc...." The writers went further – they didn't need women for the colour effects:

"The first thing we noticed in the street was the butchery. As it happens, there is a space in the middle of the houses: in this space there is a hole, and in this hole blood, guts, urine, an arsenal of the warm tones available to the colourist. The stench all around is murder; nearby, two crossed sticks from which a hook is hanging. This is the place where the animals are killed and where the meat is retailed!" (Flaubert, *Jérusalem*)

This sketch became a full-scale picture in *Salammbô*, the masterpiece of historical Orientalism, which, unfortunately, inspired no one except Rochegrosse, unless Moreau's *Salome* is considered as a sister of the priestess Tanit. In paintings based on Byzantine history, blood, gold, and purple are also shown together.

The Sultan, lord of the massacres and treasures, whose subjects were slaves and who was accountable to none but Allah, and his representatives, the viziers and pashas, had to have a superhuman beauty. William Beckford was the first to portray the cruel Vathek, who resembled Lucifer more than Harun ar-Rashid; these traits were used also by Byron in several of his poems and by Victor Hugo for more than one of his Orientals. In *La Douleur du Pacha,* "Qu'a donc le doux sultan? demandaient les sultanes" [What's the matter with the sweet sultan? asked the sultanas], we encounter the theme of melancholy, the concomitant of absolute power, of the immediate gratification of each and every desire. In this case the Sultan is sad because his Nubian tiger has just died (incidentally, there are no tigers in Africa). This is the solitude of Sardanapalus perched on his treasure. When Regnault wanted to paint a pasha he thought unconsciously of Sardanapalus: "...a tame lioness will lick his feet, his two favourite slaves will light the incense, and he won't even know whether someone has just given him a few more provinces ... he will have some fresh bodies next to his, that's all...."

At the Alhambra Gautier day-dreamed: "The caliphs seated on gold-brocade divans, their black eyes staring fixedly out of stony faces, their hands buried in their silky beards, listening to the plaints of the faithful...."

More attractive than the sultan, the Giaour was a Christian adventurer who had gone over to the service of Islam. This dandy who found in the East a life-style that was not possible in Europe was invented by Byron and taken up by numerous poets, including Musset, who wrote in *Namouna:*

Il était indolent, et très opiniâtre;
Bien cambré, bien lavé, le visage olivâtre,

Des mains de patricien, — l'aspect fier et nerveux,
La barbe et les sourcils très noirs, — un corps d'albâtre.
[He was indolent and headstrong; well made, washed, with an olive skin, patrician hands, he looked proud and virile, with black beard and brows and an alabaster body.]

These ominous figures, to whom Balzac often likened his heroes, were "the tigers of humanity." Thanks to them painters introduced a new kind of masculine beauty, which can first be discerned in the paintings of the Egyptian campaign and in those of Géricault, although there the neoclassical build was still retained. After seeing real African and Oriental princes, the type was refined and finally perfected in *The Caliph of Constantine* by Chassériau. The magnificently dressed mercenaries and the Bedouins also had great nobility; they were lords, free men, with the virile beauty of romantic heroes. Their dignity impressed even such down-to-earth painters as Horace Vernet, who contrived to express real grandeur in some of his Algerian canvases by portraying the white-clad governors. This kind of character was also found in the pages of Tasso's *La Gerusalemme liberata.* In antithesis to that virile Oriental type, painters of medieval history showed the Western knights as pink and fair, though Delacroix's Franks in *The Entry of the Crusaders into Constantinople* have the proud look of Moroccans despite the standards they carry.

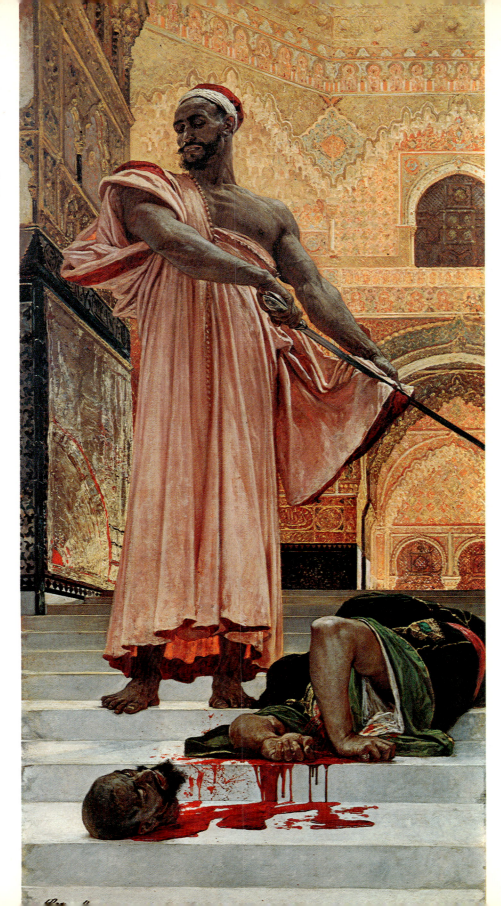

Henri Regnault: Summary Execution under the Moorish Kings of Granada. *Oil, 302×146 cm. Musée du Louvre, Paris. – A Moroccan scene set in the Alhambra.*

The studios of the Orientalists were decorated with trophies, sparkling scimitars, *yataghans,* long-barrelled rifles with inlaid butts. These were the weapons thrust into the belts of the Albanian mercenaries in the paintings by Gérôme and Lecomte du Noüy or brandished by Chassériau's and Horace Vernet's Moroccans. Battle scenes had an important place in baroque Orientalist painting and throughout the nineteenth century. European armies were fighting numerous wars, either against Turkish regiments or against Algerian and Tartar troops. It started with the Egyptian campaign, then came the Greek War of Independence, begun in 1821, to which the Powers gave their enthusiastic but materially only modest support. Most poems in Victor Hugo's *Les Orientales* were inspired by the heroism of the Greeks and the savagery of the Turks. Admiral Canaris's exploits and the victory off Navarino over the Egyptian fleet in 1827 compensated the French for their humdrum life after the exciting days of the Empire. Ary Scheffer himself painted Philhellenic pictures, which the public found less baffling than Delacroix's masterpieces.

For propaganda purposes, the government of Louis-Philippe sent many painters to follow the different phases of the conquest in Algeria. The king's favourite painter, Horace Vernet, painted the enormous *Capture of Abd-el-Kader's Train by the Duc d'Aumale,* the centre-piece of the Salon of 1845, which Baudelaire called a "cabaret panorama." There was plenty of violence, but it was shown without passion; we do not hear the women yell, the herds stampede, the shots, or the tumult that the battles of horsemen by Delacroix and Chassériau conjure up so well.

The Crimean War of 1854, in which English, French, and Turks fought the Russians, was lacking in spectacular episodes, apart from the famous *Charge of the Light Brigade* immortalized by Tennyson. From that period dates the decline of heroic painting, which could not survive the comparison with the sketches sent home by the correspondents of illustrated magazines, like Constantin Guys. Photography was making its appearance, and it became increasingly difficult to believe in a sublime or even picturesque form of violence. The lovers of *panache* had to take refuge in past exploits, as did the Austrian and Polish painters who took their subjects from the seventeenth-century campaigns against the Turks.

Fortunately there were the Arab cavalcades, the fantasias: "Through a haze of dust and burning powder the riders succeeded one another without respite. Imagine the wildest disorder, the most lightning speed, the most dazzling of crude colours lit by the sun. Imagine the glint of arms, the cloaks loosened, the wind blowing through clothes.... Give the scene its true calm, fair tone, and perhaps you will be able to discern the sheer joy in the muddle, an intoxicating feast, like war – that fabulous show called an Arab fantasia." (Fromentin)

Finally, when there was a dearth of battles, hunting provided a subject for colourful pictures. Whereas Delacroix's hunts were the product of his imagination, Fromentin watched gazelle hunts in Algeria: "Young Bel Kassem, who sets out with his hunt and hounds, with his falconers in their best clothes and his foreign pages, and himself carries a hawk attached to his leather gauntlet."

Charles-Emile (Callande de) Champmartin: Massacre of the Janissaries, 1827. Oil, 472 × 628 cm. Musée municipal, Rochefort-sur-Mer. – One of the finest scenes of slaughter painted under the influence of Gros and Girodet.

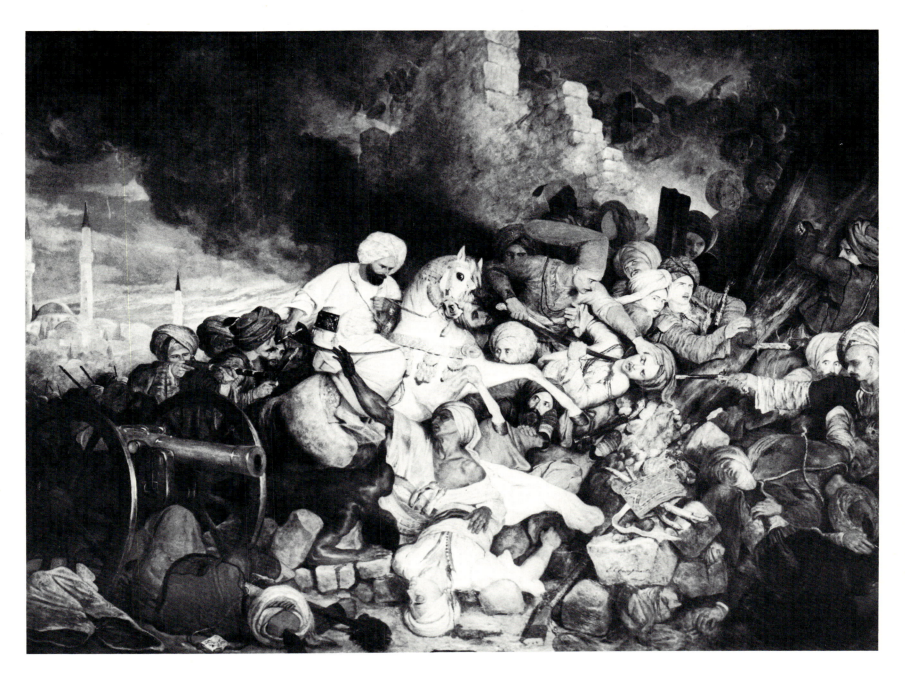

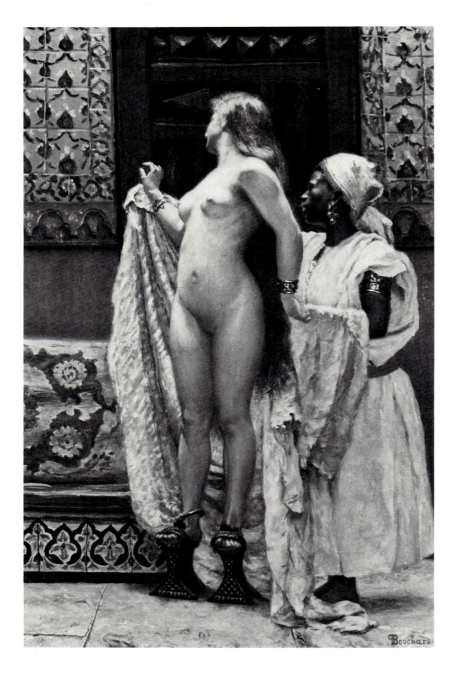

The presence of slaves was an important aspect of paintings that carried the flirtation with an alien culture to the point of violent and erotic fantasies. Nothing could more skilfully convey the combination of the twin subjects of death and pleasure than the slaves at Cleopatra's feet in Makart's famous *Death of Cleopatra*. Cleopatra herself, a languid Viennese, towers above a black woman who is lying dead amidst the furs and flowers. Another slave struck down by a sovereign anger is shown lying at the Pharaoh's feet in Lecomte du Noüy's picture, *The Bearer of Bad Tidings*, exposing a muscular back that was to prove shattering to the pubescent Julien Green.

The idea of owning slaves fascinated a great many people who cared little for the principles of the French Revolution or for Victorian puritanism. The fact that slaves could be bought in the markets of Constantinople and Isfahan simply added to the glamour of these towns. These lines by Musset have a note of sadism:

> *Il arriva qu'alors six jeunes Africaines*
> *Entraient dans un bazar, les bras chargés de chaînes.*
> *Sur les tapis de soie un vieux juif étalait*
> *Ces beaux poissons dorés, pris d'un coup de filet.*
> *La foule trépignait, les cages étaient pleines,*
> *Et la chair marchandée au soleil se tordait.*
>
> (Namouna)

[Then six young African girls entered a bazaar, their arms in chains; on the silk carpet an old Jew spread out these beautiful fish caught in one throw of the net; the crowd stamped, the cages were full, and the flesh on sale writhed in the sun.]

Paul-Louis Bouchard: At the Turkish Bath, c. 1880. Oil, 55×36 cm. Galerie Tanagra, Paris. – Connoisseurs enjoyed such contrasts between fair and dark.

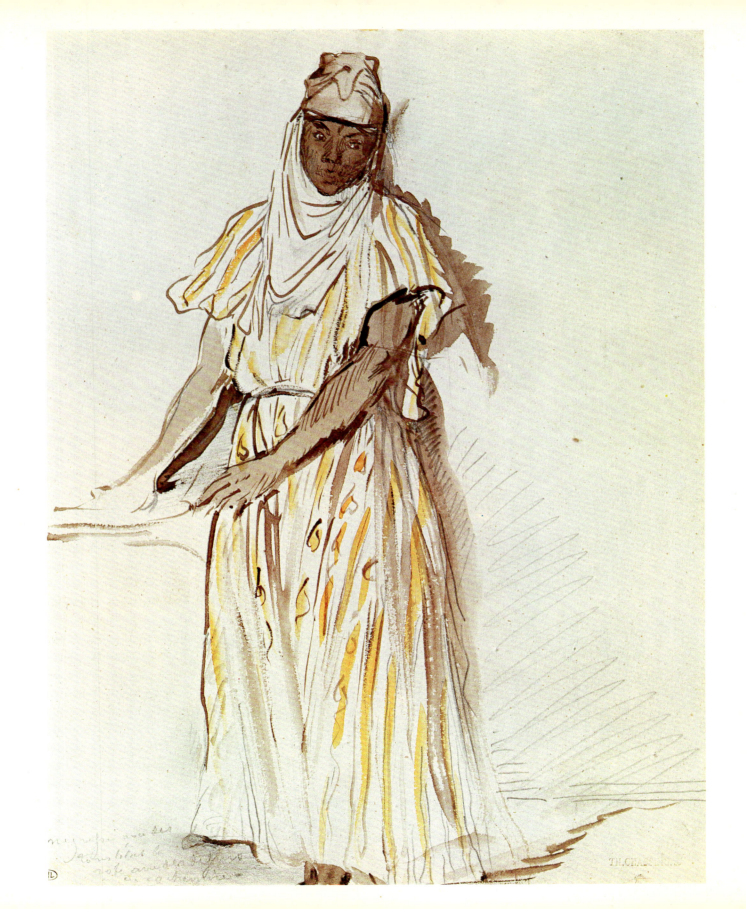

Théodore Chassériau: Negress from Algiers, 1846. Watercolour, 31×23.5 cm. Musée du Louvre, Paris. – This sketch, reminiscent of Delacroix, was made during a stay in Constantinople.

Frank Duveneck: The Turkish Page, *c. 1880. Oil, 42×56 cm. Pennsylvania Academy of the Fine Arts, Philadelphia (Temple Fund Purchase, 1894.1). – Studio Orientalism by an excellent American painter.*

Slave markets were a popular subject with painters, enabling them to place their nudes in genre scenes – female nudes, usually white, Circassian women revealed under muslin or uncovered as an impatient customer tears at the veils. Male nudes, always black, with powerful muscles, were still a useful way of showing your craftsmanship while pandering to a lust for power. Baudelaire must have been thinking of blacks when he wrote,

> *Et des esclaves nus, tout imprégnés d'odeurs,*
> *Qui me rafraîchissaient le front avec des palmes.*
> *(La Vie antérieure)*

[And naked slaves permeated with scents cool my brow with palms…]

The dreamer had an army of servants, devoted to the point of crime, on which he could call to satisfy his whims. Black servant-women massaged white women (Debat-Ponsan), brought coffee (Liotard and Lewis), provided a dark foil to moist nudes in the bath (Ingres and others), held up curtains that were as gaudy as their clothes (Delacroix), or, magnificently arrayed, were servants in rich Jewish houses (Chassériau). The Impressionists chose black servant women when they needed that colour in a painting, like the Negress who brings flowers to Olympia, or the ones whom Bazille – who was really tempted to become an Orientalist – painted beside a large bouquet or drying a Susannah after the bath.

White slaves were often shown as dancing girls by Diaz and Monticelli. These *bamboulas* were a far cry from the true Oriental dances described by Gobineau and painted by Eugène Giraud: "Then to an extremely slow and monotonous air accompanied by a jerky roll of drums, a dull, terse sound, the dancer, hands on hips, made some movements with only her head and the upper part of her body. She turned slowly on the spot. She looked at nobody, she seemed impassive and absorbed. Every eye followed her, everyone waited for her to do something, but she did nothing; and precisely because of this unfulfilled expectation she was watched more intently and breathlessly every moment." *(Nouvelles asiatiques)*

These dancers often were boys, like those Flaubert saw in Cairo: "…Wide pants and an embroidered jacket, eyes made up with antimony; the jacket goes only as far as the pit of the stomach while the trousers, held up by a huge cashmere belt folded several times, do not start higher than about the pubis, so that the whole stomach, the loins, and the upper part of the buttocks are naked under a thin black veil…

Count Amadeo Preziosi: Turkish Woman Holding a Pipe, with a Black Servant at her Side, 1852. Gouache, 38×51 cm. Edmonde Charles-Roux Coll., Paris. – Painted for the Empress Eugénie.

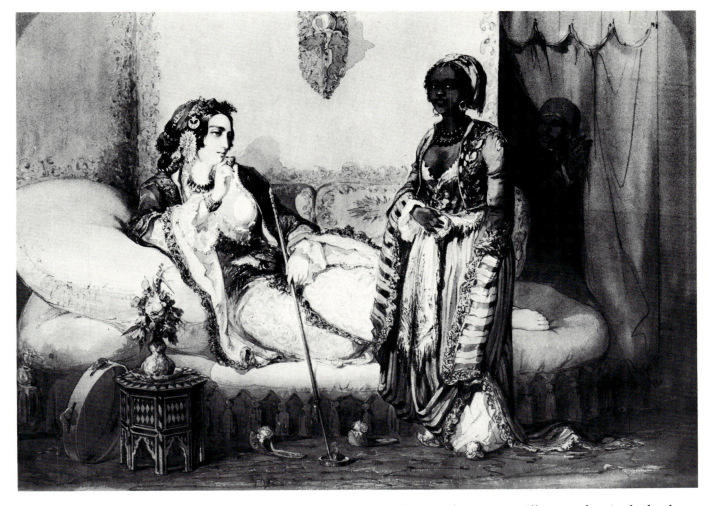

which ripples round the hips with every movement they make – the face expressionless under the greasepaint and the sweat which is running down...."

Loti saw much the same spectacle thirty years later in Constantinople. But whereas suggestive descriptions abound in literature (especially in Byron), they are rare in painting, which was aimed at a very conservative clientele. Girodet's swooning page-boy, who was still neo-classical, had no equally disturbing equivalent among the Orientalists. On the other hand Pasolini's film taken, more or less, from the *Arabian Nights*, which consists of a succession of dazzling Orientalist pictures, shows slaves of both sexes and all colours, offering their pleasures with a frankness that would not have been tolerated in the West until very recently.

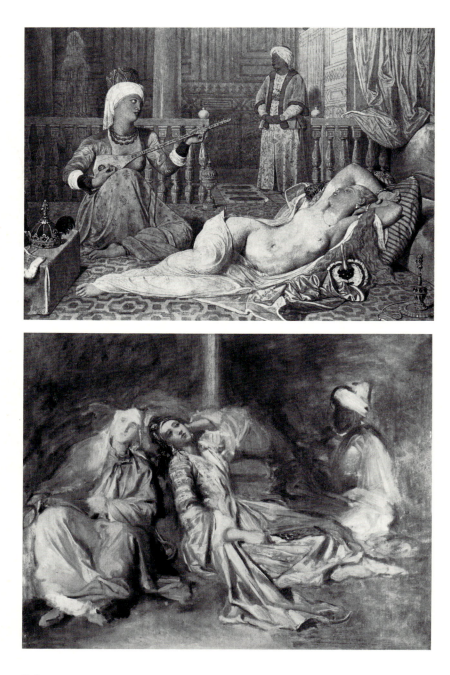

From Delacroix through Makart to Rochegrosse, the East was a pretext for associating violence with sensuality, death with nudity. Most of the Orientalists sought to evoke pictures of easy pleasure and passive beauties, the slaves. To the European the idea of a harem became a familiar fantasy. What could be more pleasant than to imagine one was a sultan and could choose from among beauties who were eager to please or only submissive. Of all the harems described by Byron, the most seductive is that into which Don Juan is smuggled disguised as a woman:

> Lolah was dusk as India and as warm;
> Katinka was a Georgian, white and red,
> With great blue eyes, a lovely hand and arm,
> And feet so small they scarce seem'd made to tread,
> But rather skim the earth; while Dudù's form
> Look'd more adapted to be put to bed,
> Being somewhat large and languishing, and lazy
> Yet of a beauty that would drive you crazy
>
> (Canto VI, 41)

At the time when Byron was writing these lines, an extremely obscene novel appeared in England, *The Lusty Turk*, which was very specific in its descriptions of such suggestive

Jean-Auguste-Dominique Ingres: Odalisque with her Slave, *1858. Drawing, 34.4×47 cm. Musée du Louvre, Paris. – The setting and the costumes of the people around this blonde Circassian are taken from eighteenth-century travel books.*

Théodore Chassériau: Harem Interior, *1856. Oil, 55×66.5 cm. Musée du Louvre, Paris. – A sensual daydream – the model was probably a Parisian. The painter's last work.*

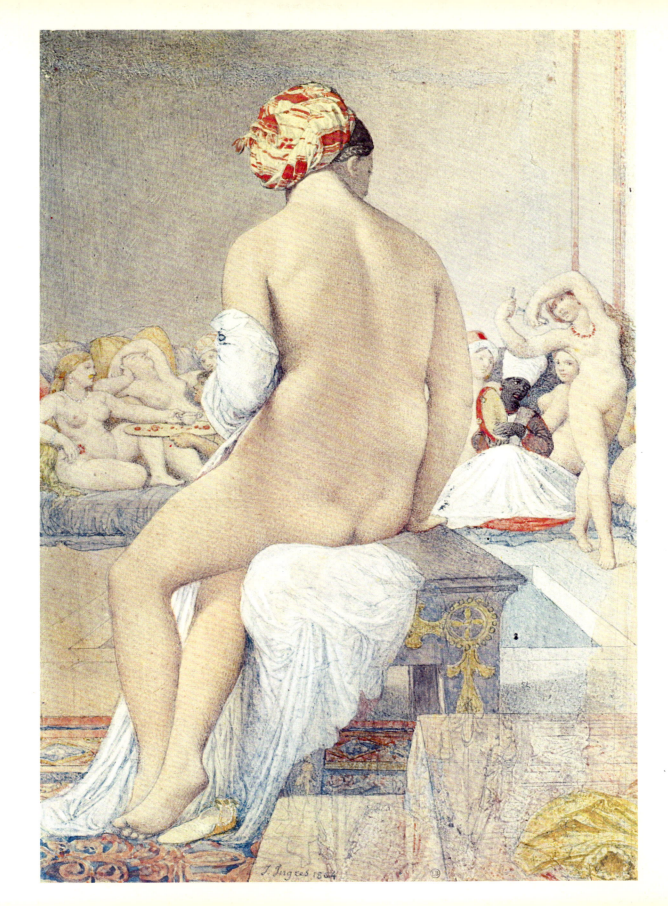

Jean-Auguste-
Dominique Ingres:
Odalisque, 1864.
Watercolour,
34.5×23.5 cm.
Musée Bonnat, Bayonne.
– Study for The Turkish
Bath. Orientalism
permitted the use of the
most sensual subjects.

Jules-Robert Auguste (known as "Monsieur Auguste"): Three Oda-lisques. *Pastel, 30×22 cm. Musée des Beaux-Arts, Orleans. – Intriguing contrast between black women and a white woman by a connoisseur who greatly influenced the Orientalists.*

scenes. Orientalist paintings offered a wide choice of harems, some exquisite, others picturesque, and others more like brothels. Ingres showed the first kind in his large *Oda-lisque* of 1807 and in the strange *Turkish Bath* painted in his old age. He took the settings and costumes from engravings in old travel books. The Roman women who posed for it might be Circassians awaiting the sultan's whim in the marble halls, smoking their hookahs. Their attitudes suggest that they know how to while away the time pleasantly, for Lesbianism was not frowned upon excessively. Without going so far as the two girl friends painted by Courbet for a pasha, many painters depicted the passions of the harem, chronicled originally by the first Orientalist, Monsieur Auguste, according to whom the complaisance of black women slaves was boundless. Perhaps it was reassuring to attribute perverse tastes, which could in fact be found in all countries, to the sole influence of the East. In his *Confessions* Arsène Houssaye spoke in these terms of the relationship between George Sand and Marie Dorval: "This wasn't only a frenzy of feeling but an unrestrained surrender to Oriental, Indian, Japanese voluptuousness." We know that George Sand sometimes smoked a hookah and at home wore Turkish slippers and wide silk trousers.

But only a perverse mind would be suspicious about the delightful Egyptian women, painted by Lewis, having coffee in the shade of lattices or the elegant *"Turqueries"* by Count Amadeo Preziosi and Thomas Allom.

Gérôme, Benjamin Constant and Debat-Ponsan put the accent on the setting rather than on drearily academic nudes. Their harems generally contain a bath with flowered tiles in the centre, and in the foreground, a still life sparkling with copper. Clairin added peacocks, fan-bearers, and enormous eunuchs. As he was rather bad at painting nudes, he covered

Richard Dadd: Fantasy
of the Egyptian Harem,
*1865. Watercolour,
25.7×17.9 cm.
Ashmolean Museum,
Oxford. – A madman's
vision of the Orient.*

his women with gems and velvets. Rochegrosse was also picturesque, but the ladies, dressed in orange and green muslins and sprawling on cushions, look as if they were waiting for a gentleman client to be shown up. Every "house" contained a Moorish woman in baggy pink trousers and a spangled bolero.

Many a dancing-girl at the Salon came from Chabanais rather than the Porte, like the *Eight Sisters of the Pasha* in brown and orange coats painted by J.-G. Vibert when, for once, he abandoned his cardinals. We might even speak of a Montmartre Orientalism when we recall the *Belly Dance* which Toulouse-Lautrec painted on La Goulue's stall, and those *almahs* Picasso put in the background of Gustave Coquiot's portrait in 1901.

There was one painter who expressed Arab sensuality marvellously, and that was A.-E. Dinet. He did Algerian love scenes on terraces on star-lit nights: mauve shadows on the young tanned bodies of the girls; scents of incense, kef and jasmin seem to waft out. It is reminiscent of Flaubert's meetings with the courtesan of Luxor.

The idea of the harem and its facilities was exciting to European men, but so was its very opposite, the veiled, forbidden woman. Flaubert wrote from Cairo: "She goes ahead, with a rustle of skirts, the sound of golden coins in her headdress, a clear slow sound...." But these beauties were too mysterious for the painters, and Constantin Guys, a reporter, was the only one who sketched Turkish women in crinolines giving officers the glad eye through the slits of their yashmaks.

The East has always been full of those contrasts that delighted the Romantics. The richest towns and the most lush oases are surrounded by vast deserts, through which caravans travel slowly. Like the skulls which baroque painters put beside jewels and flowers to symbolize the impermanence of human life, the desert was a constant reminder of ever-present death. All the travellers described the deserts they had to pass through, but none better than Balzac, who contented himself with the day-dream:

"In every direction the blackish sands of the desert stretched as far as the eye could see, sparkling like a steel blade caught in a bright light. He did not know if this was a sea of ice or of mirror-smooth lakes. A fiery haze eddied and whirled above the moving soil. The sky had an Eastern brightness, so pure that it filled you with despair for it left the imagination completely satiated. The sky and the earth were on fire. The awe-inspiring wild majesty of the silence was appalling. The infinite, the vastness beset the mind on all sides, not a cloud in the sky, not a breeze in the air." *(Une Passion dans le Désert)*

In rather similar terms Beckford described the terrifying lands through which the outcast Caliph dragged his court and his women. Victor Hugo's Jinns passed across this desert like whirlwinds. The best artists attempted to depict this solitary thought-provoking wilderness; they can be divided into three categories: the picturesque, the historical, and the despairing. In the first category, Decamps achieved true greatness in his paintings of desolate valleys:

"In front, a dusty path, white with shimmering light, runs

Léon-Adolphe-Auguste Belly: Pilgrims Going to Mecca. *1861. Oil, 161×242 cm. Musée du Louvre, Paris. — One of the masterpieces of academic Orientalism.*

100

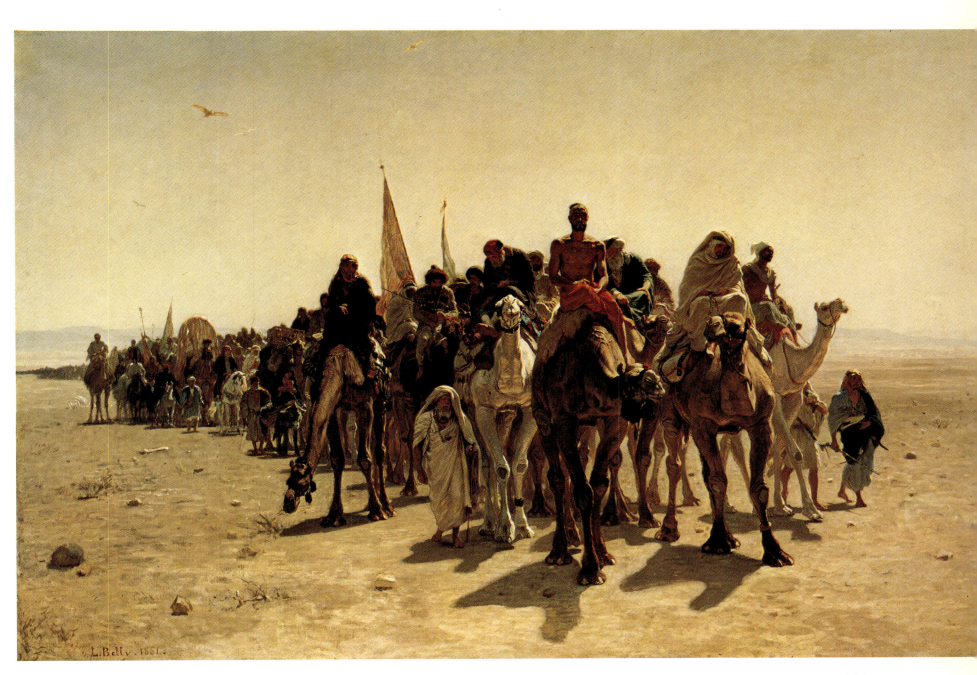

round the top of a hill which a camel is climbing laboriously. Far off, below, lies the immense plain, broken by chalky scars, its vegetation scorched, the lawns tawny like a lion's coat. The noon sun falls straight on to this dismal, silent, arid wilderness where even nature seems to faint with heat. It is untamed, grandiose, and superb." (Théophile Gautier)

Equally wild and superb caravans wound their way across these deserts, none more splendid than that in the *Pilgrims Going to Mecca* by L.-A.-A. Belly, which had a tremendous success in 1861: "Each visitor seemed to come out of the Salon as if he had himself been a member of the caravan," wrote a critic.

For Gérôme and the painters of historical subjects the desert was the realm of the sphinx with its face deeply etched by sandstorms. The desert stretched from the gates of Cairo to the red mountains of Upper Egypt. In these deserts, which had been crossed by the armies of Darius, Alexander and Bonaparte, there were ruins: Palmyra and Antioch, which inspired deep thoughts in travellers and the English water-colour painters. As much as the whisper of history, the voice of God could be heard in these accursed regions where Holman Hunt abandoned *The Scapegoat* in a torrid wilderness. Millet, and even Corot, painted an abandoned Hagar there; Luc-Olivier Merson let his Holy Family shelter in the shade of the sphinx. The mosques, half-buried in sand, by Marilhat, Vereshchagin and David Roberts are also thought-provoking.

Finally there was the accursed desert in whose scorched wilds there is nothing to be seen but the skeleton of a camel and some fallen pillars, and perhaps a Bedouin tent:

Produit des blancs reflets du sable
Et du Soleil toujours brillant,

Nul ennui ne t'est comparable
Spleen lumineux de l'Orient.
(Théophile Gautier, *Emaux et Camées*)
[Offspring of the white reflection of sand and the glaring sun, there is no tedium like you, shining spleen of the East.]

The best painter of the less renowned Algerian desert was Guillaumet, whose landscapes might have achieved an abstract quality if he had not given too much emphasis to some of the details in order to convey the desolation.

Fromentin painted some nice deserts with hunters carrying hawks on their wrists, but his *Land of Thirst* with its caravans winding through the rocks has so much pathos as to be almost funny.

Whereas Orientalist literature abounds in descriptions of mirages, very few artists chanced them except the illustrators of the *Arabian Nights* and *La Gerusalemme liberata*. But the Bedouins, who are forever crossing the desert in every direction, perpetually moving their dwelling place, attracted many painters, as much by their swarthy faces and dark cloaks as by being the last free men. They also stood for incorruptible dignity in the face of the temptations of the West. The desert, which was the cause of so much suffering but which stripped the soul down to a sober spiritual awareness, haunted the Orientalists when they returned home. They all felt like the Algerian writer Sliman ben Ibrahim, who illustrated wholly Islamic poetry with pictures by Dinet (who often painted the desert as well as voluptuous subjects): "The Sahara, sultan of the waves of light, disappeared far out of sight, wet blue waves chilled my limbs, then the black ocean of northern smoke and fog covered my heart with a mantle of mourning."

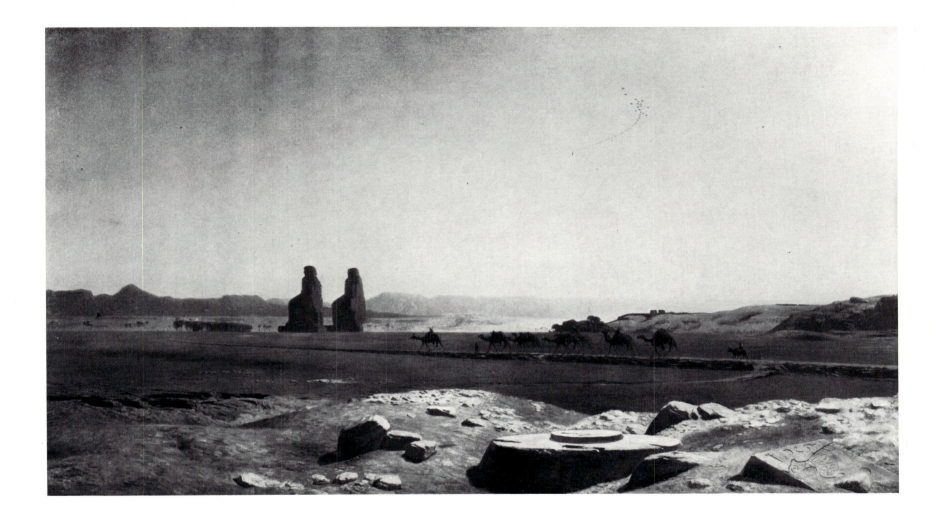

Jean-Léon Gérôme: View of the Plain of Thebes, *1857. Oil, 76 × 131 cm. Musée des Beaux-Arts, Nantes. – The colossi of Memnon, a caravan, the desert, and the Nile – all most thought-provoking.*

Théodore Géricault: Mameluke Restraining a Horse, *c. 1817. Drawing, 27.8×25 cm Musée du Louvre, Cabinet des Dessins, Paris. – Drawing inspired by the guards Bonaparte brought back from Egypt, and by the nobility of the Arab steed.*

The animals of the desert share its nobility. The lion was dear to Gérôme – we find it in his Roman circus scenes – even though the Impressionists laughed at him for his "tawny lion" palette. One of the most highly praised lions at the Salon of 1850 was that by Louis Matout shown in the process of devouring an Algerian girl and probably the inspiration for the Douanier Rousseau's *Sleeping Gipsy.*

Barye had seen lions only at the Zoological Gardens but he showed them in settings of sand and blue-black skies, as well as panthers, which – according to Balzac – fanned "passions in the desert".

In the desert race horses encountered no obstacles, and the love of liberty and space led to an equestrian Orientalism. Vernet's lithographs of Mamelukes restraining thoroughbreds had a wide circulation, as did those of Gros from 1819 on. Géricault also did lithographs of the same subject, and Victor Adam was often commissioned to draw horses for lithographs. In Morocco Delacroix was fascinated by the half-wild horses and their fights which offered an opportunity for painting flying manes, and Chassériau and Fromentin painted thoroughbreds, like that Sultan about whom Lamartine wrote:

Et toi, mon fier Sultan, à la crinière noire,
Coursier né des amours de la foudre et du vent,
Dont quelques poils de jais tigraient la blanche moire,
Dont le sabot mordait sur le sable mouvant.

[And you, my proud Sultan, with the black mane, a race-horse born of lightning and the wind, your white silk was striped with jade, your shoe bit into the shifting sands.]

Rivalling the speed of horses in hunting were the salukis or gazelle hounds, which were also often painted.

Camels are indispensable in these Eastern countries. Gérôme, who painted whole caravans, could write in all seriousness: "The camel is the ship of the desert." Cesare Biseo, an Italian painter, excelled at caravans in the burning sands.

Only the third-rate Orientalists went in for monkeys and parrots. Elephants, which had hardly been depicted since

Théodore Chassériau: Arab Horseman Setting out for a Fantasia, *1846. Watercolour, 31×38 cm. Musée du Louvre, Paris. – Elegance of line and of costume recalling a Persian miniature.*

Lebrun, appeared as a decorative feature in Delacroix's *The Death of Sardanapalus,* were shown in herds by Tourne-mine, laden with treasure by Brangwyn and Sert y Badia, the Imperialist painters, and featured in the splendid water-colours Besnard did in India.

Finally we find fantastic animals, such as the Roc bird and the winged horses which Gustave Moreau took from Mogul miniatures.

"You can recognize Moslem country from afar by the rich dark green that veils it delicately; trees in whose shade you can sit, splashing fountains beside which you can dream, and mosques with frail minarets rising from the bosom of the devout soil." This was Lamartine's nostalgic account in his *Voyage d'Orient;* and many a painter turned his back on the desert, preferring oases or rather charming villages reflected in the water, shaded by palm trees. The pictures of that serene Orient almost invariably contain those white minarets that were so useful in balancing the composition of a landscape. Brest and Tournemine encountered them on the shores of the Bosphorus, Crapelet and Marilhat in Egypt, Montfort in Beirut; Edward Lear did not miss a single one, either in Egypt or in Greece; William Wyld drew a great many in his Algerian lithographs. The viewer must imagine the chant of the muezzin punctuating life by prayer. One of Gérôme's best works shows the hour of prayer on a Cairo terrace around which Mameluke minarets rise like elegant flasks against a reddening horizon. The studded doors, the bulbous arch, the fine twisted columns and the lattices were as indispensable as the minarets. Behind the filigree shadow cast by latticed wooden screens on the marble of the seraglio, the ladies painted by Lewis and Allom watched the swarming crowds in the street or the visitors whom their master was entertaining in the great hall.

The English were particularly good at conveying the monotonous complexity of Moslem architecture and its calligraphic style of decoration while retaining the romantic aura of the mellow buildings. In Daniell's engravings, domes and minarets rose above temples deep in the Indian forest. In Roberts's lithographs, minarets watched over Mameluke tombs on which the desert sands were encroaching. This was the kind of picture Gautier adored: "You would think that,

through some magic trick of perspective, an open window beyond the last room lets us glimpse the necropolis of Cairo. It was Marilhat's genius that made that gap in the wall. Instead of our misty sky, we have the sparkle of a hot clear sky in which vultures are circling; instead of grey houses, the ramparts, the domes, and the minarets of the Arab town rise with a copper glow in the scorching sun..." (*Exposition de Tableaux modernes,* 1860)

The city of the dead leads us to the visionary townscape based as much on Oriental archaeology as on religious legends. The most famous at the beginning of the nineteenth century were John Martin's Ninevehs and Sodoms with infinite perspectives, caught at the moment when they are struck down by divine wrath; and, perhaps less spectacular but more exact, the dilapidated sanctuaries painted by Bauer, the Dutchman, c. 1900. Turbaned figures out of Rembrandt practise forgotten rites under the arches, or beggars wait in the shelter of stalactite porches for some prince to pass.

The Moslem cemeteries, where family picnics were held on holidays, were as impressive in their simplicity as the mausoleums where forgotten despots slept; Fromentin got the subject for a delightful picture from them and Holman Hunt for a strange watercolour. Byron meditated on Hassan's tomb:

> A turban carved in coarsest stone,
> A pillar with rank weeds o'ergrown,
> Whereon can now be scarcely read
> The Koran verse that mourns the dead.
> (*The Giaour,* 723–6)

Pierre Loti was to have similar thoughts in the cemetery at Eyub.

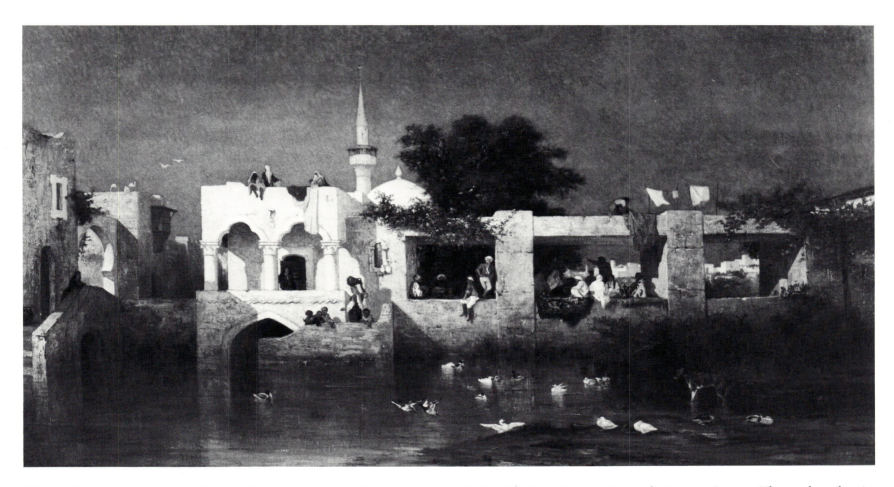

Charles-Emile de Tournemine: Turkish Dwellings near Adalia (Asia Minor), *1856. Oil, 60 × 124 cm. Musée du Louvre, Paris. — This neglected artist has the same sense of the picturesque as Decamps, but is a much better colourist.*

The public wanted to see on the stage, too, those "visions of the East" that had delighted them at exhibitions. Like theatre set-designers, architects – especially in Germany – also began to build Moorish pavilions; at the end of the eighteenth century, the mosque of Schwetzingen raised its minarets above the classic park. Later, under the influence of Schinkel's stage sets for *The Magic Flute* in 1816 and Wilhelm Hensel's for *Lalla Rookh,* the King of Prussia fol-

lowed Prince Pückler-Muskau's example and acquired a large Moorish-style conservatory; then Carl von Diebitsch designed the sumptuous pavilion at Linderhof for King Ludwig II of Bavaria (1865). He also drew up the plans for a Moorish stock exchange. Brighton beach is overlooked by the minaret-like turrets of the Prince Regent's Pavilion, with its Chinese interior and Mogul-style exterior. Neo-classical aesthetes, like Thomas Hope, invented an exotic Saracen style with Arab features, but it had little success except with a few French Restoration decorators. It would be interesting, though this goes beyond the scope of this book, to examine the influence these exotic pavilions had on the international exhibitions and to what extent they accounted for Moorish casinos in spas, and for the luxurious Turkish Baths built during the Second Empire in Vienna, London and Paris.

In spite of their Romanticism, the Orientalists remained aware of the prestige of antiquity, whose architecture they had studied in their Art Schools and which still furnished the subjects for competitions. It is not easy to shake off a culture, however dead it may seem. When Delacroix arrived in Tangiers, he wrote enthusiastically: "Imagine, my friend, what it's like to see Consuls, Catos, and Brutuses, who certainly don't lack that superior air you would expect from the lords of the earth, lying in the sun, walking through the streets, mending old shoes. These people possess only one blanket in which they dress, sleep, and are buried, and yet they look as pleased as Cicero. There is nothing finer in Antiquity. All this in white, like the Roman senators and the Athenian Panathenaea."

These words could have been written by Gleyre after the four years in Egypt that enabled him, thanks to the light of the Nile and the poses of the Nubian girls, to paint his masterpiece, *The Lost Illusions*. A stay in the East helped painters to depict classical subjects more turbidly or more truthfully, and in any case more interestingly. The women Chassériau painted in the frescoes of the Cour des Comptes are certainly closer to the Jewish women of Constantinople than to the models of the Ecole des Beaux-Arts. Makart's *Cleopatra* is an excellent example of this influence. Lecomte du Noüy's *The Bearer of Bad Tidings* is more theatrical.

We must distinguish between classical antiquity and Eastern and biblical antiquity. In the first case, the memories of Africa in artists like Delacroix and Chassériau are mainly unconscious; in the second, folk traditions and archaeological discoveries played a much greater part. Holman Hunt's Assyrian *Sardanapalus,* and some Royal Academician's *Building of an Egyptian Temple* are dreary examples of these

William Pars: Ruins of the Temple of Apollo at Didyma, *1764. From* Ionian Antiquities.

meticulous reconstructions. But Holman Hunt's and Gleyre's biblical scenes could be as moving as Hugo's poem *Booz Endormi*. A section of the public rejected the picturesque and demanded pictures with an antique grandeur. Guillaumet wrote about a caravan in Kabylia: "I feel as if I were rereading a page from Genesis. I dreamt that this scene had been reenacted in exactly the same way from age to age, from century to century, in all its touching simplicity, with the same gestures and probably the same dialogue."

The similarities between Oriental and classical societies also made classical painters look towards the East. In both societies there were slaves, and the women hardly left the gynaeceum or the harem. But we must admit that a dyed-in-the-wool Orientalist like Gérôme did not add the least Oriental grace to his antique scenes. On the other hand, Rochegrosse's Helen, just like his Salammbô and Salome, looks like an Algerian tart.

And of course all those who piously drew classical or Egyptian ruins enlivened them with turbaned figures. The English excelled in this genre. One of the earliest and best examples is the watercolour by William Pars (1764) showing the Turks squatting on the capitals of the Temple of Apollo at Didyma. Edward Lear, equally lovingly, painted Egyptian temples reflected in the Nile, and William Henry Bartlett depicted grandiose ruins in Syria with Arab villages huddled in their midst.

Arabian Tales, *frontispiece of the popular edition of* A Thousand and One Nights, *about 1840. Wood engraving.*

The World
of the Orientalists

We shall now follow the footsteps of the painters who went round the Mediterranean and as far as India in search of a light, a picturesque quality, and a truth they no longer found in the West; we shall see how far each of these Eastern countries is reflected in the work of the artists who settled there. For instance, subjects taken from Morocco tended to be violent, Egyptian ones sensual, while Turkey provided bravado.

Until the middle of the nineteenth century, the job of an Orientalist was not without danger. Excursions farther afield than Cairo, or Smyrna, or even Athens and Granada, became expeditions through regions where robbers and policemen were equally formidable. There was much to fear — the fanaticism of the faithful, the greed of ruling officials, and all sorts of fevers; returning travellers were subjected to a hateful quarantine. Many of the painters must have been like that unfortunate young man whom Gobineau met in a caravan: "He had fallen in love with the East through reading travel books and he wrote poetry. His ideal was Thomas Moore's *Lalla Rookh* and, he said, he wanted to get his inspiration from the very source of rapture and sublimity. The poor boy wasn't very knowledgeable. His hair was long, he had a red silk belt, the kind of sword worn by knights of old, heavy boots with gilt spurs and a feather in his hat. He hadn't much money, and to save, he ate with the mule drivers and slept on their blankets. He was thin, pale, and weak; he had chest trouble. He died before getting to the Persian frontier." *(Nouvelles asiatiques)*

Opulent publications, and more modest ones too, made armchair travel possible. The great Russian noblemen sought to leave a lasting memento of their expeditions; in 1845 Prince Soltykoff published a very fine album of lithographs. The two-tone plates show India in all its glorious variety — warriors, elephants, and turbaned sikhs. In 1838,

the prince had already published a book on Persia illustrated after drawings by Colombari. Lemercier's coloured lithographs for the *Voyage en Orient* (1851) by Count Andrassy, a Hungarian, were very lifelike. Prince Demidoff took Auguste Raffet to the Crimea. The album published by a Prussian prince who had gone to Egypt and then to India in 1853 was less picturesque. We might also mention Tremoux's *Journey to the Sudan,* dating from 1847, although this really comes under ethnography, with lithographs made from photographs.

These albums were on the shelves of successful artists, rulers, diplomats, and bankers, and they encouraged a taste for distant countries, a fashion that also owed something to colonial ambitions, an aesthetic sense and an interest in history. There were also albums of watercolours, which it was the fashion to leave lying about in one's drawing room; while works by pupils of Bonington and Decamps, and sketches sent by cousins serving as officers in Algeria or India, took their place beside the usual Scottish or Breton scenes and the flowers painted by the young ladies of the family. From 1830 on, the popular *Magasin pittoresque* often contained rather unsophisticated reproductions of Orientalist pictures and wood engravings illustrating fantastic tales. Then of course there was *Le Tour du Monde,* the splendid magazine that, from 1860 for some thirty years, carried on the tradition of the romantic travel albums with lithographs. The best of these artists were Bida and Crapelet. The illustrations were wood engravings made from sketches by travellers and from photographs. These articles were often collected in book form, like Rousselet's *L'Inde des Rajahs* (1875), *La Civilisation des Arabes* by Gustave Lebon (1884), and *Les Bords de l'Adriatique* by Charles Yriarte (1878), which, though nearer home, also had

its share of bashi-bazuks and minarets. These books, in their red and gilt bindings, provided the material for studio Orientalists. Germany and England had similar magazines, and traded articles with *Le Tour du Monde*. Jules Verne got ideas and material from it. The illustrations by Mathias Sandor for *Michel Strogoff* and *Round the World in Eighty Days* contain many Orientalist subjects. But *Le Tour du Monde* lost a great deal of its charm when photographs began to be reproduced; that, too, was the start of the era of the *monde fini*, the closed world defined by Paul Valéry, a world where there is steadily less scope for the imagination.

Some regions, like Andalusia and Greece, very quickly threw off their Eastern character, whereas in others, like Persia and Morocco, the process of Westernization is far from complete even now.

After three hundred years of Turkish domination, the Balkans had little to offer except picturesque folk traditions and a lot of ruins. Unfortunately the region, which was within such easy reach of the West, was made hazardous by brigands. Edmond About's charming book, *Le Roi des Montagnes,* illustrated by Gustave Doré, was not at all exaggerated. But then, during that period of insurrection, it was sometimes difficult to distinguish between the brigand and the hero.

To the serene and colourless Greece of the neo-classicists, Byron opposed the image of a modern, impoverished but colourful Greece. The corsair's daughter, Haidée, who sheltered Don Juan, seems to have stepped out of a Liotard pastel:

"She wore two jelicks – one was of pale yellow;
Of azure, pink and white was her chemise
'Neath which her breast heaved like a little billow.
With buttons form'd of pearls as large as peas.
All gold and crimson shone her jelick's fellow…
Her nails were touched with henna…."
(*Don Juan,* Canto III, 70; 75)

Delighted by this description, Corot painted a Haidée on a seashore that looks more like Brittany than a Greek island. These picturesque features were already discernible in Delacroix's *Greece Expiring on the Ruins at Missolonghi.* Greece, very close to the West yet already very Oriental, was dominated by the figure of Byron, dressed in Greek costume and soon part of a legend. According to that legend he was an intimate friend of the sumptuous and cruel pasha of Janina, who controlled the Balkans in the Napoleonic era and was finally subdued by the Porte after many intrigues and many massacres.

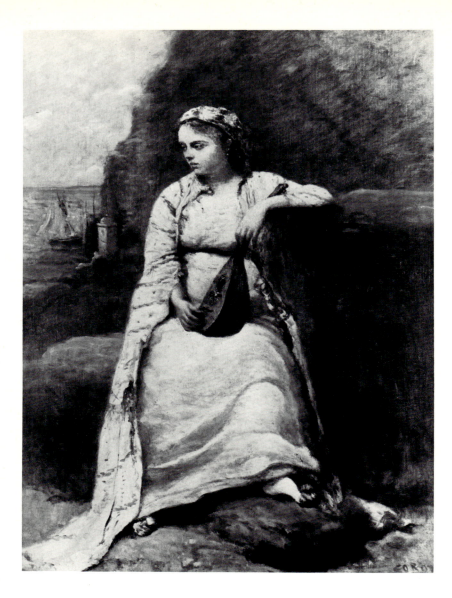

Camille Corot: Haidée, *c. 1870–72. Oil, 60 × 44 cm. Musée du Louvre, Paris. – A pale image of Byron's heroine.*

German artists came in the wake of the Prince of Bavaria, who ruled Greece as Otto I from 1833 to 1862. The most gifted of these was Peter von Hess, whose *Arrival of King Otto at Nauplia* is the most picturesque official painting one could wish for. He also decorated the gallery of the Hofgarten in Munich with large scenes from the Greek War of Independence. The watercolours which Karl Krazeisen brought back from the wars against the Turks, in which he served as an officer, are not unlike those by Louis Dupré and Carl Rottmann, who came in 1834 and painted Nazarene landscapes enlivened by figures in costume.

We must also mention Raphaello Ceccoli, who taught in the Athens School of Fine Arts from 1843 to 1852, and Vicenzo Lanza, two Italians who painted mainly ruins under a torrid sky, with the usual kilted figures in the foreground. The Greek painters of the War of Independence were generally delightful primitives, but King Otto sent the most gifted of his subjects to study painting in Munich, where they acquired superb craftsmanship and a strange nostalgia for the East. The best were Theodore Vryzakis, Nicephorus Lytras, a pupil of Piloty, the painter of historical subjects, Nicolas Ghyzis, whose canvases with their Decamps-style colouring became very famous in Munich, and finally Theodore Ralli, who exhibited successfully at the Salon and the Royal Academy. Besides Parisian-type scenes and landscapes, they all painted very attractive pictures of subjects drawn from the bazaars and villages where Turkish influence remained very strong.

In that very near East, the costumes attracted the artists much more than the rather uninteresting Islamic buildings. Louis Dupré did a very fine costume album of coloured lithographs in 1826, and as late as 1878 Yriarte's book on the Adriatic contained bashi-bazuks with pyramidal turbans, kilted brigands, and Montenegrins in embroidered costumes. The finest and bravest were the Albanian mercenaries, called Arnauts, who enrolled in Egyptian service. In 1893 the *Studio* published sketches made in Dalmatia by Joseph Pennel and nearly all derived from Orientalism.

"Spain is half African, Africa is half Asian," Victor Hugo wrote in the preface to *Les Orientales*. Two famous travellers, Byron and Chateaubriand – and no doubt many others – bore out this statement. Childe Harold and Don Juan went through Spain, as Byron himself had done. Chateaubriand lingered there with a mistress and brought back *Les Aventures du dernier Abencérage*. A little later, in *Almansor*, Heinrich Heine praised the charms of Islam compared with drab Christianity: "On the tower where the muezzin called to prayer there is now the melancholy tolling of church bells. On the steps where the faithful sang the words of the Prophet, tonsured monks are acting out their lugubrious charades...."

Passage after passage in Théophile Gautier's delightful *Voyage en Espagne* takes up the same subject. Spanish Orientalism always came back to the Alhambra in Granada, and travellers wrote little more than variations on Chateaubriand's famous lines describing the moment when he thought he could see the blood of the women executed through Boabdil's jealousy still staining the paving of the Court of the Lions: "Something voluptuous, something religious and something warlike seemed to breathe in this magnificent building; a kind of cloister of love, a mysterious retreat where the Moorish kings savoured every pleasure, and forgot all the duties of life."

When young Henri Regnault discovered the Alhambra in 1868, he went wild: "My divine mistress the Alhambra calls me: she has sent me one of her lovers, the sun, to let me know she has finished her preparations and is already beautiful and ready to receive me. I have to leave you. Allah, you are my God, and you, Mohammed, be praised, for you have inspired such incomparable marvels. I love you because you are the father of my darling adored Alhambra...."

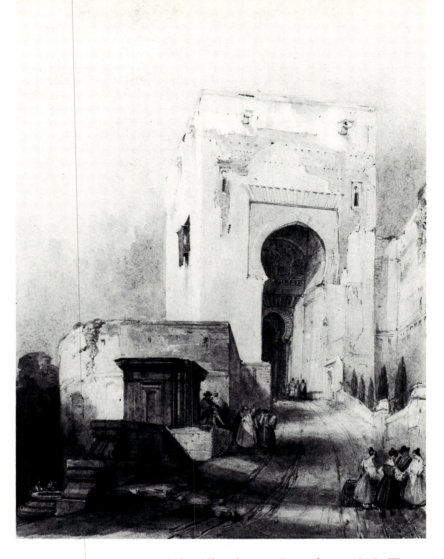

David Roberts: A Gate of the Alhambra at Granada, c. 1830. Water-colour, 27.6 × 19.3 cm. R.G. Searight Coll., London. – This Scottish stage-designer discovered the Orient in Andalusia.

The architecture of the Alhambra was the background of one of Regnault's large paintings, the *Summary Execution under the Moorish Kings of Granada*, and also featured in many less ambitious pictures. From 1830, each capital had its Alhambra, a theatre or a fun-fair that imitated it more or

less exactly. Moreau's Salome danced in the colonnades of the Alhambra. It became a highly popular building thanks to numerous engravings, like those illustrating the *Voyage en Espagne* by Baron Taylor, the thirty lithographs for Giroult de Prongey's *Les Monuments arabes et mauresques de Cordoue, Séville et Grenade,* and the more accurate ones executed after the many drawings made by David Roberts during his trip in 1826. Roberts became famous through his stage sets for Mozart's *Seraglio* and was called the Scottish Canaletto. John Phillips, another Scot, preferred contemporaneous Spain and went in for the kind of "Spanish fancies" that had brought success to Eugène Giraud, a Frenchman who had gone to Spain with Alexandre Dumas in 1847.

Alfred Dehodencq used his long visits to Andalusia and his study of Spanish painters, whose dominantly ochre and black colouring he adopted, as a preparation for Africa. He was more romantic at heart than might be thought from his rather realistic paintings: "Seville with its gorgeous architecture makes you think of the *Arabian Nights.*... I am looking at thousands of orange trees, thousands of Negroes, and Moorish columns as far as the eye can see; the water is splashing over the flagstones. What scents! What Eastern smells! And I shall have to wrestle with all this, this host of ideas, this muddle of pictures, and to bring out something that retains the dream and yet has the power of life."

Gautier might have been describing a Dehodencq painting when he wrote: "Cordova looks more African than any other town in Andalusia. You walk between interminable chalk-coloured walls, with only an occasional iron grille, and you meet no-one except a few unprepossessing beggars, and the odd devout figure in a black cloak, or perhaps a *majo* flying past on his brown horse with white harness...." Deep inside the Spaniard, thought Alfred de Vigny, there is still an Arab: "A Spaniard is an Oriental, he is a Catholic Turk, his blood either languishes or boils, he is a slave to indolence, ardour, cruelty...."

The work of Mariano Fortuny, a particularly brilliant painter, showed clearly that Andalusia could be considered African and Morocco a continuation of Spain. Fortuny was a Catalan born in 1838; he joined General Prim's expedition to North Africa in which Spain acquired Tetuan and part of the province of Tangiers in 1859. He fought as a soldier and admired the wild, picturesque, sometimes sordid mountain people of the Rif. His lively, sharp sketches with their emphatic blacks foreshadowed the superb engravings he was to do later. A whole section of his work was based entirely on the campaign: Moroccans playing with vultures, snake-charmers, fantasias, and executed malefactors. Another, purely Spanish part of his work is rather like Goya rethought by Meissonier. In Rome, where he was soon surrounded by a clique of Orientalist apprentices, Fortuny met Regnault and persuaded him to come to Spain and then to Morocco. In 1871 he had a studio in the Alhambra. Not content with painting and engraving, he chiselled weapons in the manner of the Moors. Then he returned to Rome with a collection of textiles and ceramics, and died there young, in 1874. We can get an idea of the atmosphere in which Fortuny worked if we visit the Palazzo Pesaro degli Orfei, which his son, a marvellous designer of fabrics, bequeathed to the city of Venice.

Mariano Fortuny: The Moroccan Executioner, 1870. Watercolour, 25.4 × 13.9 cm. R. G. Searight Coll., London. – Tangiers recalled by the great Spanish Orientalist.

For the European of the last century, Morocco meant Tangiers, a half-Jewish city, which had long been Portuguese, with some English influence due to the proximity of Gibraltar. Nobody ventured into the rest of the country, which was often in the throes of tribal wars and in which Christians were loathed, unless they accompanied an ambassador, as Delacroix did.

As soon as he caught sight of the white terraces of Tangiers, Delacroix took out his sketchbook and his little box of watercolours. Anyone who has travelled through Morocco, at least until quite recently, will find his own impressions mirrored in those sketches – the souks of Fez, Marrakesh on a feast day when the horsemen come down from the Atlas mountains, wrapped in their white wool cloaks. Delacroix was struck by the dignity of the Moors. The muscular, virile men who changed so swiftly from somnolence to violence were like the wild beasts he drew so often. As their religion forbade making any form of likeness they were not easily approachable. Delacroix even observed them in their baths, where black masseurs pummelled and stretched their bronze bodies under dark arches.

Of course, there could be no question of seeing a woman. The Jews were more hospitable, and the Dragoman of the Consulate, Abraham ben Chimol, introduced travellers to the women of his family. The sketchbook shows them, fat and comely, covered with jewels and silks, sitting on a divan like a row of idols or gossiping at the fountain. "The Jewish women are wonderful. I think it is difficult to do anything with them except paint them. They are the pearls of Eden." He went to a wedding where Arabs and Jews crowded round dancing-girls and dishes of couscous in the small courtyard of a rich house. The bride, covered with sequins, "her eyes closed, oblivious of everything going on around her,"

117

bothered Delacroix. Here the woman really was man's prey;
immediately the word "victim" came to him, not without a
thrill: "And the resigned sufferer is the victim sacrificed to
the curiosity of this rowdy audience."

Morocco, alone among the Algerian countries of the
Maghreb, had never known the degrading Turkish yoke, and
travellers were impressed by its originality, its character, and
its simple, majestic architecture. At the Salon of 1841, Pierre
Blanchard's "very dignified" picture of a *Funeral in Tangiers*
was highly praised. In 1845, Horace Vernet, who had pre-
viously found enough local colour in Algeria, came to
Morocco, and what he saw there struck him as far superior.
The Moroccan Orientalists distinguished themselves by
their sobriety. They preferred atmosphere to the picturesque
or pretty, the casbah to the bazaar. The fact that the
Moroccans had remained a free people accounted for this to
a great extent. We rarely find anything equivocal, as in
Turkey, effete, as in Egypt, or sordidly poor, as in Algeria.

The best of the "Moroccans" was Alfred Dehodencq, who
had married in Spain and often left his large family in Cadiz
while he went to stay in Tangiers, that enchanting green and
white city of Tetuan. He also visited such ports as Mogador
and Salé. Like Delacroix, he was unable to observe anything
closely except the customs of the Jews. Several of his *Jewish
Brides* are very good. His most characteristic painting was
the *Execution of a Jewish Woman* who had pretended to be
a convert to Islam. Dehodencq himself was nearly stoned
when he was sketching some scenes of violence like those

Eugène Delacroix: Moorish Conversation-Piece, *1832. Watercolour, 14×18.5 cm. The Metropolitan Museum of Art, New York. — A composition based on sketches made in Tangiers.*

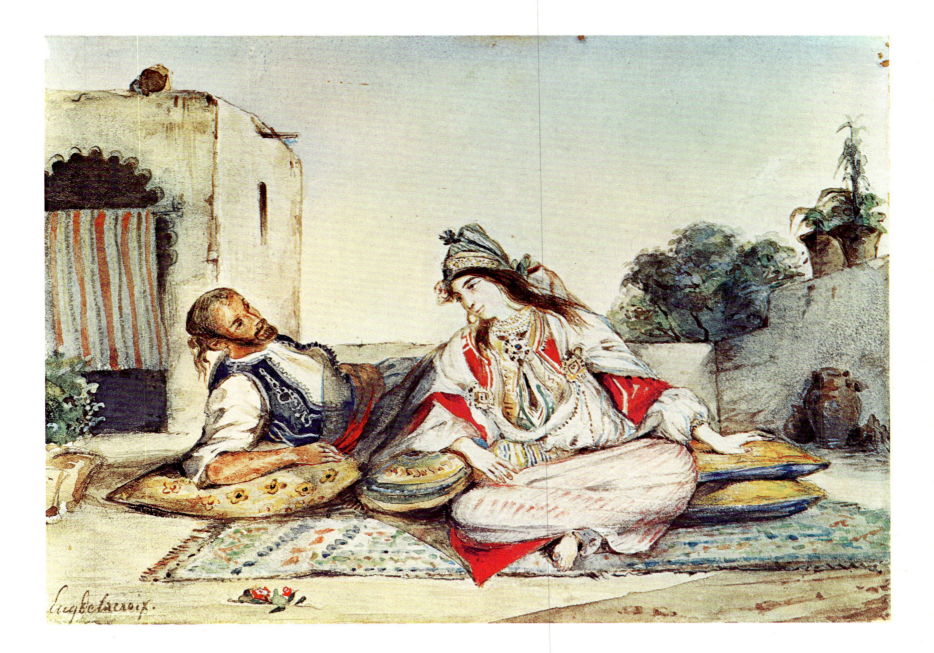

Henri Regnault: A Halt in the Desert, 1869. Oil, 41×58.5 cm. Musée Grobet-Labadié, Marseilles. – Like a Fromentin, but with more warmth. Painted on the outskirts of Tangiers.

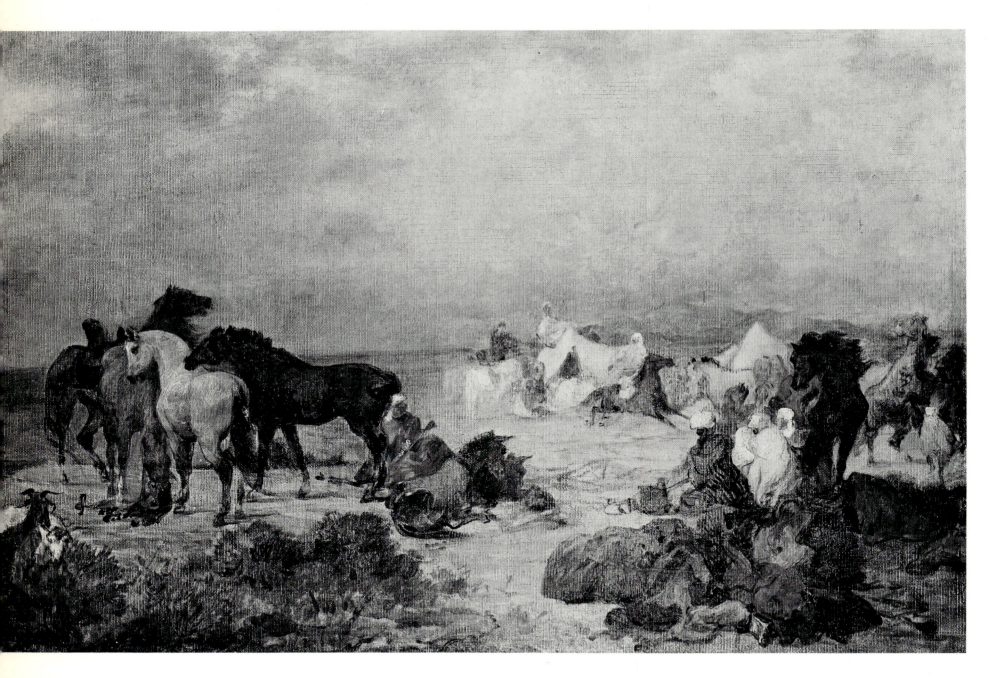

seen in Delacroix's *Convulsionaries at Tangiers*, 1836. Another famous picture, at the Salon of 1874, *The Dance of the Negroes*, showed the kind of mystic jugglers that can still be seen in the square of Marrakesh. Back in France, the painter wrote about this picture: "I can still hear the sound of the oboe and the charmer's flute; in dreams, I can still breathe in the smell – perfume to me – of old hay, butter, the dust that envelops you as soon as you set foot on Moroccan soil." All this hubbub can be seen in Dehodencq's ink drawings, which are covered with blots and scrawls but have very fine movement.

In the most ambitious pictures he sent to the Salon, this verve ran riot and turned into a gratuitous violence which displeased the public. Under the Second Empire, unctuous tints and graceful compositions were more popular. Mme Dehodencq begged her husband to forget the violence of Morocco; he listened to her and painted dull religious pictures and portraits of his family harking back to Spain.

Henri Regnault wanted to set up a sumptuous studio in Tangiers, like the one which his friend Fortuny had in Rome, and to live the carefree life of a real Moroccan. From this all too short spell nothing remains but a few watercolours and the *Summary Execution under the Moorish Kings of Granada*. This picture had a very great influence on Benjamin Constant, who went to Morocco in 1872.

Fortuny's influence brought Italians to Tangiers. Stefano Ussi and Cesare Biseo accompanied a diplomatic mission in 1875, of which Edmondo de Amicis, the writer, left a picturesque account. Carlo Bossoli spent all his youth in the

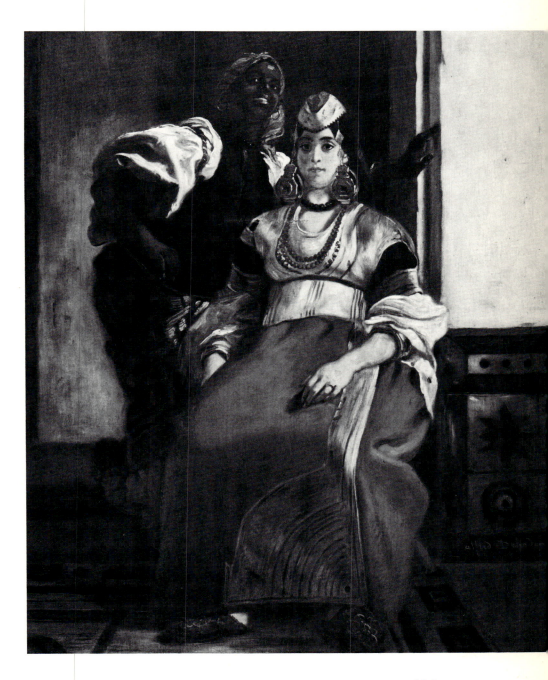

Edmé-Alexis-Alfred Dehodencq: A Jewish Bride in Morocco, c. 1870. Oil, 922×739 cm. Musée de Reims. – The influence of Delacroix can be seen here, except that the colours are heavier.

Crimea and brought back a mass of canvases in the manner of Decamps. Later he travelled to Morocco to refresh his memory, and he built a Moorish house in Turin. The Italian Orientalists came from Piedmont and Lombardy. The Neapolitan school, which was excellent in the nineteenth century, had all the local colour it needed on its doorstep and did not have to seek it in the Levant.

A lot of work was brought back from Morocco by a strange Englishman, a very gifted and rich connoisseur whose career — a great deal of it posthumous — was as bizarre as his name, Hercules Brabazon Brabazon. During visits to Tangiers in 1868 and 1884 and to Cairo in 1874, he accumulated a large quantity of watercolours, treated in a sweeping style not unlike that of Turner. Sargent, who admired him greatly, organized an exhibition in 1896 at which museums and collectors fought for his watercolours, but after the artist's death his family sold several thousand of them, and their value dropped from two or three hundred pounds to one or two.

Louis Comfort Tiffany, an American, H.J.E. Evenepoel, a Belgian, and Frank Buchser, a Swiss, were also attracted to Morocco in the wake of Delacroix.

As soon as General Liautey had restored order while fully respecting the traditions of the country, painters set up their easels in towns that had hitherto been forbidden. Only Lévy-Dhurmer brought back some really interesting work from there, very evocative in the Symbolist manner, going beyond the picturesque, the sunset glow on the walls of Marrakesh and street scenes of Rabat, white with mauve shadows and tightly closed houses. In the Thirties a rather eclectic group of artists settled in Morocco, including Majorelle, Edy-Legrand, a brilliant draughtsman, and François Louis Schmied, a book illustrator and lacquer artist.

Until 1830 Algeria contributed little more to Western painting than the inspiration for scenes of abduction by Berber pirates. There was a kind of thrill in the idea that these nuns and young girls would be sold to pashas, a delicious horror that did not diminish the proper sense of pious indignation. The French conquest, decided by Charles X and completed, not without difficulty, by Louis-Philippe and Napoleon III, led to profound changes. First of all, Louis-Philippe followed the monarchical tradition of appointing battle painters; together with the troops he sent out artists he knew from their work on the decoration of the gallery in the Palais Royal and some who were going to work on the "big stuff" in the Galerie des Batailles at Versailles. Then, very soon after the occupation of Algiers and the coastal towns, independent artists hurried out. From then on, the East was only three days from Marseilles.

Horace Vernet is as inseparable from the conquest of Algeria as Marshal Bugeaud: "He is a soldier who paints," Baudelaire said of him. His uniforms are exact to the minutest detail, his horses impeccable. Vernet was an excellent draughtsman, a rather severe painter, and marvellous at composition. His enormous (23 metres long) *Capture of Abd-el-Kader's Train by the Duc d'Aumale,* which has been exiled to Versailles for political reasons, attracted a lot of notice at the Salon of 1845. It has been rather unjustly accused of consisting of a series of anecdotes. The colour, in the dominant ranges of red and ochre, would alone suffice to give unity to the enormous confusion of a camp surprised by the enemy. The king's favourite painter, Vernet abandoned teaching at the Villa Medici to follow the army of occupation in 1833. In Algiers he ran into his friend Wyld. Within ten days he had three subjects for the planned Algerian room at Versailles. "I have made sketches, the King will

122

seen in Delacroix's *Convulsionaries at Tangiers*, 1836. Another famous picture, at the Salon of 1874, *The Dance of the Negroes*, showed the kind of mystic jugglers that can still be seen in the square of Marrakesh. Back in France, the painter wrote about this picture: "I can still hear the sound of the oboe and the charmer's flute; in dreams, I can still breathe in the smell – perfume to me – of old hay, butter, the dust that envelops you as soon as you set foot on Moroccan soil." All this hubbub can be seen in Dehodencq's ink drawings, which are covered with blots and scrawls but have very fine movement.

In the most ambitious pictures he sent to the Salon, this verve ran riot and turned into a gratuitous violence which displeased the public. Under the Second Empire, unctuous tints and graceful compositions were more popular. Mme Dehodencq begged her husband to forget the violence of Morocco; he listened to her and painted dull religious pictures and portraits of his family harking back to Spain.

Henri Regnault wanted to set up a sumptuous studio in Tangiers, like the one which his friend Fortuny had in Rome, and to live the carefree life of a real Moroccan. From this all too short spell nothing remains but a few watercolours and the *Summary Execution under the Moorish Kings of Granada*. This picture had a very great influence on Benjamin Constant, who went to Morocco in 1872.

Fortuny's influence brought Italians to Tangiers. Stefano Ussi and Cesare Biseo accompanied a diplomatic mission in 1875, of which Edmondo de Amicis, the writer, left a picturesque account. Carlo Bossoli spent all his youth in the

Edmé-Alexis-Alfred Dehodencq: A Jewish Bride in Morocco, c. 1870. Oil, 922 × 739 cm. Musée de Reims. – The influence of Delacroix can be seen here, except that the colours are heavier.

121

Crimea and brought back a mass of canvases in the manner of Decamps. Later he travelled to Morocco to refresh his memory, and he built a Moorish house in Turin. The Italian Orientalists came from Piedmont and Lombardy. The Neapolitan school, which was excellent in the nineteenth century, had all the local colour it needed on its doorstep and did not have to seek it in the Levant.

A lot of work was brought back from Morocco by a strange Englishman, a very gifted and rich connoisseur whose career — a great deal of it posthumous — was as bizarre as his name, Hercules Brabazon Brabazon. During visits to Tangiers in 1868 and 1884 and to Cairo in 1874, he accumulated a large quantity of watercolours, treated in a sweeping style not unlike that of Turner. Sargent, who admired him greatly, organized an exhibition in 1896 at which museums and collectors fought for his watercolours, but after the artist's death his family sold several thousand of them, and their value dropped from two or three hundred pounds to one or two.

Louis Comfort Tiffany, an American, H.J.E. Evenepoel, a Belgian, and Frank Buchser, a Swiss, were also attracted to Morocco in the wake of Delacroix.

As soon as General Liautey had restored order while fully respecting the traditions of the country, painters set up their easels in towns that had hitherto been forbidden. Only Lévy-Dhurmer brought back some really interesting work from there, very evocative in the Symbolist manner, going beyond the picturesque, the sunset glow on the walls of Marrakesh and street scenes of Rabat, white with mauve shadows and tightly closed houses. In the Thirties a rather eclectic group of artists settled in Morocco, including Majorelle, Edy-Legrand, a brilliant draughtsman, and François Louis Schmied, a book illustrator and lacquer artist.

Until 1830 Algeria contributed little more to Western painting than the inspiration for scenes of abduction by Berber pirates. There was a kind of thrill in the idea that these nuns and young girls would be sold to pashas, a delicious horror that did not diminish the proper sense of pious indignation. The French conquest, decided by Charles X and completed, not without difficulty, by Louis-Philippe and Napoleon III, led to profound changes. First of all, Louis-Philippe followed the monarchical tradition of appointing battle painters; together with the troops he sent out artists he knew from their work on the decoration of the gallery in the Palais Royal and some who were going to work on the "big stuff" in the Galerie des Batailles at Versailles. Then, very soon after the occupation of Algiers and the coastal towns, independent artists hurried out. From then on, the East was only three days from Marseilles.

Horace Vernet is as inseparable from the conquest of Algeria as Marshal Bugeaud: "He is a soldier who paints," Baudelaire said of him. His uniforms are exact to the minutest detail, his horses impeccable. Vernet was an excellent draughtsman, a rather severe painter, and marvellous at composition. His enormous (23 metres long) *Capture of Abd-el-Kader's Train by the Duc d'Aumale,* which has been exiled to Versailles for political reasons, attracted a lot of notice at the Salon of 1845. It has been rather unjustly accused of consisting of a series of anecdotes. The colour, in the dominant ranges of red and ochre, would alone suffice to give unity to the enormous confusion of a camp surprised by the enemy. The king's favourite painter, Vernet abandoned teaching at the Villa Medici to follow the army of occupation in 1833. In Algiers he ran into his friend Wyld. Within ten days he had three subjects for the planned Algerian room at Versailles. "I have made sketches, the King will

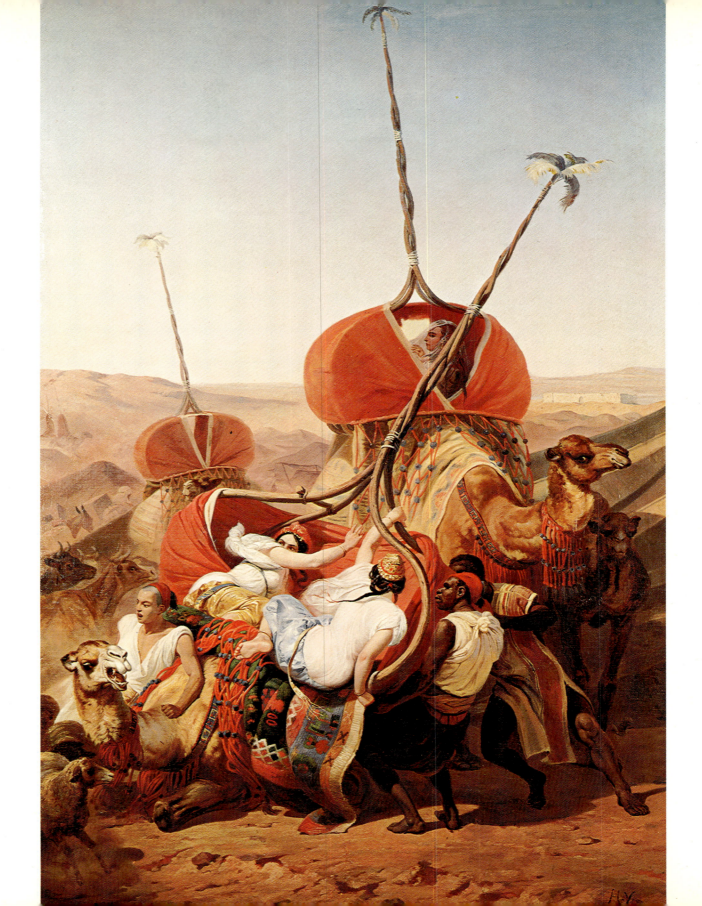

Horace Vernet: The Capture of Abd-el-Kader's Train by the Duc d'Aumale: the "Attatichs", *1845. Oil, 135×88 cm. Naguib Abdalla Coll., Paris. – A study for the huge painting in the Musée de Versailles.*

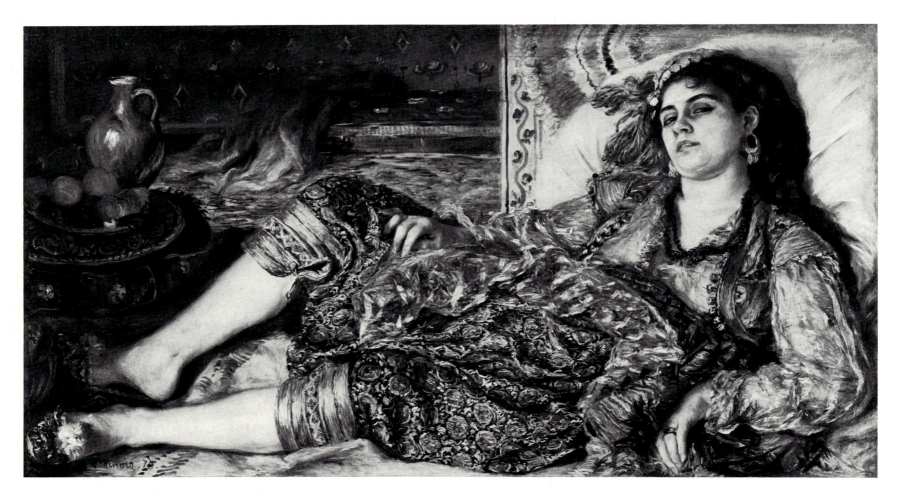

Auguste Renoir: Odalisque, *1870. Oil, 69.2×122.6 cm. The National Gallery of Art, Washington, D.C. (Chester Dale Collection, 1962). A tribute to Delacroix.*

choose," he wrote to his wife. His letters were not stylish, but lively and torn between horror (The Siege of Constantine) and admiration (he, too, felt something biblical in the atmosphere). He was one of the first to appreciate the glamour of the Arabs. In an ambush he admired General

Yūsuf: "My man took off his coat, jumped on a splendidly harnessed large white horse, his arms bare up to the shoulders and laden with gleaming gold weapons, his eyes sparkling, a fresh wound on his handsome young face. From that moment I did not leave my hero. If I had been a woman, my

Alphonse-Etienne Dinet: Moonlight at Laghouet, 1897. Oil, 465 × 728 cm. Musée de Reims. – The somewhat equivocal sensuality of Dinet's pictures contributed to his long-lasting success.

virtue would have been in serious danger. As it was I made drawings of him from the front, from the back, from above, from below...."

In the *Mass in Kabylia* of 1852, Vernet set out to illustrate the effort Napoleon III was making to reassure opinion. This earned him a general's treatment with military honours. His *Capture of Bougie* and *Battle of Isly* flattered Fench chauvinism. His reputation was such that the Tsar invited him to spend two years in Russia. Vernet had many imitators, like Eugène Ginoin and Captain Théodore Leblanc, whose

Henri-Jacques-Edouard Evenepoel: The Orange Market at Blida, *1898. Oil, 81×125 cm. Musées royaux des Beaux-Arts de Belgique, Brussels. – This Belgian pupil of Gustave Moreau's went to Algeria in search of colour.*

sketches, enhanced by watercolours, might have been taken for Delacroixs if the details in ink had not deprived them of all spontaneity. Leblanc, a pupil of Charlet, was killed at the siege of Constantine.

Dauzats, much more than Vernet, appreciated the grandeur of the Algerian countryside, where resistance was being organized. He accompanied the Duc d'Orléans, who succeeded in crossing the gorge of the Iron Gates in the Djur-

djura range. A painting (Salon of 1853) and lithographs illustrating an account by Charles Nodier commemorated that exploit. Dauzats was the first to paint the mosque in the harbour of Algiers, which was to be such a popular subject until Marquet. Raffet did numerous lithographs to glorify feats of French arms, thus rounding off his famous earlier series of Bonaparte in Egypt. We must also mention Félix Philippoteaux, a mediocre painter of military subjects, who did rather better with indigenous models. The commentary on an engraving after his *Shopping Booth in Algiers* published in *l'Artiste* in 1841 is characteristic of the relationship between the mother country and the new colony: "This is one of the last representatives of the old-style shopkeepers, always grave and silent; gradually this kind of face is disappearing, the nomad dealers are adapting to the use and custom of the civilizing trousers. M. Philippoteaux reminds us of General Bugeaud's prisoners; there we had the same dark, contemptuous immobility...."

The picturesque had to be grasped quickly, before it disappeared. Théophile Gautier wrote about William Wyld: "He was one of the first to rush out, armed with a palette, to the Moorish shores when Algiers was still aglow with all its barbarian sparkle, and the whole town had that Moorish air which now has to be sought on the heights of Sidi Mohamed Scheriff." In collaboration with Lessore, Wyld brought out the *Voyage pittoresque dans la Régence d'Alger* in 1835. He arranged for Delacroix to meet the courtesans who posed for the *Women of Algiers.*

The whiteness of Algiers entranced Chassériau: "The town is white like stucco and marble; the horizon pink and bluish; above the sea, the blue sky, light, a little opalescent. Old men with curious Oriental faces seen against white walls; children with a pure beauty, their colouring rosy and

William Wyld: Algerian Shops, 1833. Gouache, 29 × 46 cm. Nicolas Clive Worms Coll., Paris. — A picturesque scene based on accurate records, typical of the Anglo-French watercolour school stemming from Bonington.

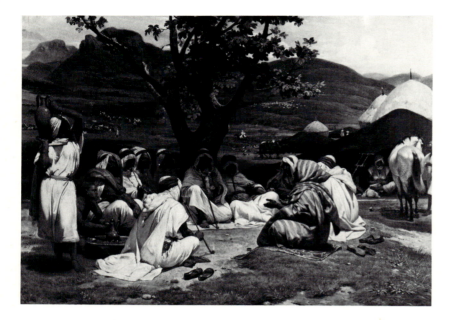

Horace Vernet: Arab Story-Teller, *1833. Oil, 100×138 cm. Wallace Collection, London. – Homer among the Berbers.*

pale; white houses, often in half-tints with silvery and golden tones; the beams that hold up the buildings sometimes blackened, and that dark contrast sets off the whole.''

At the invitation of the Caliph of Constantine, Chassériau spent the spring and July 1846 in Algiers, a short enough stay when we consider the important place Algeria has in his work. Like Delacroix, he filled notebooks with watercolours, studying particularly the Jewish women. The Algerian women were as unapproachable as the Moroccan ones.

At that time Eugène Fromentin was also in Algeria; he had gone there in 1846, simply for the wedding of a friend's sister at Blida. The young bourgeois of La Rochelle – he was 23 – was immediately captivated by the place and decided to return as often as possible. In 1847–48 he stayed for a long time at Biskra, then at Constantine. In 1853 he and his wife settled at Biskra for several months. From the moment Fromentin sent his works to the Salon, he took the lead of the second generation of Orientalists, who preferred simplicity to the picturesque. He had no fewer than five canvases at the Salon of 1859: *The Audience with the Caliph* seemed to have a biblical grandeur because of its monumental buildings. The *Bab-el-Ghardi Street at El Agouhat,* so highly praised by Baudelaire, expressed all Fromentin's pessimism and fatalism; he is in sympathy with his models, who so easily forget their troubles in sleep. This melancholy pervades most of Fromentin's work and accounts for much of its success. His characters, even when racing or hunting, have a kind of sadness: they just pass through life, and this more than the lack of the picturesque could have rebuffed customers at the Salon. The execution was skilful and the subjects conventional, but Fromentin's Algerian women are much more Arab than those painted by his contemporaries.

Much of Guillaumet's work was derived from the austere, luminous *Bab-el-Ghardi Street at El Agouhat;* he was twenty years younger than Fromentin and he, too, wrote well about Algeria. He left for Rome, changed his plans on a sudden whim, embarked at Marseilles, and fell so deeply in love with Algeria that he went back there at least ten times. Although his health was ruined by malaria, he settled in the poorest places, and became a sort of minor Millet. His *Prayer in the Sahara,* more severe even than Fromentin's work, was very successful at the Salon of 1863. Today it hangs in the Palais de Justice in Lyons. Several of his works had places of honour in the Musée du Luxembourg. Exotic poverty, which did not necessarily exclude brilliant colour-

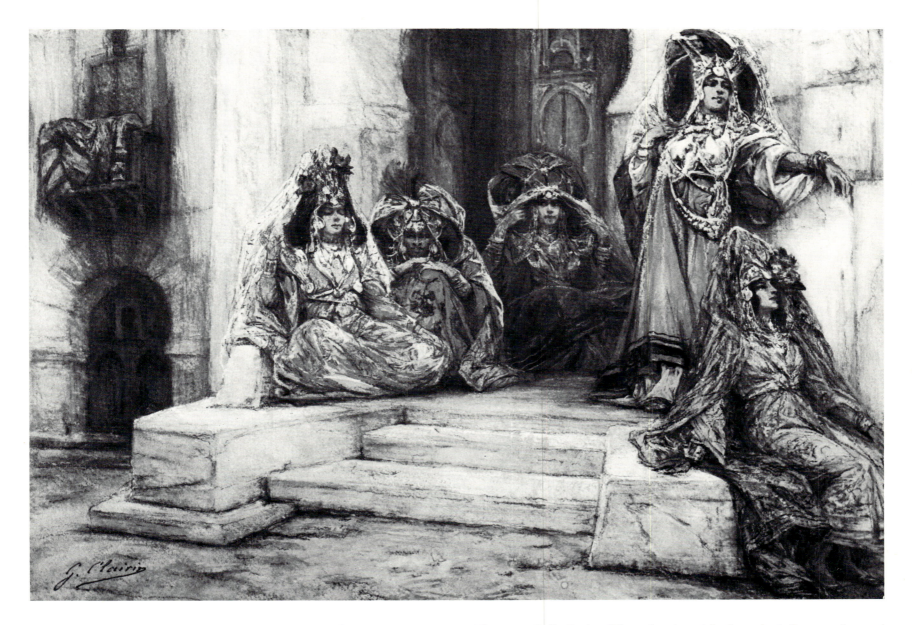

Georges Clairin: Ouled Nail Women, c. 1895. Gouache, 36×48 cm. Lynne Thornton Coll., Paris. — These dancing-girls show the influence of two of the painter's friends: Henri Regnault and Sarah Bernhardt.

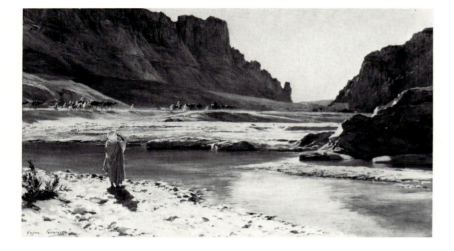

Eugène-Alexandre Girardet: The Wadi, *c. 1880. Oil, 66×106 cm. Private coll. – Greatly influenced by Guillaumet.*

Gustavo Simoni: Caravan in Tunisia *(detail), 1885. Oil, 36.8×54.6 cm. R.G. Searight Coll., London. – Photographic accuracy.*

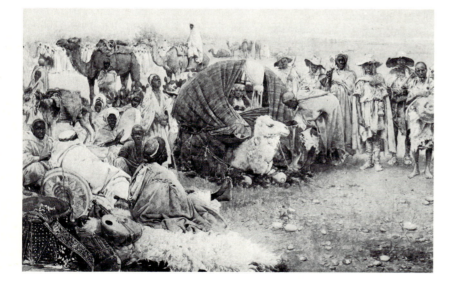

ing, was beginning to win disciples at a time when the first flush of conquest was over and there was a growing interest in the local population.

When Algiers became a large French city with its own Ecole des Beaux-Arts and its own museums, it attracted many official artists, e.g., Marc-Alfred Chataud, who is considered the founder of the School of Algiers. He took up Regnault's subjects in a softer manner. But gradually Algiers had nothing further to offer to modern painting and only provided landscapes and other subjects for a lot of minor painters. By 1900 it was permissible to smile at these lines by Théophile Gautier: "Utilitarian spirits might say that Algeria is useless and unprofitable for France. Those of us who are not economists love it for what it has given to art. It has brought a new element. The journey to Algeria has become as indispensable to painters as the pilgrimage to Italy. There they will learn about the sun, study the light, find original characters, customs, and primitive, biblical attitudes." (*Abécédaire* of the Salon of 1861)

Impressionists continued to go to Algeria, but this did not make them Orientalists. Lebourg painted Algiers as he would have painted Le Havre. Jean Seignemartin, a young man from Lyons who died in Algeria, painted sensitive landscapes, without picturesqueness, seeking neither to teach nor to amuse. Only Renoir approached Orientalism by its easiest features. He paid a long visit to Algiers in 1879, perhaps driven by his admiration for Delacroix.

Most of the painters who were belatedly influenced by Algeria were charming and bizarre rather than great. A.-E. Dinet deserves a place apart: after an initial journey with Lucien Simon, he settled in 1882, was converted to Islam and, after the pilgrimage to Mecca, was known as Hadj Nasr Ed Dine Dini. He died in 1929 and was buried at Bou

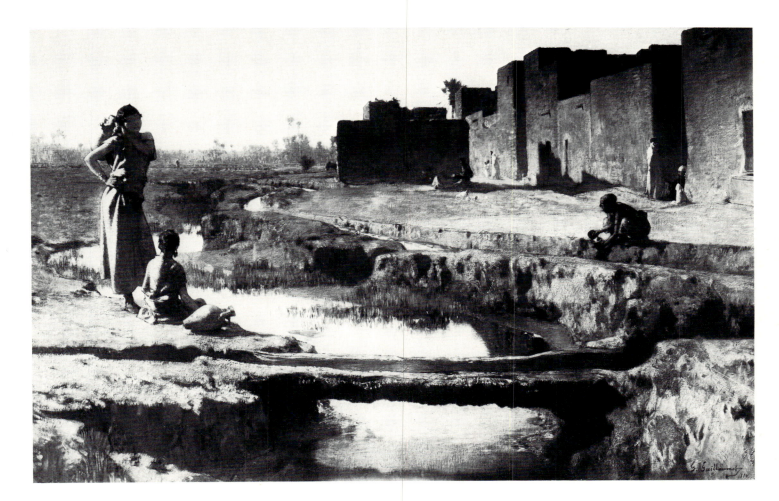

Saada, where he had lived for many years. His paintings are generally bathed in the mauve shades of tropical nights; lovers embrace in the shade of palm trees, barely nubile girls titillate handsome dignitaries on the terraces. These are variations on *Moonlight at Laghouat*, the success at the 1888 Salon, which determined his genre. But he also painted views of the desert and violent scenes from Islamic legends, like *The Revenge of Antar's Children*. Around 1910, when

Gustave Guillaumet: The Seguia-Biskia, Landscape, *c. 1870. Oil, 100× 155 cm. Ancien Musée du Luxembourg, Paris. – Biblical simplicity rediscovered in Algeria.*

Dr Mardrus's translation of the *Arabian Nights* had revived the fashion for the East, he illustrated several books for the publisher Piazza.

131

The numerous dancing girls in Algerian paintings belonged to the Ouled Nail troupe; decked in light gauze and heavy jewellery, they had been a great success at the Exhibition of 1900. Clairin, who discovered North Africa through Morocco, stayed several times in Algeria and exhibited his portraits of dancing girls. Rochegrosse's Eastern scenes were more like the sphinx of Rue de Provence than the one guarding the pyramids. And yet he knew North Africa very well, had taken part in excavations on the site of Carthage when he was illustrating *Salammbô,* and died at Algiers in his house, which was decorated with ceramics and marble basins. He was very impressionable and retained the brilliant colouring of that exotic world, but his composition sometimes was strange. His Algerian scenes were like these notes made by the Goncourt brothers on their arrival in Algiers towards the end of the Second Empire:

"The Eastern profligacy of the most clashing and most brilliant colours… this kaleidoscope of human clothes… the Arab wrapped in his white burnous, the Jew in his pyramidal headdress, the Moorish woman a white ghost with gleaming eyes, the Negro in his yellow madras and blue striped shirt, the Moor in a skull cap with a blue tassel, a red vest, white pants and yellow slippers, children dressed to the nines in velvet and gold, the rich Turk in a kaftan glittering with embroideries…."

This is the rather over-ripe Algeria discovered by Tartarin. In a few lines about Algeria, Albert Besnard, who went to North Africa in 1894, defined what a Symbolist Orientalism might have been like: "I remember Algiers, with its blood-red clay after the November floods, its blue, steely blue, vegetation, and its blue sea too, but dark blue, like the pupils of a blonde who wants to make love. Everywhere nature's daring harmonies are triumphant. The mornings are pinker than at home, the evenings more violet. The white of the walls, under a thousand glints, blazes in full blue; and the *koubas,* which seem to have been coated with a luminous milk, seen through the leaves of the olive trees look like pale stars. The landscape appears to have been embroidered on the sky, which can sometimes be so delicately coloured that you would think it was a shred of satin."

This was also the way Maurice Denis saw Tunisia. Tunisia, which did not become French until 1885, was smaller and less picturesque than Algeria and attracted few painters, except Cottet and Crapelet. The former, who subsequently specialized in costumed Breton women, showed black-clad Arab women in cemeteries. Crapelet left some drawings and watercolours of the old town of Tunis, one of the most noteworthy in the Arab world. He was one of a team working for *Le Tour du Monde.* There was also Paul-Albert Laurens, who accompanied André Gide to Tunisia in 1893 and made drawings of their boy friends.

Of all the countries that attracted painters in the nineteenth century, Egypt was by far the most popular. There were many reasons for that: the climate, the Nile valley, and the desert, the splendour of old Cairo, the ruins of the Pharaohs and the fine-looking hospitable people were certainly an attraction; but in addition travellers found better facilities there than in any other Moslem country. From 1840, there were good hotels in Cairo; from 1868, Cook's tours went as far as Aswan; and the government called in many Europeans to modernize the country. The dynasty founded by Muhammad Ali, a Macedonian who came to power after the British had driven out the French, had some outstanding members, and one of the most illustrious, the Khedive Ismail, supported the building of the Suez Canal. Politically Egypt, the main stop on the way to India, remained under England, but culturally it looked to France. Louis-Philippe sent several missions there; the one Dauzats accompanied, directed by Baron Taylor, was sent to supervise the transportation of an obelisk from Luxor.

In 1820, the British were in a hurry to reach the Red Sea and took the overland route through Cairo; Alexandria, thanks to the export of cotton, became one of the foremost Mediterranean ports with a society of many peoples under the general label of Levantines. Many artists settled in Cairo for months, sometimes years, like J.F. Lewis, Gérôme, and L.K. Müller. The domain of Egyptian Orientalism is so vast that we have to divide it into three regions: Cairo, for the lovers of the picturesque, Upper Egypt with the Nile and the desert for the thinkers, and briefly, but actively, the region of Suez, when the engineers were working on the Canal.

Despite chaotic modernization, incredible filth, and shocking demolition, Cairo, which is reminiscent of both New York and Marrakesh, can still have moments of breath-

John Frederick Lewis: A Story-Teller in Cairo, *1856. Watercolour, 45 × 58.4 cm. R.G. Searight Coll., London. – The artist's success was based on charm, a feeling for the picturesque, and painstaking detail.*

taking beauty. Today's tourist who surveys it from the top of the citadel might say like Flaubert: "From here I have Cairo below me: to the right, the desert with camels gliding over it, escorted by their shadows; opposite, beyond the meadows and the Nile, the Pyramids. The Nile is dotted with white sails; the two crossed sails spread like two huge wings make the boat look like a swallow in flight. The sky is a cloudless blue. The sparrow-hawks are wheeling over our heads. The liquid light seems to flow into the core of things."

After visiting the necropolis of the caliphs, we might say, like Fromentin in 1869: "These great mute monuments,

133

William James Muller: The Carpet Bazaar at Cairo, 1843. *Oil, 62.2 × 74.9 cm. The City Art Gallery, Bristol. – One of the best English Orientalists.*

deserted, a little more gilded than the sun, darker when the sun casts shadows, lighter when the oblique rays fall on them. These marvels reveal a flawless taste, with their walls striped a faded red, their inlaid domes, the few minarets delicately notched against the sky, these bear the most beautiful witness to the flowering of Arab genius."

David Roberts, a Scot, had put down very similar thoughts in his diary twenty years earlier when he was painting the burial mosques with their lacy minarets and egg-shaped domes in the reddish light of a sandstorm. The few

streets in Cairo that have survived more or less intact round the bazaar and going down from the Citadel, with their overhang, their lattices, the coming and going of donkeys and handcarts, are the photographer's delight. They have tempted countless painters from the beginning of the Victorian era, some of them, like John Varley and Henry Wallis, meticulous watercolour artists anxious mainly to copy the architectural features; Varley, the son of the famous Romantic watercolourist, also exhibited oil paintings during the last third of the century at the Royal Academy: views of Cairo and of the Alexandria Canal, etc.

The best English Orientalist, John Frederick Lewis, lived – according to his friend Thackeray – the life of a lotus-eater in Cairo from 1842 to 1851. At first a watercolour artist, Lewis had a fabulous success with *The Harem* at the Watercolour Society in 1850. When he turned to oils, Ruskin praised him: "Labour thus concentrated in large purpose, detail thus united into effective mass has not been seen till now." Lewis reproduced so minutely the lattice-work of the *moucharabiehs*, the embroideries on the kaftans, the embossing on weapons, that he has been associated with the Pre-Raphaelites although he was their senior and had no connexion with the brotherhood. But just as the *Belles Dames sans Merci* and the *Ladies of Shalott* painted by the Pre-Raphaelites were and remained first and foremost Victorian ladies in medieval costume, so Lewis's sultanas were keepsake figures, Covent Garden dancing-girls like those drawn by Edward Chalon, young people from Belgravia preparing for an Oriental fancy-dress party. His street scenes were closer to reality.

David Roberts did six splendid albums of Islamic architecture taken from all parts of the Near East. He obtained permission to paint inside mosques after he had given an assur-

ance that his brushes did not contain a single pig's hair. In 1838 he went up the Nile as far as Ethiopia and then explored Palestine dressed as an Arab. The English artists found it hard to resist the temptation to go native, to exchange their top hats for turbans and their boots for slippers: they settled in Arab quarters, bought slaves, smoked hashish and were able to indulge tastes that were unacceptable in their home country.

Henry Wallis, famous for his *Death of Chatterton,* was very close to the Pre-Raphaelites. He returned from Cairo with street scenes which were extremely exact but had neither Lewis's vitality nor Roberts's colouring. Old Cairo also inspired the best Austrian Orientalist, Leopold Karl Müller, who spent several years painting scenes from the life of the common people: the most famous of them, *The Market in Cairo,* though well drawn and richly coloured, was spoilt by excessive detail. That large picture was soon reproduced and brought him many commissions, especially from England. In 1872, he persuaded Lenbach and Makart, two much more famous painters, to come to Egypt. Makart, who took himself for another Rubens (and he did have the same verve and sense of splendour) went there with a princely suite, a whole caravan; he brought back his renowned *Cleopatra.*

Many painters were inspired by the colourful crowds, the dervishes, the camels laden with carpets, and to foreigners these were quite overwhelming on feast days, as in the procession of the *Mahmal* which Makovsky painted in 1870 and Deutsch in 1909. Ludwig Deutsch with his anecdotal, highly polished, almost photographic work, was a sort of Meissonier of Old Cairo.

Prosper Marilhat based many of his paintings on Cairo, although he spent only a few months there in 1833. A pupil

Charles-Emile-Hippolyte Lecomte-Vernet: A Fellah Woman, *1872. Oil, 60×42 cm. Galerie Tanagra, Paris. – The beauty of Egyptian women, set off by their black garments, delighted travellers in the 1870s.*

135

of the easy-going Roqueplan, he had a forcefulness in drawing and a sharpness in painting that sometimes surpass Decamps. Théophile Gautier admired him: just to look at one of Marilhat's paintings made him want to live in the East. Izbekieh Square, which became a huge pond during the floods of the Nile, inspired one of his best pictures. Much later, around 1900, Emile Bernard, a disappointed Symbolist, lived in Cairo and tried to revive Orientalism by imitating the Venetian masters. Cairo contains one of the shrines of Orientalism, the palace of Prince Muhammad Ali, a pastiche of every Arab style; decorated with canvases bought at the Salon, including very colourful Clairins in Arab-style heavy gilt frames.

The desert started at the gates of Cairo. The pyramids and even more the sphinx, which the Arabs called "the father of terror", impressed painters and writers. Fromentin wrote on the Suez road: "Wide spaces, bogs, barges along the way. The Nile vast and calm, a real mirror from 300 to 400 yards wide…. No uniform colouring anywhere, green shading to grey, the tawny blue of the river, the delicate blue of the sky. All the fellahin dressed in black or brown. A completely naked fellah is giving a buffalo a bath."

The fellahin, the splendid Egyptian type surviving from the days of the Pharaohs, inspired painters who rejected the facile picturesqueness of the bazaar. Holman Hunt gave the fellah woman, draped in black, in his *Afterglow in Egypt* the kind of sensual dignity with which the Pre-Raphaelites invested their biblical heroines. As for Gautier, he sought the more mysterious goddess:

L'antique Isis légua ses voiles
Aux modernes filles du Nil;

Mais sous le bandeau deux étoiles
Brillent d'un feu pur et subtil.
(Emaux et Camées)

[Ancient Isis bequeathed her veils to the modern daughters of the Nile; but under the headband two stars shine with a pure, subtle fire.]

Gleyre, a Genevese, spent the whole of 1836 in Upper Egypt; he thought he had rediscovered the Garden of Eden. The Nubian women he painted certainly did not wear any more than Eve. In a bizarre picture called *Egyptian Modesty* he showed a young woman bather covering her face before an Arab horseman while her body remained naked. Gleyre did numerous watercolours of the temples at Denderah and fine studies of fellahin at Karnak. His diary is a valuable source for the difficulties encountered on the journey. The first one he lists is unexpected: "It's impossible to find a place where you escape from the company of painters. There are at least a dozen of them here, all bursting with talent, at least by their own account; they have spoilt Cairo for me." Muhammad Ali isn't very formidable: "A little old man. His eyes and figure are anything but heroic, exceptionally lively, humorous eyes, his nose a bit wandering, a fine white beard, carefully combed; he was dressed very simply, a white turban, a grey lined robe…." At Abydos, downstream from Denderah, Gleyre had the experience on which he based his famous classical painting, *Lost Illusions*. He wrote at Aswan: "Must remember a little girl from Philae who crossed the Nile on planks." When he reached Abu Simbel: "What peace, what silence! The wide river is flowing majestically. The palm trees wave their dishevelled heads gracefully. The softened shapes of the temple mountain have something imposing tonight…." Gleyre drew the temples,

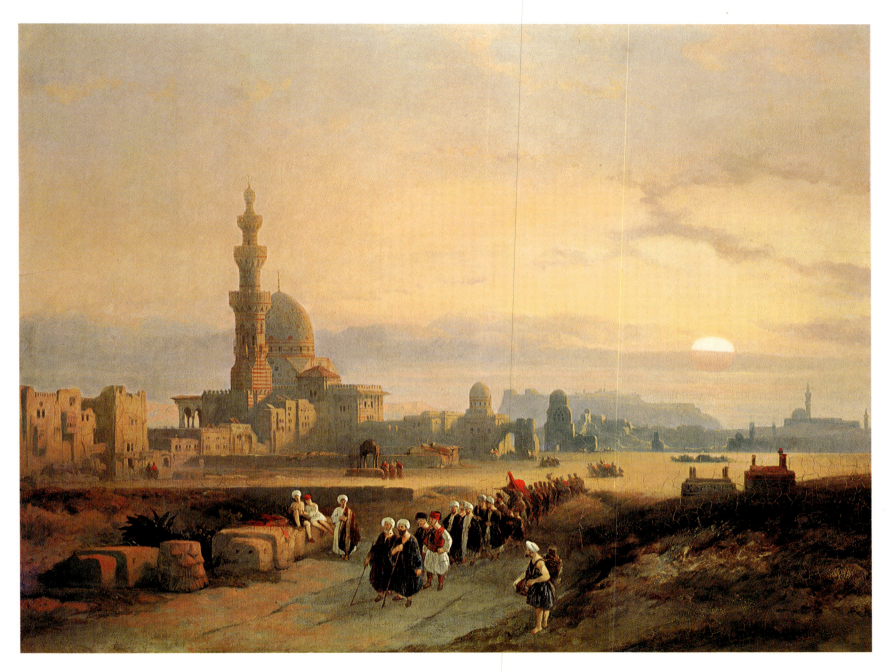

David Roberts: A Procession Passing the Tombs of the Caliphs in Cairo, *1846. Oil, 69.5×91 cm. Private coll. – The mausoleums on the edge of the desert are steeped in what Flaubert called "a sooty film".*

killed a hyena, and from time to time complained at having nothing but raw onion in his soup: "The arid black mountains of Nubia seem to be permanently covered by a dark veil. Oh, beautiful Italy!..." He came back very poor, sick, and would have lost his sight as a result of ophthalmia if his monkey had not licked his eyes right up to the moment when he could get to a doctor in Beirut. There he was taken in by another painter, d'Etouilly, who promptly died of typhoid fever. Gleyre finally came back through Leghorn "in a state a thousand times worse than that of the Prodigal Son," who inspired one of his pictures. As we can see, romantic journeys needed robust health. Flaubert, who made more or less the same trip fifteen years later, also came back sick, but probably as a result of his erotic adventures. He had met the painter in Lyons before setting off.

The Suez Canal, finally, brought quite a number of artists to Egypt. Lesseps had been consul in Alexandria in 1837, and Père Enfantin had brought out Saint-Simonian engineers. Draughtsmen like F.-P.-B. Barry and Narcisse Berchère, who wrote *Le Désert de Suez,* were attached to the team of engineers while the Canal was being built. Many were invited to the splendid inauguration festivities in November 1869 by the Khedive Ismail, who bankrupted himself to receive the Empress Eugénie, the Austrian Emperor, and a fair number of princes and ambassadors. The festivities at Persepolis in 1972 can give us an idea of those

Marc-Gabriel-Charles Gleyre: Egyptian Modesty, *c. 1838–39. Oil, 77×63 cm. Musée cantonal des Beaux-Arts, Lausanne. – A thoroughbred, ruins, slaves, and a palm-tree – these ingredients contribute to the success of one of the painter's early canvases.*

Prosper Marilhat: Ruins of the El Hakem Mosque in Cairo, *1840. Oil, ▷ 84×130 cm. Musée du Louvre, Paris. – The picturesque quality of this fine work is matched by the architecture and the sense of desolation.*

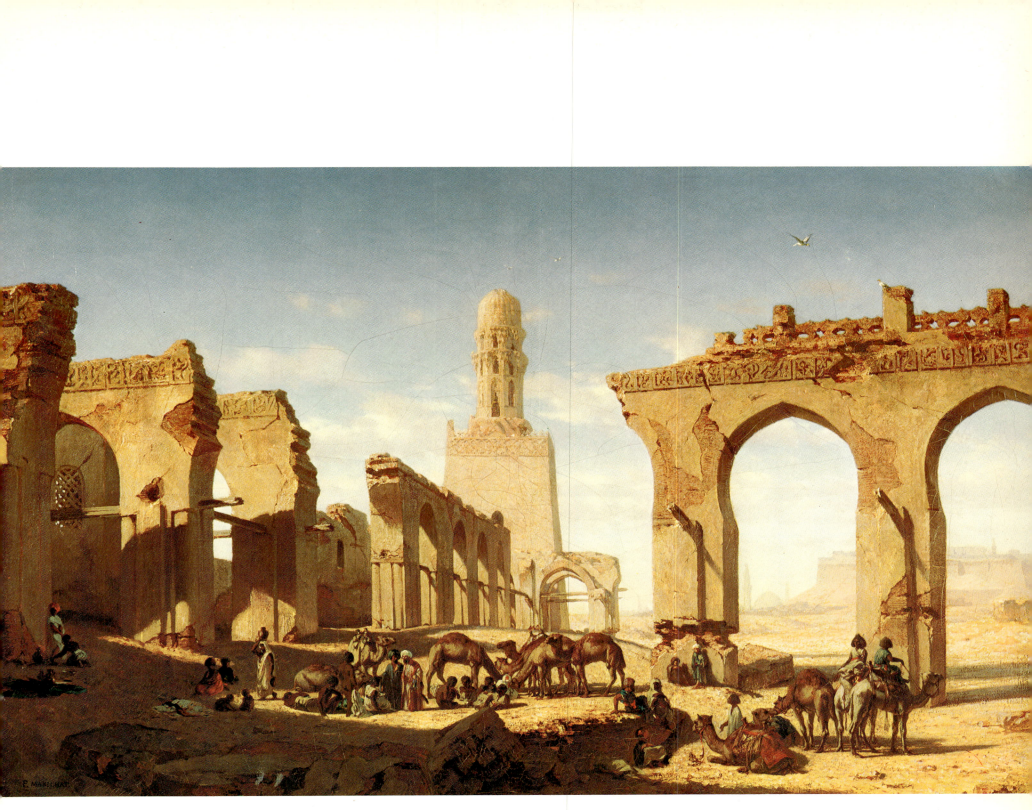

139

organized along the Canal. Even Gautier ran out of adjectives. Fromentin, who was delicate, tired easily. Riou, the draughtsman, left some lively sketches showing the Empress in full sail on a camel and her ladies-in-waiting contemplating the pyramids. It would have needed a Regnault to record these last *Arabian Nights* before the East lost its aura.

Théodore Frère: The Island of Philae, *1869. Watercolour, 31×40 cm. Compagnie Financière de Suez, Paris. – Before the dam-waters submerged the temples.*

Théodore Frère: Begging in a Cairo Street *(detail), c. 1855. Oil, 35× 27 cm. Joseph Soustiel Coll., Paris. – The prototype of the inexhaustible Orientalist, Frère exhibited scenes of this kind at the Salon with great success from 1834 to 1882.*

Ludwig Deutsch: Procession of the *Mahmal* (Holy Carpet) in Cairo, ▷ *1909. Oil, 287×295 cm. Galerie Jean Soustiel, Paris. – A late display of academic Orientalism.*

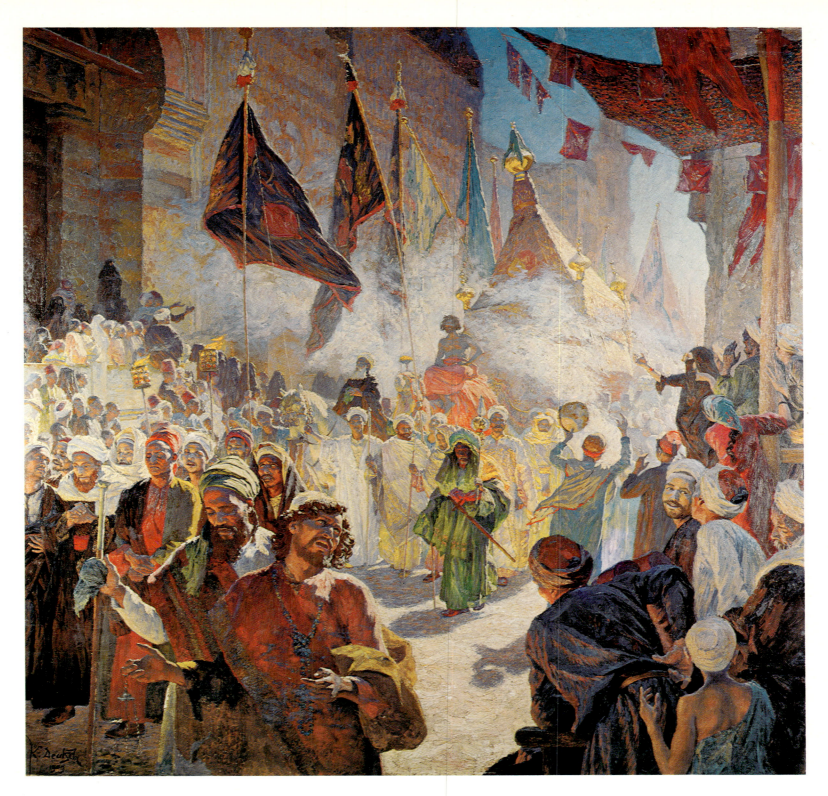

141

Carl Friedrich Heinrich Werner: The Mosque of Omar in Jerusalem, *1863. Watercolour, 49.5×34.3 cm. R.G. Searight Coll., London. – Splendour and mystery of the Islamic building on the site of Solomon's temple.*

Chateaubriand was the pioneer of a crusade that brought a steadily growing stream of artists into that particularly desolate province of the Ottoman Empire – Palestine. "When you travel through Judaea, you first feel a tremendous *ennui;* but then, as you go on, that feeling gradually leaves you and you are filled with a secret terror; but, far from lowering your spirits, this raises your courage and arouses your mind. Everything on all sides reveals a land weathered by miracles: the burning sun, the imperious eagle, the sterile fig tree, all the poetry, all the pictures from the Bible are here. Each name contains a mystery; each cave speaks of the future, each peak resounds with the voice of a prophet. God Himself has spoken on these shores: the dried-up streams, the split rocks, the open tombs, bear witness to the miracle; the desert seems struck dumb by awe, and you feel that it has not dared break the silence since it heard the Voice of the Almighty."

No-one was better able to reproduce that dramatic impression than Dauzats, who went to Mount Sinai in 1850. His *Interior of the Convent of Saint Catherine* with its Turks and Greek clerics gives us an excellent idea of what the Holy Places were like at that time. Many French painters went through Palestine, for instance, Henri de Chacaton, Emile Loubon, and Antoine Montfort. Gleyre came back from there with the idea for a painting of Ruth and Boaz. Two lithograph albums, with forty years between them, showed pictures of the Holy Places. The first, and more remarkable, was that of the Comte de Forbin, who also went to Egypt and Asia Minor in 1819. A future curator of the Louvre, he did imaginative genre scenes and architectural features. More precise, but unfortunately printed in an ugly chromo-lithography, Rear-Admiral Paris's album gave a very clear idea of Jerusalem as described by the Vicomte Melchior de

Vogüé in his book, which was famous at the time. That work and — in a very different spirit — the writings of Ernest Renan urged artists to be painstakingly accurate when painting places from Bible history.

Jerusalem, however, was not shown much, as it was less picturesque than Cairo and appallingly filthy. Flaubert wrote:

"Jerusalem is a walled charnel house. Everything in it is rotten, the dead dogs in the streets, the religions in the churches. It is full of shit and ruins. The Polish Jew in his fox-fur cap glides silently along the dilapidated walls; in their shade, the torpid Turkish soldier counts his Moslem beads, smoking all the while. The Armenians curse the Greeks, and the Greeks loathe the Latins, who in their turn excommunicate the Copts. All this is sad even more than grotesque. The Holy Sepulchre is the summit of all possible execrations. In that minute space there is an Armenian church, a Greek, a Latin, and a Coptic church. They abuse each other, curse each other from the bottom of their hearts, and try to filch each other's candlesticks, carpets, and pictures, and what pictures!"

Twenty years after Flaubert, the charming Edward Lear wrote in his sketchbook: "...Let me tell you, physically Jerusalem is the foulest and odiousest place on earth. A bitter doleful soul-ague comes over you in its streets. And your memories of its interior are but horrid dreams of squalor and filth, clamour and uneasiness, hatred and malice and all uncharitableness."

Simeon Solomon: Aaron with the Scroll of the Law, *c. 1880. Pastel, 31.7 × 15.2 cm. The Southampton Art Gallery, Southampton. — The mystery of the Hebraic East by a Jewish artist who was a tardy disciple of the Pre-Raphaelites.*

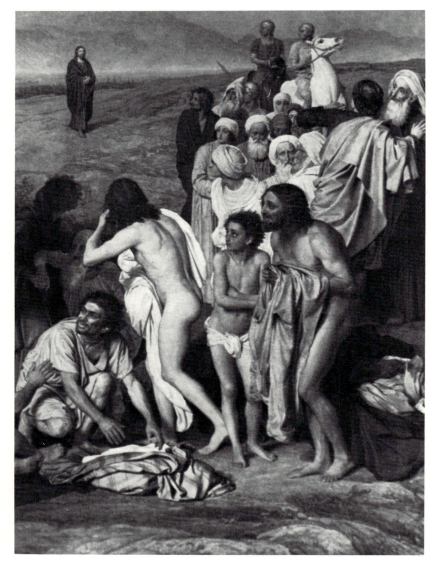

Alexander Andreyevich Ivanov: Christ Appearing to the People (detail), c. 1840. Oil. Tretyakov Gallery, Moscow. — The painter travelled through Judaea and made a number of studies of Arabs for this vast painting.

Richard Dadd, an Englishman who stayed there in 1842, finally was driven mad by such impressions and by his isolation there. He had had a very early success as a painter of scenes from Shakespeare. His watercolours, views of the desert and costumes, are just pretty, almost naive, but after he was shut up for killing his father, he did paintings based on his memories of Judaea with something ferocious in their meticulousness, biblical nightmares and icily inhibited harem scenes. Rodolphe Bresdin, another visionary, did not have to go to the East to visualize Jerusalem. The fantastic City stands on a rock in the background of his engraving of *The Good Samaritan*. In spite of the tropical forest around them, the Samaritan and the camel are entirely authentic. Bresdin also drew turbaned Turkish patrols.

One of the very famous painters who undertook the journey to Judaea was Sir David Wilkie, who had done genre paintings until then, scenes from the life of the common people, in the Dutch manner. In the East he looked for inspiration for huge biblical scenes. A Persian prince who was living in exile in Constantinople posed as — a somewhat too elegant — Christ. Wilkie died at sea on his way home, leaving many sketches of people and landscapes. After him, many painters who were Orientalist only on that one occasion went to stay, very uncomfortably, in the Holy Land in order to be in the country where Christ had lived. The best known of them, Holman Hunt, the Pre-Raphaelite, painted his terrifying picture, *The Scapegoat*, on the shores of the Dead Sea. He had set up his studio at the height of summer on its arid shores. His imperturbable dignity so impressed the Arabs, who generally fleeced foreigners, that they asked him to become their sheik. From this trip Hunt brought back his love of rich colours and a stifling atmosphere, a sort of liturgical mystery that gives a sense of disquiet to subjects he

Adrien Dauzats:
St Catherine's Convent
on Mount Sinai, *1845.*
Oil, 130×104 cm.
Musée du Louvre,
Paris. – Dauzats excell-
ed in sun-baked rocks,
precipices, and for-
bidding architecture.

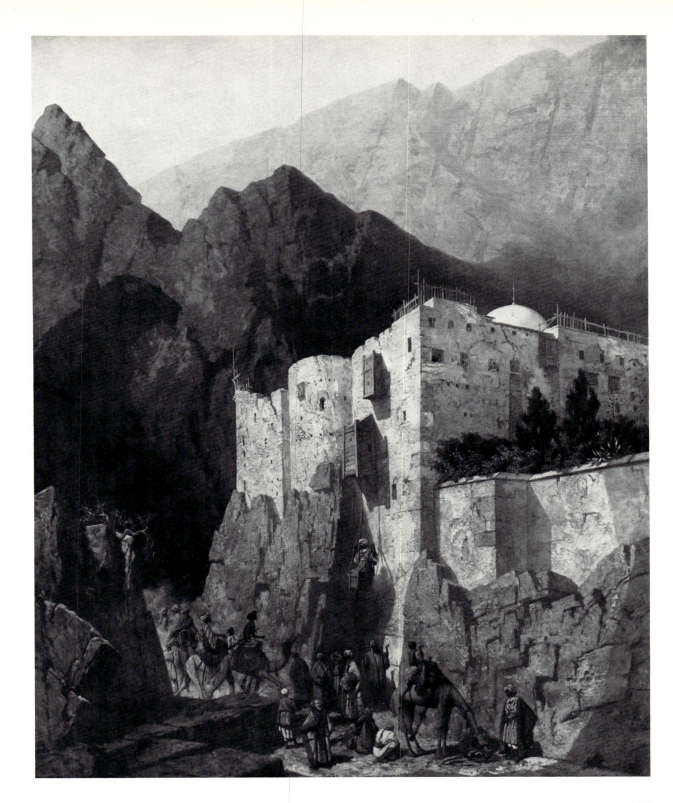

wanted to be especially serene. He did numerous views of Jerusalem. Thomas Seddon, a pleasant artist, accompanied Hunt on that journey and often exhibited scenes of caravans.

At the end of the century, James Tissot, an equally accurate artist, stayed for a long time in Judaea in order to illustrate the Gospels in the places where Christ had taught and died. This painter of demi-mondaines had been converted after his mistress died, and he studied the filthiest cloaks with as much care as dresses by Worth. The result was not felicitous when he filled his pictures with too many people, but his rocky landscapes with the odd olive tree have a real grandeur. Ivanov, a Russian who was preparing a very large *Christ Appearing to the People,* did some nice studies of young Bedouins. Dante Gabriel Rossetti, who was not greatly concerned with the truth of the Scriptures, was often influenced by the sensuous poetry of the *Song of Songs.* His *Venus Astarte* was more like the Shulamite.

Until the creation of the State of Israel, the Jews came to pray at the foot of the wall that had been part of the Temple of Solomon (since the eleventh century the mosque of Omar). This Wailing Wall inspired several painters of Jewish life, who continued the Eastern tradition in Russia and Central Europe right up to Chagall. Simeon Solomon, a disciple of the Pre-Raphaelites, successfully depicted Hebrew ritual in his paintings, but with a rather unquiet undercurrent.

In North Africa, as Delacroix, Chassériau, and Dehodencq had found, it was only in Jewish houses that artists could get an idea of Oriental life. The same was true of the Levant. Gérôme wrote from Damascus: "I was at a very odd Jewish party given by a rich banker. A lot of women were sitting on sumptuous divans, smoking a hookah, in very elegant rooms. Their dresses were completely bare at the bosom, and the breasts were veiled only by transparent gauze."

James Tissot: The Marriage at Cana *(detail), from* The Gospels, *1895.*

146

Archaeologists and draughtsmen went to Palmyra very early, but Syria was dangerous: it was safest there to pretend to be an Arab, like Byron's Giaour. In fact, T. E. Lawrence was still a Byronic figure, the last of the eminent or picturesque visitors whose exploits found an echo in the paintings of their contemporaries. None has a stronger appeal to the imagination than Lady Hester Stanhope, who dazzled the Arabs with her ruinous luxury and who, after imagining she was Queen of Palmyra, died in poverty in a Lebanese village. She made a deep impression on Lamartine, who visited her in 1832. He compared her to a Sibyl, for wasn't she crazy about astrology? "The East is your true homeland," she said to him after taking him round her marvellous gardens. Her fame spread through Germany. Heinrich Heine wrote of his friend Prince Pückler-Muskau, aesthete and traveller, who published a charming account of his trips: "Or is he riding on a camel's hump across the Arabian desert where he has an assignment with the Queen of Sheba, the friend of the great King Solomon of Judaea and Israel? That fabulous old princess is probably waiting for the famous tourist in a lovely Ethiopian oasis, amidst green palm trees and splashing fountains, as the late Lady Hester Stanhope, the crazy sultana of the desert, once said." Pitt's flamboyant niece inspired Bresdin's engraving of *The Arab Horsewoman*.

There were other English travellers besides Lady Hester Stanhope. Edward William Lane (1801–76), draughtsman and explorer, left some interesting works and an incomplete translation of *The Thousand and One Nights* (1839–41). A disturbing figure, the great writer Sir Richard Burton managed to go to Mecca disguised as a merchant. He was consul in Damascus, spent a large portion of his life in the East, and loved shocking his contemporaries, whether by his unexpurgated translation of *The Thousand and One Nights*

William Henry Bartlett: A Lebanese Landscape, c. 1835. Wash, 11.4 × 18.7 cm. R. G. Searight Coll., London. – One of the many works used for the engravings in albums on the Near East.

(1885–88), or by publishing fake Arab poems under the name of Hazzi Abu. The poet Wilfrid Scawen Blunt (1840–1922), also a romantic figure because he married Byron's granddaughter, was an enthusiastic breeder of Arab horses; he detested English influence. Foremost among explorers (we cannot use any other word, for the Ottoman Empire was uncharted and highly dangerous as soon as one left the main caravan routes) were John Lewis Burckhardt (1784–1817) in Syria, Arabia and Nubia, a Swiss in English

service, who also dressed up as an Arab; Robert Curzon, who went as far as Mount Sinai to buy manuscripts for the British Museum; and Charles Montagu Doughty, whose *Travels in Arabia Deserta,* written in 1876–78, became a classic.

Damascus, the holy city, was not very hospitable, and the painters did not stop there for long. But Smyrna, the capital of the Levant, was only half foreign to them, as they were welcomed by the Greek and Jewish tradesmen and sometimes received by a pasha. Decamps collected enough material there for his total output throughout the next thirty years; so did William Muller, an Englishman who went there in 1838 and 1843. Like Decamps, he loved Rembrandt, and his scenes are always a trifle theatrical. The best known of the official painters, Lord Leighton, came back from the Levant with enough columns, ceramics, and basins to build an Arab hall in his Kensington studio. But Leighton, who became President of the Royal Academy in 1878, preferred antique to Oriental subjects.

The ruins of Baalbek and Palmyra attracted numerous English watercolorists. Carl Haag, a German who settled in London, painted some very lively scenes there in 1860. Indefatigably, W. H. Bartlett did washtints of hundreds of landscapes and ruins in Lebanon and Syria. Influenced by Turner, his compositions are a little artificial, but they have a picturesque quality. He was a keepsake artist, and thanks to him we can see the landscape through the eyes of Lady Hester Stanhope, enlivened with riders and turbaned peasants. Most of his work was used for engravings to illustrate J. Corne's book *Syria, The Holy Land, Asia Minor.*

English artists, unlike their French counterparts, had access to the accounts published by these travellers, often illustrated with lithographs or steel engravings. Therefore the English Orientalists generally displayed much more authenticity of detail and did not content themselves with the kind of picturesque impression gleaned in the studio and used ever after; and yet they were able to stay quietly in their own country, loyal subjects of Queen Victoria.

As we have seen, foreigners might fare very differently in the different towns of the Ottoman Empire. In Constantinople, where the process of Europeanization proceeded to a background of palace revolutions and massacres, the Eastern town with its rococo palaces shown in A.-I. Melling's splendid engravings and J.-B. Hilaire's delightful watercolours, was completely different from that sketched sixty years later by Constantin Guys, when it had been turned into a hideous Western-style circus. Before the reforms of 1827, the luxury and variety of costumes dazzled the visitor. Louis Dupré, a French artist, did a series of watercolours from which he made lithographs. Around 1820, William Page, an Englishman, was still able to do large watercolours of the Promenade of the Sweet Waters of Asia and the summer houses on the Bosphorus, but Byron already complained, "Each villa on the Bosphorus looks like a freshly painted shop-sign or a piece of scenery from the Opera." All that soon became anachronistic, and artists made charming *"Turqueries"* of it. Of all the Mediterranean cities that inspired the West, Constantinople was the most theatrical.

The English alliance supported the "Sick Man of Europe", as the Ottoman Empire was called, against Russian ambitions. There were many Europeans in Constantinople, as well as Armenians and Jews who imitated them and built whole European-style districts. This meant that in Constantinople the visitor was not plunged so completely into an alien world as in Cairo. The presence of the Sultan weighed on everything. Chateaubriand was aware of it when he wrote in his *Itinéraire de Paris à Jérusalem:*

"The cemeteries without walls, standing in the middle of a street, consist of splendid cypress forests: the doves nest in these cypresses and share the peace of the dead. Here and there you see a few antique buildings, which have no connexion with people today or the modern buildings surrounding them; they seem to have been transported to this Eastern town by a magic wand. You never see any sign of cheerfulness, no-one looks happy: what you see is not a people but a herd led by the imam and slaughtered by the janissary. There is no pleasure except debauchery, no penalty except death. Sometimes the sad sound of a mandoline drifts out from the depth of a café, and you see foul children doing shameful dances before ape-like creatures sitting in circles on small tables. In the midst of penitentiaries and prisons stands the seraglio, the Capitol of bondage."

The same thoughts are expressed in the Hugo's *Les Orientales.* This was an ill-starred city, the seat of an evil tyrant. Lamartine, a great Turk-lover, drew a picture of the Bosphorus worthy of a Turner, or rather of the first, excellent, paintings by Ziem:

"Terraces of houses rising like pyramids, step by step, and between them the tips of orange trees and the sharp black spires of cypresses; higher up, seven or eight large mosques on the top of the hill, flanked by their open-work minarets and the Moorish colonnades, raised their gilt domes to the sky, blazing with the reflected rays of the sun: their walls are painted a delicate blue, and the lead-covering of the domes made them look like transparent glaze on porcelain. The century-old cypresses, dark and immobile, watched over the domes, and the different shades of the houses made the large hill blaze with all the colours of a flower garden; no noise disturbed the quiet of the streets; no shutter on the countless windows was opened, not a single movement betrayed the presence of inhabitants."

To Gérard de Nerval, things seemed less grand but even more beautiful. If he was looking for mystery in the East, he could not but be delighted by scenes like this one reminiscent

149

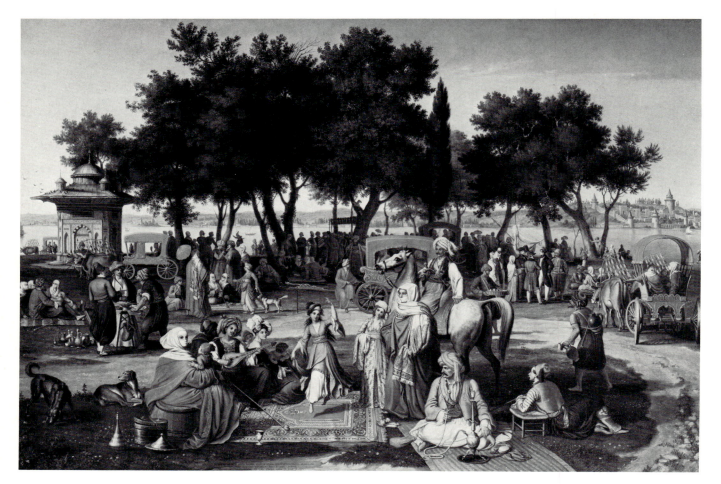

Johan Michael Witt-mer: The Sweet Waters of Asia, *c. 1810. Oil, 81 × 118.5 cm. Bayerische Staatsgemäldesamm-lungen, Munich. — A favourite subject for painters in Constantinople since the eighteenth century.*

of eighteenth-century prints of the Promenade of the Sweet Waters of Asia: "We landed in a delightful meadow intersected by streams. The skilfully thinned woods cast their shade here and there on the high grass. Some tents with fruit and refreshment stalls made it look like one of those oases where nomad tribes stop. The meadow was crowded with people. The different colours of their clothes blended with the green like bright flowers on a spring lawn. In the middle of the largest clearing you could make out a white marble fountain shaped like a Chinese pavilion, a special architectural feature you see everywhere in Constantinople." This recalls the engravings by Jean Brindesi which were used as studies for the lithographs in *Souvenirs de Constantinople*, or perhaps those genre scenes reminiscent of comic opera painted by Stanislas von Chlebowski, who stayed there from 1861 to 1876 at the invitation of Abd al-Aziz. Horace

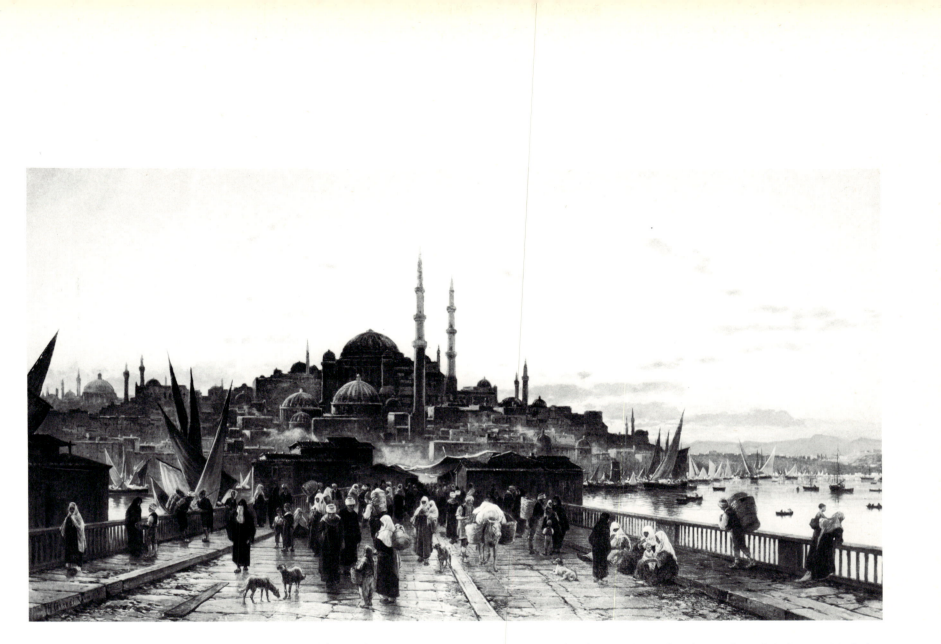

Hermann David Salomon Corrodi: The Bridge of Galata at Twilight, with the Yeni Valide Djami Mosque, *c. 1880. Oil, 86 × 165 cm. Joseph Soustiel Coll., Paris. – The twilight of Orientalism.*

Vernet, who was used to Algerians, noted bitterly: "Everything is round and soft, it's a mental seraglio. It would not take long for my ideas to grow paunchy like the hideous Turks I see in the street! Dear Arabs, your lice and fleas are better than the perfume of your unworthy enemies."

In 1856, Théophile Gautier published a book on Constantinople, which was a real repertoire of Orientalist subjects. At the Bazaar: "Nothing is stranger than the shelves laden with outlandish shoes, with turned-up toes pointed like Chinese pagodas, and turned-down flaps, in leather, velvet, brocade, quilted, spangled, braided, decorated with tassels

151

of down and flossy silk, impossible for European feet. Some are arched with raised beaks like Venetian gondolas; some are more like jewel boxes than real slippers; the yellow, red, and green disappear under the gold and silver braid.... The Eastern shop is very different from the European one: it is a kind of alcove in the wall, closed at night with shutters like deadlights; the tradesman, squatting like a tailor on a bit of mat or Smyrna carpet, smokes his *chibouque* or lets the beads of his *comboloio* slip through his inattentive fingers with a detached, impassive air, and he will stay that way for hours on end, apparently quite untroubled by practical matters; the customers usually stay outside in the street, where they examine the goods piled up in front without the slightest attempt at making them attractive to a buyer."

Camille Rogier, a draughtsman and a great friend of Gautier, spent several years in Constantinople. He acted as Nerval's guide to the haunts of vice. He and Thomas Allom, an Englishman, drew charming Turkish-style scenes of harems and bazaars, which were reproduced as lithographs with great success. So were the gouaches by Amadeo Preziosi, a Maltese married to a Greek woman and received in Turkish houses. Preziosi was more Turkish than the Turks, yet his works are *"Turqueries"*. In 1858 he published an album in Paris called *Stamboul, Souvenir d'Orient*. Jean Brindesi applied himself to picturesque scenes with the precision of a Canaletto. It was clear that the glamour of Constantinople would not last long. Karl Pavlovich Bryulov, a Russian painter of portraits and historical subjects, passed through Constantinople in 1835. He brought back some exotic props and used them in several delightful conventional bath scenes. All these painters showed Turkey the way the Empress Eugénie would have liked to see it in 1869. She was very disappointed to find the sultanas dressed by Worth.

The Bosphorus landscapes painted by G.-Fabius Brest in 1857 and by Félix Ziem in 1859, although successful, were already anachronisms, for factories had begun to disfigure its shores. Ziem wisely decided, "The East is Venice," and he stuck to views of the lagoon for forty years. Théodore Frère remained faithful to Constantinople, where he spent six months in 1851.

Soon after Gautier, Constantin Guys came out as a correspondent in the Crimean War and found his way to the brothels, where crinolined prostitutes with Oriental make-up and hairstyles stood at the doors and made eyes at the soldiers. In *The Procession of Sultan Abd al-Majid* Guys showed similarly incongruous juxtapositions of East and West.

One of the best Italian Orientalists, Alberto Pasini also drew his material from the Turkish army. He specialized in Turkish scenes, doing splendid horses and was restrained in his picturesque features. He was a very good painter and is sought after in Italy today. Carlo Bossoli, whom we have already met in Morocco, had devoted an album – published in England – to the war in the Crimea, the region where he had been brought up and of which he had published eighty lithograph views in 1842. His pictures full of fun, with elegant architectural features, were a little like operatic sets. Later a Swiss-Italian, Hermann Corrodi, who sometimes exhibited at the Royal Academy, paid a long visit to Constantinople. His large painting of the Galata bridge, built by the British in 1875, gives some idea of the incredible variety of costumes that could still be seen around 1880.

The Sultan himself was becoming a fantastic anachronism. Pierre Loti saw Abd al-Hamid going to the Ayub mosque to gird on the Uthman sword: "Halberdiers opened

Carlo Bossoli: Square of the Tartars at Bahçeka, 1854. Tempera on paper, 112×157 cm. Joseph Soustiel Coll., Paris. — A caravan of Tartars from the Crimea arriving in a small town in the European part of Turkey.

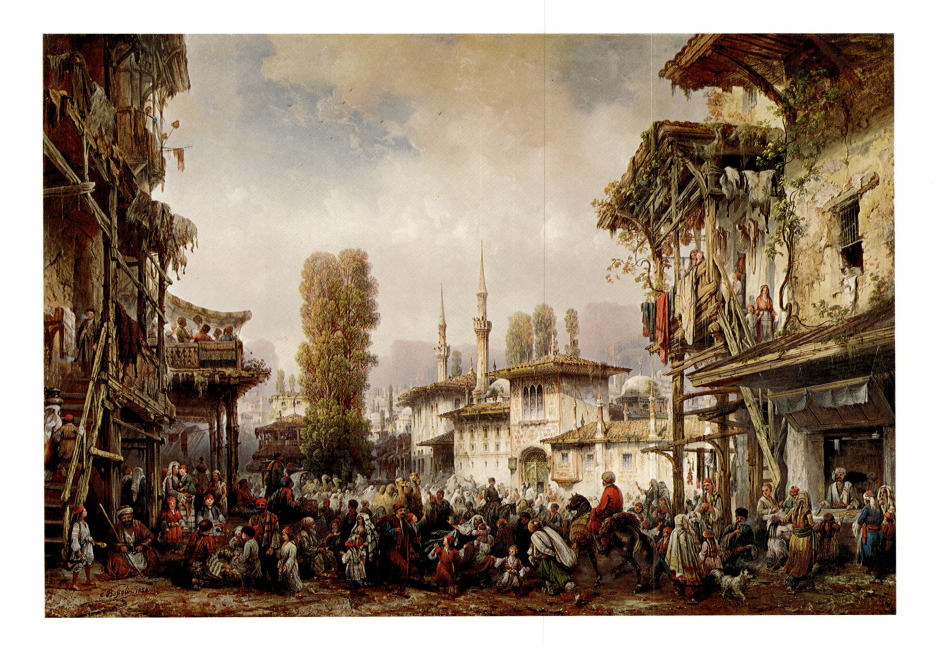

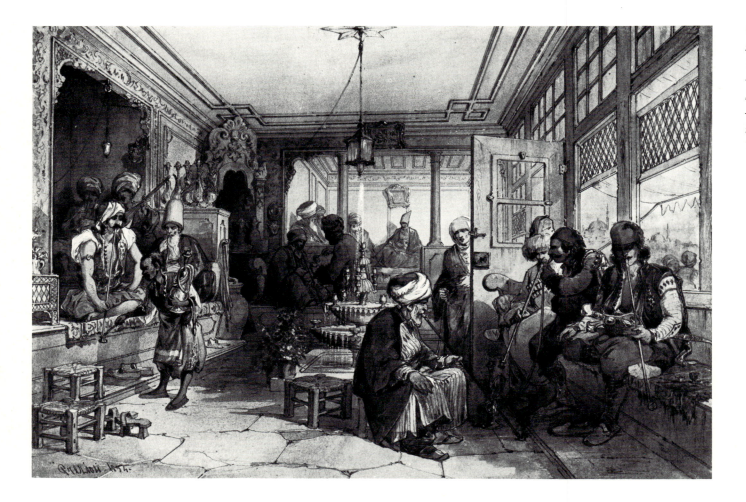

the procession, six-foot high plumes on their heads, dressed in scarlet clothes smothered with gold. Abd al-Hamid, on his monumental white horse harnessed with gold and gems, rode in their midst. The sheik-ul-islam in a green coat, the emirs in cashmere turbans, the ulemas in white turbans with gold bands; the great pashas and the high dignitaries followed on horses glittering with gilt. Octogenarian ulemas supported by footmen on their quiet mounts showed the people white beards and dark looks both fanatical and secretive.... The waving crowd of Turkish ladies stretched along the heights of Ayub. Each of the female bodies wrapped down to the feet in brightly coloured silks, all these white heads hidden behind the folds of the yashmaks, with black eyes peeping out, blended under the cypresses with the

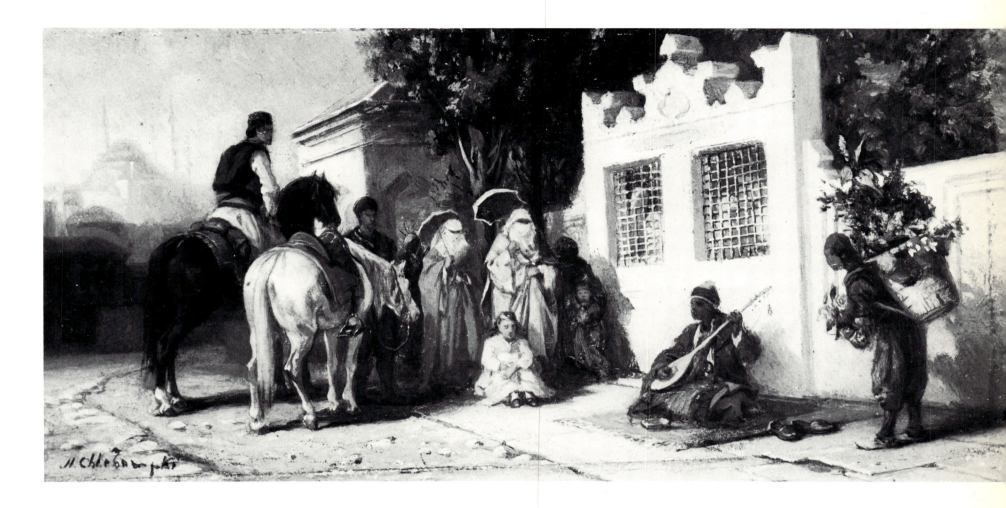

painted storied stones of the tombs. It was all so colourful that it was more like a fantastic composition by some crazy Orientalist than something real."

These pages are taken from *Aziyadé*, a series of water-colours, melancholy despite their lustre, of old Turkey in its decline. Lévy-Dhurmer showed Pierre Loti with steady eyes but short, stubby hair, the last of the *icoglans* with whom we

Stanislas von Chlebowski: Musician in a Stamboul Street, *1872. Oil, 10×19.5 cm. Marie-Christine David Coll., Paris. – This canvas, with its reds and yellows, would make a suitable illustration for Pierre Loti's* Aziyadé.

started our journey. Behind the writer lies Constantinople, its host of cupolas, minarets and gardens in a blue darkness as if already sunk into oblivion. The Westernization, the

Alberto Pasini: Constantinople, *1886. Oil, 37.1×60.3 cm. The Metropolitan Museum of Art, New York (bequest of Mrs. Martha T. Fiske Collord in memory of Josiah M. Fiske, 1908). – The Italian Fromentin.*

Emile-Charles Labbé: Kief (Friday Rest) on the Asiatic Shore of the Bosphorus at Constantinople, *1863. Oil, 120 × 157 cm. Musée du Périgord, Périgueux. – Labbé was a little-known disciple of Decamps and a friend of Fromentin.*

Germain-Fabius Brest: Shores of the Bosphorus, European Side, *1857. Oil, 18.5×24 cm. Musée des Beaux-Arts, Marseilles. — A more conscientious Ziem.*

often severe climate, and the meddlesome police made Constantinople less attractive than Cairo. It was difficult to set up your easel in the hubbub of a large city.

The Turks themselves began to paint Orientalist pictures and found a clientèle among the pashas. Their canvases can be seen in the Dolman Pagché Palace, a wonderful white and gilt setting for the Second Empire *Arabian Nights*. These painters imitated Gérôme, more or less successfully; the best of them, Osman Hamdy-bey, was his pupil. A final gleam of Orientalism sparkled in the watercolours done by Signac in Constantinople in 1905. Looking at them, we are reminded of these verses by Anna de Noailles:

> *J'ai vu Constantinople étant petite fille,*
> *Je m'en souviens un peu.*
> *Je me souviens d'un vase où la myrrhe grésille,*
> *Et d'un minaret bleu.*

[I saw Constantinople when I was a little girl, and I remember it a little. I remember a vase in which the myrrh was shrivelling, and a blue minaret.]

Jules-Joseph-Auguste Laurens: Courtyard of a Mosque in Constantinople, c. 1850. Pencil, 28.5×41 cm. Musée Duplessis, Carpentras. – An excellent example of the talent of the artists who accompanied scientific expeditions.

matic missions or were themselves diplomats, like Sir Robert Kerr Porter, who published an album in 1820, and, twenty-five years later, James Silk Buckingham. Jules Laurens, a pupil of Paul Delaroche, an excellent draughtsman, accompanied a scientific mission from 1846 to 1849 and brought back material for a hundred lithographs. Persia attracted adventurers like Colonel Colombari, who invented a system for loading cannons on the back of camels; he did very life-like watercolours of the court and army of Muhammad Shah around 1840. If we look at the photographs of Nasir ad-Din Shah, who reigned during the second half of the nineteenth century, we can see that due to the lack of opulence the

Ilya Repin: The Cossacks Defying Sultan Mahmud IV. *Oil, 67 × 87 cm. Russian Museum, Leningrad. – These Cossacks could well be used to illustrate Gogol's* Taras Bulba *– the Orient began in the Ukraine.*

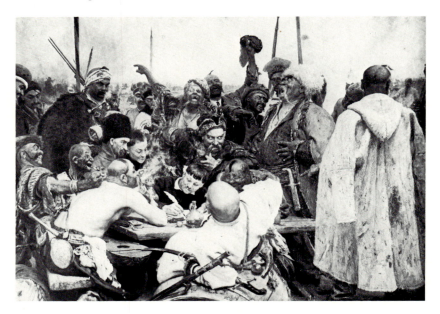

F. Colombari: Portrait of Muhammad Shah, *1838. Watercolour, 22 × 18 cm. Lynne Thornton Coll., Paris. – The Kajar sovereign painted by an Italian engineer in the Persian manner.*

Inaccessible, shaken by dynastic feuds, infested with brigands, Persia attracted only very few artists. Nor was there any local outlet for Western painters, because Persia was the only Moslem country that had its own school of painting, primitive portrait painters called Kajar after the dynasty, and, of course, illuminators. But artists accompanied diplo-

outlook for artists was not very bright. The illustrations for Mme Dieulafoy's books, executed mainly after photographs, give a rather sad impression of Persia about 1880.

The Persian influence made itself felt indirectly and rather tardily through the Ballets Russes and Pierre Loti's book *Vers Ispahan* (1904). After 1900, the miniatures attracted notice. Several illustrators imitated them, but none more charmingly than Edmond Dulac, a Frenchman who made his career in England.

Thanks also to the Ballets Russes, the West learnt about the picturesque features of Central Asia, about the arts of the tribes on the fringes of China and Islam and, closer to us, on the borders between Islam and Orthodox Christianity. Many Russian painters used that part of the Orient as material for pictures of great conquerors and the more recent wars of expansion. Vereshchagin was the most amazing painter of those deserts strewn with skulls and of mosques with bright blue ceramic domes standing out against a black sky. After spending some time in Gérôme's studio, he joined the Tsar's armies in the campaigns against the Emir of Bukhara in 1867; in some ways he was the Horace Vernet of these expeditions, but with an awareness of solitude and death that was completely lacking in Vernet. Vereshchagin also went to India and Syria. He did immense canvases that recall Tamerlane and Napoleon I. He died in 1904 at Port Arthur during the Russo-Japanese War. Also noteworthy was Ilya Repin, the best known Russian painter of the second half of the nineteenth century; his *Cossacks Defying Sultan Mahmud IV* is a masterpiece of military Orientalism. Guillaume Apollinaire wrote a jovial poem inspired by that colourful picture.

Rudolph Ernst: The Sanctuary, *c. 1880. Oil, 80 × 55 cm. Galerie Tanagra, Paris. — The mystery of a Hindu temple evoked by one of the most skilful Orientalists.*

161

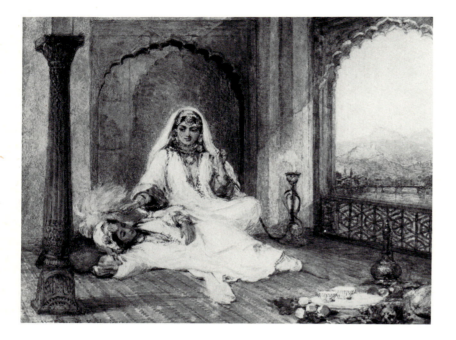

William Carpenter: Nautch Girls in Kashmir, *1854. Watercolour. Private coll. – A charming example of Victorian exoticism.*

As we have said at the beginning, India inspired eighteenth-century Orientalists as much as Turkey did. The public admired G.-F. Doyen's *Bayadère* at the Salon, and at Versailles the portrait of a *Maharajah* by Tilly Kettle, a gift to Louis XVI. Thanks to Dupleix, France almost had an Indian Empire. But French setbacks and then the Revolution cut short relations with the Sub-Continent, although Delacroix drew on Indian material for *The Death of Sardanapalus.* The painting certainly is reminiscent of suttee, the Indian ritual burning of widows. The English, of course, from about 1790 onwards, saw more and more Indian subjects at the Royal Academy: portraits of maharajahs and nabobs, ruins and famous buildings, and dance scenes, but relatively few scenes showing the life of the common people nor the kind of "corners of the bazaar" so popular for the Near East.

Zoffany, born in Frankfurt, was a tremendous success in England with his conversation pieces, and the rich nabobs invited him to paint their portraits. After his stay in 1786, he painted large canvases bursting with colour and violence. One of them showed the arrival of a diplomatic mission in Calcutta, guards hustling the colourful crowds, an elephant brandishing a bystander in the air at the end of its trunk, while jewel-covered figures looked on indifferently from their golden howdahs. Bizarre buildings can be glimpsed through the banyan or fig columns of pagodas. The same hubbub, the same riot of colour is found in his *Tiger Hunt.* This was the end of Zoffany's Orientalist career.

The most interesting expatriate artist was George Chinnery, who arrived at Madras in 1802, spent twenty-five years in India and then a further twenty in China. Irish by birth, he was a charming artist reminiscent of Canaletto. His rendering of buildings was both accurate and poetic, his small figures full of life; his watercolours are better than his rather sombre oil paintings. He trained numerous pupils, some Indian, some English. One of them, Sir Charles d'Oyly, an opium inspector in Bengal, painted figures midst ruins and scenes from the life of the common people; he had his own lithographic press in Patna and his works could be found in all Anglo-Indian households. D'Oyly wrote a book on life in India, *Tom Row the Griffin,* in which he described the spectacle of which Europeans dreamt, a bayadère's nautch dance: "The halls are open, the dais set up, and heavy chandeliers sway above our heads.... What can we

Frederick Christian Lewis: Halt at the Sanctuary of Ganesh, *c. 1855.*
Oil, 114.3×185.4 cm. James Ivory Coll., New York. – This overelabo-
rate Hindu style rarely tempted painters.

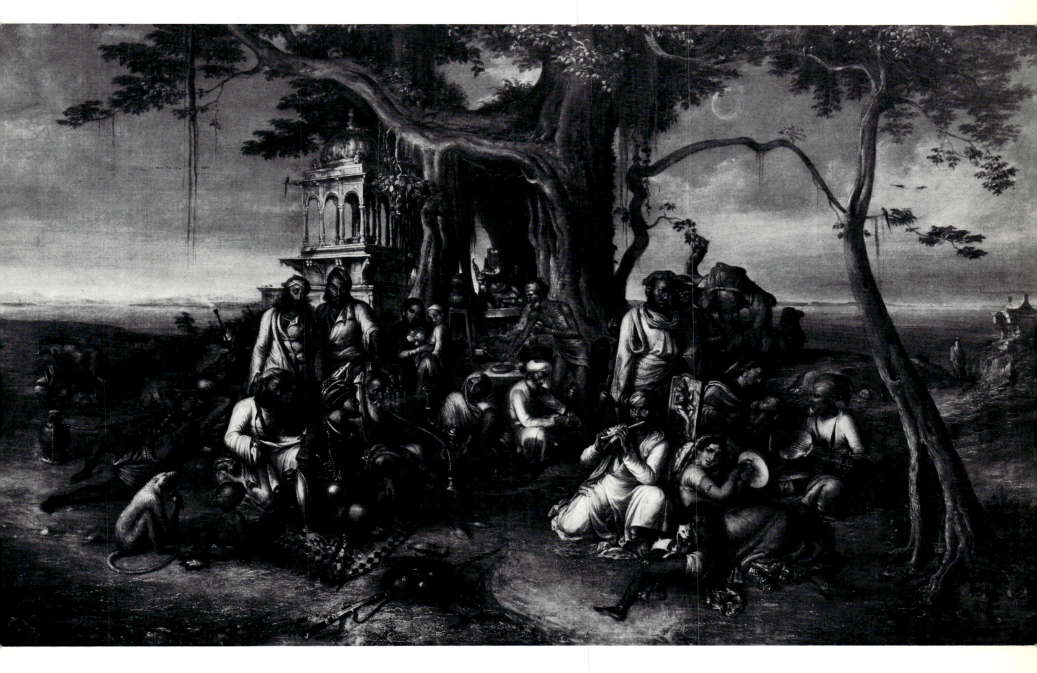

say of the rings in nostrils, rich pendants hanging from ears, bracelets, and all the other things with which Indian women load their bodies?..."

From 1805 to 1830, Robert Smith, who was interested in Indian architecture, painted the tombs in the semi-desert around Delhi, with their heavy domes and belfries. The best topographical artists were Thomas Daniell and his nephew William Daniell. In the course of several trips they did washtints of hundreds of buildings, landscapes, and the elegant colonnaded houses of the English, which were published as aquatint engravings in albums called *Oriental Scenery*.

Frederick Christian Lewis, the brother of the Egyptian Lewis, was one of the genre painters; William Carpenter a delightful watercolourist, and George Landseer, the nephew of the better known Sir Edwin Landseer, did picturesque portraits of maharajahs. The best painter at an Indian court was an Austrian, August Theodor Schoefft, who spent from 1845 to 1850 at the court of Oudh, in that fabulous palace at Lahore where you can still see the vast canvases of the Maharajah Sheer Singh and his entourage, splendid cavalcades, ceremonies in the marble pavilion, and portraits of the Begum and the princesses. These were large paintings with chiaroscuro and gold effects in the manner of Rembrandt, without Makart's verve but with a similar sense of composition, a similar pleasure in painting women, horses, fabrics, and weapons.

In 1854, the Indian Mutiny with its massacres and subsequent repression, wrought a deep change in the relationship between the English and the Indians, who were henceforth regarded as a decadent, treacherous race. India passed from the administration of the Company to that of the Crown, whose all-powerful civil servants brought out their wives, often narrow-minded, puritanical women. There is some truth in the saying that it was these wives who lost the Indian Empire. Most of the English liked the country but not its people, and were not keen to keep mementos of them, so that English painters ceased to come out. There were mainly foreigners, like Schaemberg, a Fleming, who did some of the illustrations for Rousselet's fine book, *L'Inde des Rajahs*, and Egon Lundgren, a Swede. Vereshchagin stayed for a long time in the north of India at the invitation of the Maharajahs of Jaipur, and he came back with paintings of magnificent processions, white-clad riders against a bright blue sky.

The southern temples were too gaudy and too bizarre to tempt many painters, except Marius Bauer, the Dutchman, who was good at conveying their deep vaults and their staircases leading to sacred basins, a little in the manner of Rembrandt. The common people's Buddhist India was rather frightening, whereas the memory of the Moslem Mogul emperors seemed more familiar. Pierre Loti, in *L'Inde sans les Anglais* (1903), best expressed the disconcerting, even worrying, quality in its exuberance, for instance in his description of a beautiful bayadère who might have inspired Gustave Moreau: "A sort of lovely poisonous flower, tall and slim; the face too delicate, the eyes already too slanted and lengthened even more by make-up; blue-black hair, severely plastered in bands along the cheeks; nothing but black drapery, a black loin-cloth, a black veil with the thinnest silver edge; no jewels except rubies, rubies on hands and arms; and attached to the division between the nostrils, a bunch of rubies that droops over the mouth as if there were still blood on those ghoulish lips." At the same period, Judith Gautier's very fine novel, *L'Inde éblouie*, was published; unfortunately, it did not inspire any

Paul Albert Besnard:
Fruit-Merchants in
Madura, *c. 1900. Oil.*
Ancien Musée du
Luxembourg, Paris. —
An impression of
Southern India as it
might still appear
today.

Vasily Vasilyevich Vereshchagin: Indians in Jaipur. Oil, 67 × 56 cm. Private coll. – *The famous painter of the steppes was for some time a guest of the Maharajah of Jaipur.*

painter. But Mucha illustrated *Rama,* a Buddhist tale by Paul Verola, and Kupka also took material from Hindu legends.

Lord Curzon, Viceroy of India at the beginning of this century, understood that the sole link between the maharajahs and the sovereign King-Emperor was prestige. The Durbar in Delhi in 1902 was a more sumptuous festival than the opening of the Suez Canal. Dozens of princes competed to outshine one another in the procession to the centre of the new capital. It would have taken a Delacroix, or at least a Sert y Badia (who was susceptible to such splendour) to convey such brilliancy, such a prodigious assembly of the great, including many who claimed divinity. There was only one excellent watercolour reporter; this dearth illustrates the decline of Orientalism.

Albert Besnard, a Frenchman, did a series of dazzling watercolours showing the splendour of *India without the English;* he had started as a Symbolist and finished in the academic tradition. Degas called him "a fireman who caught fire," but what he offers is a mere firework display containing all the tired themes of Orientalism in Indian guise, the mystery of Benares, the shining bayadères, gold-covered elephants and mendicant mystics. Besides dozens of watercolours and oil studies, Besnard brought back a very attractive account, *L'Homme en Rose.* This is what he said about Benares: "From that endless sky with not a wisp on the horizon, my eyes turn to the crowd two hundred steps below us, amidst the fawn sandstone chapels, near the collapsed Great Dome, along the frenetic river lined by a thousand parasols as if by mushrooms, a riot of coloured veils, like a monstrous mass of flowers strewn over the threshold of a temple. The ground strewn with flowers — no other description could fit that infinite variety of colours draped over all those statues, the dull gold which the Ganges, as if in play, covers with blades of gold in the fire of the young morning sun. A variety that is also a symphony, most skilfully orchestrated, with blood-red as its *leitmotif.* Through infinite shades, the purples turn to mauves, the yellows are startled by reds into orange, and across the whole melée a cold green drifts like the acid sound of a trumpet."

Those shifting swarming colours were those used by Leon Bakst, who, at that very moment, was changing the palette of modern painting by the brilliancy of his costumes; they were reflected in the paintings of the Fauves. The splendour of *Scheherazade* is more Indian than Persian.

The influence of Indian philosophy on the Symbolists does not come under the heading of Orientalism. Sâr Péladan advised the Rosicrucian painters to look towards India; Odilon Redon alone, to judge by his pastels based on the figure of Buddha, seemed to have been enlightened by Asiatic mysticism. Moreau found inspiration in miniatures of genii flying away on griffins, and turbaned poet princes; for the *Triumph of Alexander the Great* he copied fabulous temples and giant statues.

The Decline of Orientalism

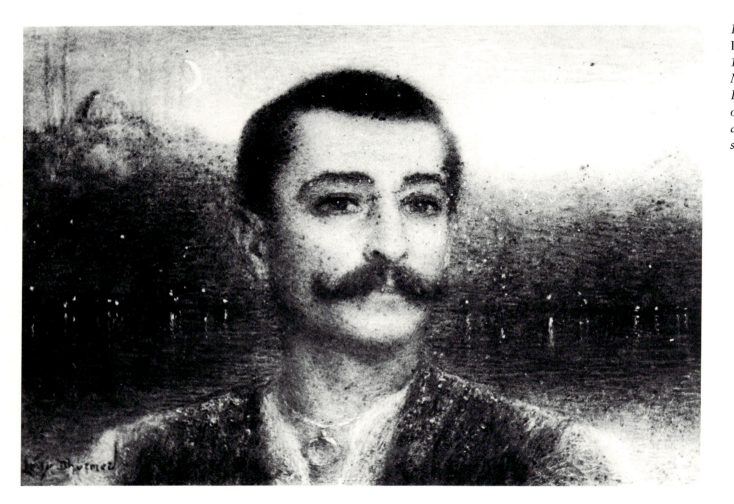

During our tour of the Islamic East we have seen some countries yielding to progress sooner than others, and thus abandoning their picturesque costumes and strange magnificent customs. Turkey was the first to yield, followed by Algeria. In spite of innumerable tourists and a government controlled by England, Egypt changed less, and Morocco remained exotic for a long time. As for India, lethargy protected it to some extent from the democracy that would strip it of all its splendour. The advance of what Westerners, with smug *naïveté,* called "civilization" left more ruins than Tamerlane – towns degutted, if not bombed, and a way of life altered by railways, dams, and the influence of the press.

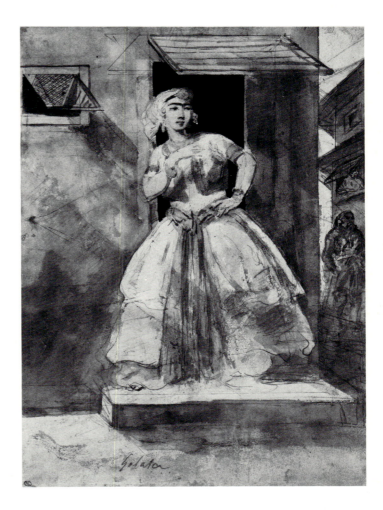

Shaky traditional governments clung to disastrous alliances or humiliating protectorates. Théophile Gautier was the first to proclaim the danger of Westernization, and every book by Pierre Loti was about a country that was losing its soul through contact with Europe. More and more, the Orientalists painted subjects whose picturesque quality was artfully reflected by the dancers and bazaar characters sent to international exhibitions to add a bit of colour. On the "Cairo Street" at the 1889 Exhibition and on the spot, Jean Lorrain saw the picturesque wallowing in the mire, and the sordid exoticism of Algeria filled him with revulsion.

"I saw the 'Mauresque' as it really was, ragged and wrinkled beneath its jewellery and make-up, its feet encircled by bracelets and rubbed with henna, rancid and perfumed at the same time, a witch and a young girl in tattered silks. Like a lover finally cured of a guilty infatuation, one of those ulcers in the soul which make you adore the worst mistresses and chain you to them more firmly the more they make you suffer, I examined it with interest beneath its gaudy finery, and fiercely counted its wrinkles and blemishes...."

Artists like Guillaumet in Algeria and Müller in Cairo who did not lose sight of the simple life were accepted as realists. Others produced visions of their travels that allowed them to be classed with the Symbolists, but the word "vulgar" cropped up more and more in descriptions of traditional Orientalists' pictures. Today's Orientalists have cameras and are satisfied with local colour more or less skilfully laid on for them.

In fact, even more than railways and democracy, photography has succeeded within half a century in stamping out those painters who once delighted the bourgeoisie with disturbing, unusual, and splendid visions. First, photography gradually replaced original works in accounts of travels and in magazines like *Illustrated London News* and *L'Illustration*, which enjoyed a wide circulation after 1850. The great artist of the Crimean War is Roger Fenton rather than Constantin Guys. It all started very soon after the invention of the daguerreotype, when Horace Vernet and his

171

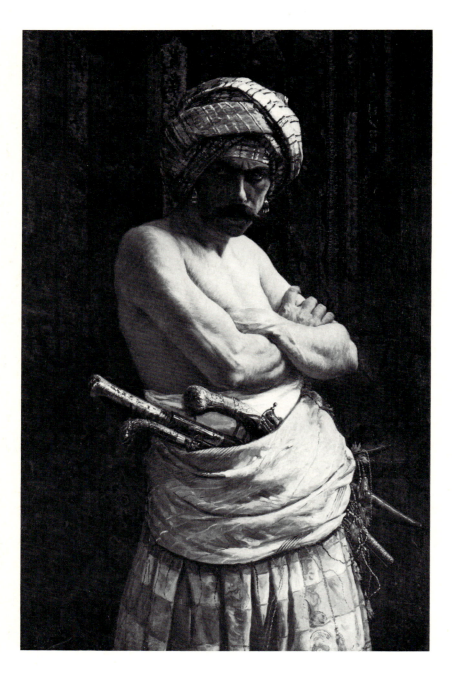

nephew, Goupil-Fesquet, travelled through the Middle East laden with unwieldy apparatus. The pictures they brought back were painstakingly engraved in aquatint and published under the title *Daguerrean Excursions* in 1841–42. If we compare, for instance, a view of Beirut with a wash drawing by Bartlett we can see that accuracy is the antithesis of art. Muhammad Ali's harem, the earliest photograph taken in Africa – on 7 November 1839 – is an admirable document but in no way a work of art. For magazines like *Le Tour du Monde,* excellent wood engravers interpreted the material brought back by travellers until about 1890, when halftone blocks began to be used. Alongside albums of lithographs, photograph albums were printed, like the admirable collection of pictures Maxime Du Camp took in Lebanon during a journey with Flaubert (1849–51), or Benecke's plates, printed in 1851 in *Photographic Varieties for the Use of Painters.*

In fact, painters soon started to use photographs, which spared them, if not the journey, at least tedious sessions of architectural transcriptions. For his first visit to Cairo, Gérôme took along a camera, and at the Salon of 1865 Gautier congratulated him on his "photographic accuracy". When he first exhibited his *Bonaparte with the Sphinx,* the beast was painted with all its cracks for the first time. In a late painting, *Women Bathing at Brousse,* the excessive importance given to architectural details and the painstaking spareness indicate the use of photographs. The same flaw is apparent in *Jerusalem and the Valley of Jehoshaphat* by Thomas Seddon, who went to the Holy Land with Holman Hunt and a photographer, James Graham.

Carlos Condé: Arnaut, c. 1880. Oil, 130×79 cm. Galerie Tanagra, Paris. – A Macedonian mercenary, in the style of Fortuny.

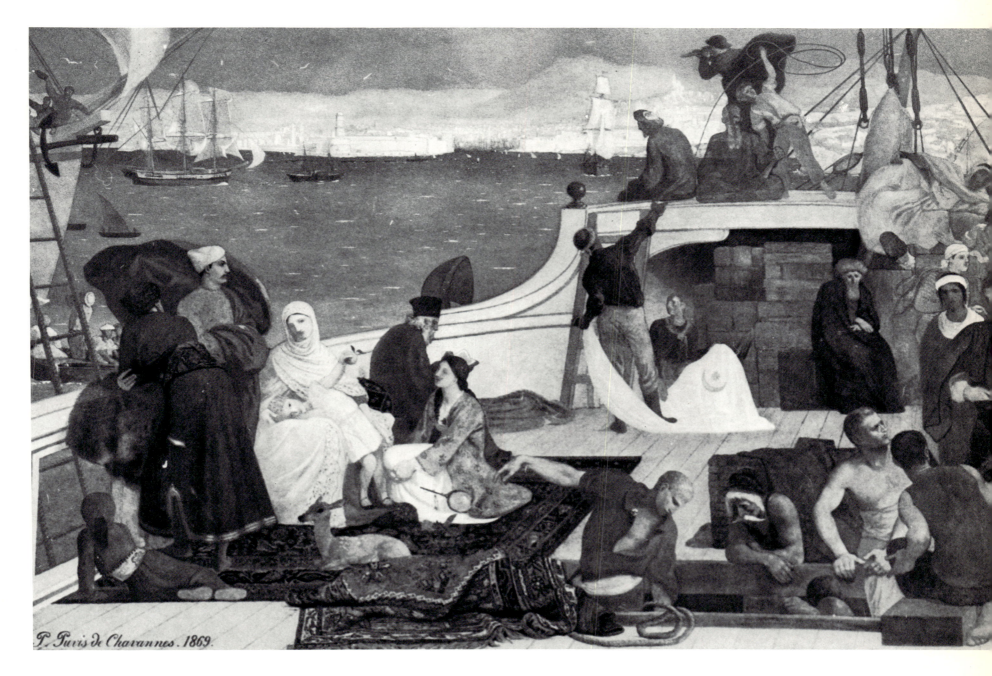

At first, the copying of photographs interested a public which, reacting against Romanticism, wanted accuracy above all, but it became less popular with the advent of Impressionism and Symbolism. Before postcards were invented, tourists bought photographs of monuments and oases, as well as picturesque scenes posed in studios. Romantic visitors to Turkey bought pictures of more or less veiled beauties, and soldiers brought back pictures from Algeria of Fatimas in varying degrees of nudity. In Paris, photographers provided painters and lovers of odalisques with sumptuously dressed bosomy models reclining on ottomans, their thighs discernible through gauzy draperies.

In 1888, Kodak brought out a portable camera, and it was immediately taken up by tourists, who were increasingly numerous thanks to Cook's tours. At that point, Orientalism was within everyone's grasp; albums of sketches were abandoned, and only young English ladies continued to dilute their water-colours with the waters of the Bosphorus or the Nile. The decline was rapid and can be seen from the mediocrity of the travel sketches published by the *Studio* at the end of the century, or the works of Mortimer Mempes, who travelled across the Far East with a camera only to bring back Madame Butterflys in oils or watercolour.

Renoir's and Whistler's paintings in the Japanese style inevitably conjure up Puccini's heroine. The Japanese trend was a great blow to Orientalists who had decided not to become Far Eastern Orientalists. A few American painters, like John La Farge, went to Japan or Hawaii to paint, but

Georges-Antoine Rochegrosse: The Musician, an Assyrian Princess, *1886. 175×110 cm. Galerie Tanagra, Paris. – More 1900 than Babylonian in inspiration.*

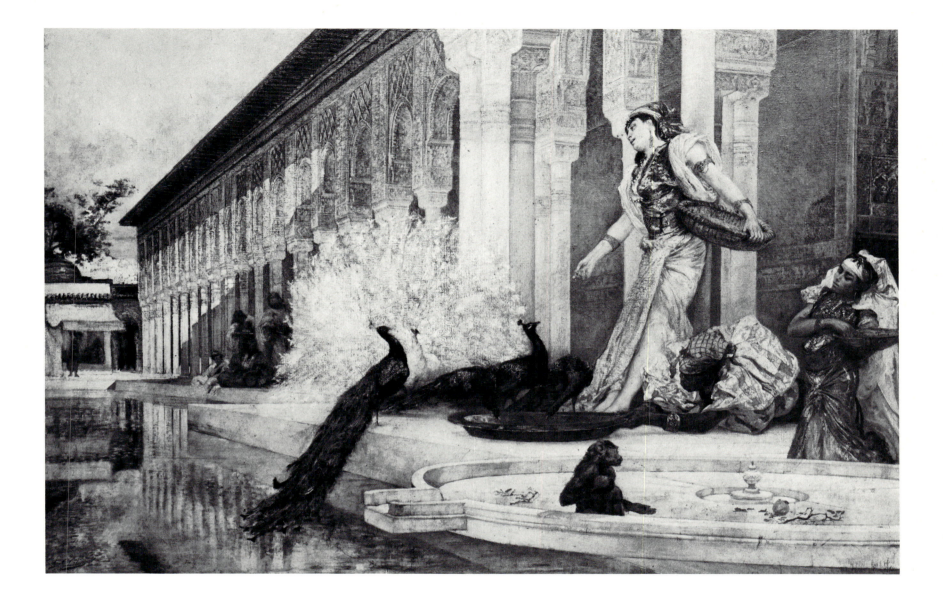

Georges Clairin: The Peacocks, *c. 1890. Oil, 110×158 cm. Félix Marcilhac Coll., Paris. – A Moorish fantasy recalling Massenet's opera* Le Roi de Lahore.

175

Charles Cottet: Fellah Women, *1894. Oil, 54×65 cm. Musée des Beaux-Arts, Strasbourg. – Shows the fascination of veiled women for the painter of the* Pardons bretons, *religious pilgrimages typical of Brittany.*

most of them found their own exoticism in the Negro districts of New Orleans or among the last Red Indians.

Round 1900, the Islamic East seemed to have nothing more to offer to artists, who would have had to travel a long way, in Gauguin's footsteps, to find new colours and beauty transcending the merely picturesque. Within twenty years, the Exotic had supplanted Orientalism, the Cubists discovered Negro art, and, if painting had not yet begun its repudiation of formalism, Mexico and the Sudan would surely have attracted artists. Albert Camus, ignoring the debt that Delacroix's and Renoir's use of colour owed to North Africa, buried Orientalism.

"Any painters who have been to North Africa know that the sun there kills colour. Beneath the grey skies of the Ile-

Lucien Lévy-Dhurmer:
Mosque at Rabat,
*c. 1920. Pastel on card-
board, 77 × 58 cm.
Pierre Bergé Coll.,
Paris. – In this Symbol-
ist twilight, poetic feel-
ing takes precedence
over the picturesque.*

Emile Bernard: A Harem, 1894. Oil, 84×110 cm. Musée des Arts africains et océaniens, Paris. – The painter of Pont-Aven retains something of Symbolist simplicity.

de-France, the smallest geranium is as bright as fresh blood. Colour needs shade. It can only exist through contrast. But the dazzling light of Africa engulfs everything. It swallows colour and dissolves it in motionless, perpetual turbulence, bleaches a sky that everyone thinks is blue, blends red and green, and brings together complementary colours in colourless splendour. By consuming shade, it burns up all the values. Ultimately, all that flamboyance is nothing more than a negation and that beauty is only a pyre."

The paintings that Marquet and Friesz did in Algeria would bear Camus out, if he had not forgotten such masters as Matisse and Klee. During his stint with Gustave Moreau,

Matisse derived from the Orient not an interest in fabulous palaces or biblical dancing girls but rather a taste for arabesque and, in the drawings he did in the Twenties, a passive sensuality that is actually very similar to the languor that had produced the skilful curves of the slaves in Ingres's *Turkish Bath*. From 1911 onwards, Matisse often went to Morocco and painted canvases worthy of their distant ancestor, Delacroix's *Women of Algiers*. He also made a study of Persian miniatures.

Paul Klee spent several months in Tunisia in 1914 but did not bring away any of its exotic flavour. Instead he learnt a simplicity inspired by the desert and by the deprivation of a poverty-stricken people. His Orientalism was a transfiguration. You can find the stacked cubes of the casbahs in his imaginary towns, Arab calligraphy in his fantastic line, and veiled women in his ghostlike forms. August Macke, who accompanied Klee, brought back abstract watercolours in vibrant tones.

We could also number Marc Chagall among the Orientalists, but, in contrast to the stricter Matisse and Klee, the young Chagall derived a cosmic vision of things from Yiddish folklore that owed as much to Judaea as to Russia and developed it in a series of biblical compositions in mystic colours. He has also painted a few beautiful landscapes in Palestine. Kees van Dongen did some very successful paintings of Egypt, which are amusing rather than picturesque. Maurice Denis was very susceptible to Tunisian light, and Raoul Dufy did very nice watercolours of Marrakesh.

After Cézanne, painters found the sun of Provence strong enough to nourish their genius; but those who wanted the exotic were protected by the Ministry of the Colonies as long as the French Empire lasted. The Colonial Exhibition in 1928 was their apotheosis. There were excellent painters

Henri Matisse: Odalisque in Red Trousers, 1922. *Oil,* 67×84 *cm. Musée national d'Art moderne, Paris. – Recalling visits to Morocco and the work of Delacroix.*

among them who will certainly be rediscovered when we are able to talk about the colonies without embarrassment or regret. Their programme was laid down by Rochegrosse in the design for a tapestry done for the 1900 Exhibition, showing the Republic bringing civilization to pleasantly undressed negresses and to monkeys jumping from baobab trees on to telegraph wires.

If we had undertaken a history of the exotic, we ought to have mentioned Dufresne in the Antilles, Bezombes in darkest Africa, and Dunand, who evoked the jungle temples at Angkor in sumptuous lacquer, but this would take up more time and space than we can afford in a work essentially devoted to a very idiosyncratic taste of the nineteenth century. To find a comparable attitude towards the Islamic East in contemporary art we would have to turn to the cinema rather than painting. In his *Thousand and One Nights,* Pasolini brought to life marvellously all the themes so beloved of our painters, like violence, sensuality and magic, in the very places where the painters set up their easels over a century ago. We should also mention the marvellous *Elephant Boy* with Sabu, the *Sheik* and *Young Rajah* with Rudolf Valentino, and Joe May's *Hindu Tomb,* a German film of the Twenties later remade by Fritz Lang. And in a lighter Orientalist vein, *à la* Monticelli, there is *The Thief of Baghdad* (1925) with Douglas Fairbanks, and

Kismet, with Marlene Dietrich, later made into a musical.

As can be seen, apart from the recent Pasolini film, Orientalism in the cinema reached its peak before the war. Today political and informative films are helping to demystify the Orient. The oil magnates belong to James Bond's world, not Ali Baba's, and the only films considered "valid" in intellectual circles show the horrors of Calcutta or the tragedies of the drug trail. Romantic painters are discouraged from lingering in a politicized Orient by the sameness of the houses, monuments made hackneyed by too many photographs, and a people discarding burnouses for jeans.

So, even without taking into account their primarily pictorial qualities, and their interest as mirrors of nineteenth-century dreams and aspirations, Orientalist paintings have the merit of keeping intact the memory of a world that crumbled almost as soon as it came into contact with progress. The singular beauty that Delacroix and even Gérôme discovered was to wane day by day. Perhaps the journey we have made in the painters' wake will remind some readers of marvellous scenes glimpsed in the streets of Fez or Isfahan, a caravan on the Palmyra or Petra road, a festival in Cairo or Bombay, or the silent courtyard of a mosque in Cordova or Isfahan, women sitting in a cemetery in Tangiers or Brousse – a series of flashing images that might be compared to gaudy scraps of silk clinging to ruins after a bombing.

Appendices

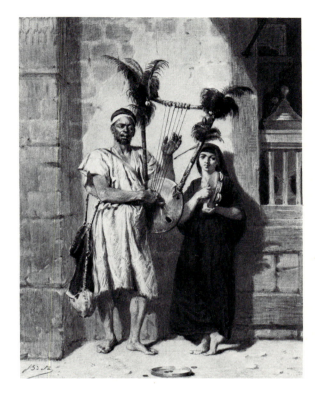

Alexandre Bida: Strolling Musicians in Cairo, *c. 1860. Highlighted drawing, 30.5×22 cm. R.G. Searight Coll., London. – By one of the best draughtsmen of* Le Tour du Monde.

ALLOM, THOMAS (1804–72), English. Studied architecture. Stayed in Constantinople. Did a very successful painting showing the unfurling of the Prophet's banner before the massacre of the Janissaries. He did architectural and genre paintings, and landscapes.
Fig. p. 80

ASCENZI, Italian. Paintings of Egypt around 1860.

AUGUSTE, JULES-ROBERT, known as "Monsieur Auguste" (1789–1850), French. A rich connoisseur; brought back objects and mementos from a trip to Syria in 1815. His sensual pastels conveyed the idea of the harems to the Romantics, on whom he had a great influence.
Fig. p. 98

BARRY, FRANÇOIS-PIERRE-BERNARD (1813–1905), French. Seascape painter, pupil of Gudin. Travelled in Egypt with Prince Napoleon. His *Valley of the Caliphs' Tombs* was noticed at the Salon of 1847.

BARTLETT, WILLIAM HENRY (first third of the nineteenth century), English. Exhibited at the Royal Academy between 1831 and 1833. Travelled in Turkey and Lebanon. Very precise landscapes, often reproduced as engravings.
Fig. p. 147

BARYE, ANTOINE-LOUIS (1796–1875), French. Sculptor and painter. Became famous with works depicting lions.

BAUER, MARIUS (1867–1932), Dutch. Painter, engraver and lithographer. Travelled extensively in Turkey, Egypt and India. Sometimes used as a pseudonym the Latin translation of his name, Rusticus.

BELLEL, JEAN-JOSEPH-FRANÇOIS (1816–98), French. Exhibited at the Salon from 1836 to 1893. His *Flight into Egypt*, 1855, was highly successful. Travelled in Algeria. Collaborated with Marilhat on lithograph albums.

BELLY, LÉON-ADOLPHE-AUGUSTE (1827–77), French. Pupil of Troyon, later imitated Decamps and Marilhat. In 1850 he visited Egypt and Syria. From then on his Oriental paintings alternated with works in the "Barbizon genre". Triumph of *Pilgrims Going to Mecca* at the Salon of 1861.
Fig. p. 101

BERCHÈRE, NARCISSE (1819–91), French. Influenced by the Barbizon School. In 1847, travelled in Spain; in 1849–50 in the Middle East. In 1856 stayed in Cairo with Gérôme and Belly and again in 1861–62 and 1869. Official draughtsman of the Suez Canal. In 1865 published *Le Désert de Suez: Cinq mois dans l'Isthme,* then accompanied the Empress in 1869: an excellent draughtsman fond of painting landscapes and buildings.

BERNARD, EMILE (1868—1941), French. Painter, poet and art critic. A close friend of Van Gogh and Gauguin, who went through an Orientalist period after a trip through Egypt.
Fig. p. 178

BESNARD, PAUL ALBERT (1849—1934), French. The most Symbolist of the official painters. Travelled in Algeria, then in India, whence he brought back splendid watercolours.
Fig. p. 165

BIDA, ALEXANDRE (1823—95), French. Pupil of Delacroix, but more influenced by Decamps and Raffet. Good draughtsman and Orientalist, highly regarded.
Fig. p. 183

BILLET, ETIENNE (1821—88), French. Pupil of Cogniet. Travelled in the East and the Maghreb. Algerian landscapes.

BINET, RENÉ (1866—1911), Swiss. Architectural painter. Travelled in Palestine and in Spain, whence he brought back excellent watercolours.

BISEO, CESARE (1843(44?)—1909), Italian. A brilliant decorator, he worked for the Khedive. Trip to Morocco, stays in Egypt. He did genre scenes, horses, and illustrations for travel books.

BLANCHARD, HENRI-PIERRE (1805—65), French. Pupil of Gros. Painted in Spain and in Morocco.

BLECHEN, KARL (1798—1840), German. Painter and decorator, he travelled in Italy and sometimes exhibited very detailed Oriental scenes.
Fig. p. 43

BONANTO, MINELLA CARLO (1855—78), Italian. Biblical scenes, somewhat in the manner of Gustave Moreau.

BONINGTON, RICHARD PARKES (1801—28), English. A marvellous watercolourist, he never went farther than Venice, but dreamt of harem scenes and was greatly inspired by Persian miniatures. Many French Orien-

talists imitated his compositions and colouring.
Fig. p. 32

BOSSOLI, CARLO (1815—84), Swiss. He spent his early years in Turkey and the Crimea where he did many canvases, then he went to Morocco. Official painter to Queen Victoria. At the end of his life he did many views of Venice.
Fig. p. 153

BOUCHARD, PAUL-LOUIS (1853—1937), French. Pupil of Lefebvre. Genre painter, sometimes Orientalist.
Figs. pp. 56, 92

BRABAZON, HERCULES BRABAZON (1821—1906), English. A rich connoisseur, he went to Morocco and Egypt and brought back hundreds of watercolours which were much in vogue.

BRANGWYN, FRANK (1867—1943), English. A painter working for the glory of the British Empire. Went round the world; stays mainly in Morocco, Constantinople, and in India. Large, highly coloured compositions.
Fig. p. 118

BRESDIN, RODOLPHE (1825—85), French. One of the best engravers of the nineteenth century, whose genius is too little known. Favoured fantastic and unusual subjects; taught lithography to Odilon Redon.

BREST, GERMAIN-FABIUS (1823—1900), French. Pupil of Troyon. Stayed in Constantinople and Asia Minor. Exhibited regularly at the Salon: views of Venice.
Fig. p. 158

BRIDGMAN, FREDERICK ARTHUR (1847—1928), American. Painted genre scenes in Algeria.

BRINDESI, JEAN (middle of the nineteenth century), Italian. Decorative painter, brought back slight, but pleasant genre scenes from Constantinople.
Fig. p. 185

184

Jean Brindesi: Turkish Carriage (Araba) – Sweet Waters of Asia *(detail),* c. 1855. Gouache, 33 × 56 cm. Jean Soustiel Coll., Paris. – Study for a series of lithographs.

Frank Buchser: Moroccan Market *(detail), 1880. Oil, 62 × 110 cm. Gottfried Keller Stiftung, Berne. – The great* suk *in Tangiers 100 years ago.*

BRYULOV, KARL PAVLOVICH (1799–1853), Russian. One of the best Russian Romantic portrait painters. From his stay in Greece and Constantinople he brought back studies for religious paintings and harem scenes.

BUCHSER, FRANK (1828–90), Swiss. Followed the Spanish-Moroccan war, then travelled in the Balkans.
Fig. p. 185

BUCKINGHAM, JAMES SILK (1786–1855), English. A diplomat, he brought back books and drawings from his stays in Persia.

BURCKHARDT, JOHN LEWIS (1818–97), Swiss. Worked in England during the first third of the nineteenth century. Travelled in the Levant.

CARAFFE, ARMAND-CHARLES (1762–1822), French. Worked in Russia, went to Egypt; exhibited Turkish scenes in a neo-classical style.

CARLISLE, GEORGE JAMES HOWARD, Earl of (1843–1911), English. A friend of the Pre-Raphaelites, he did numerous watercolours in Egypt.

CARPENTER, WILLIAM (1818–99), English. Long stay in India, where he painted and engraved genre scenes.
Fig. p. 162

CASSAS, LOUIS-FRANÇOIS (1756–1827), French. Pupil of Vien. A great traveller, he drew and engraved picturesque views of Greece. His excellent architectural paintings and his watercolours of Egyptian landscapes were greatly approved at the Salon.

CASTELLAN, ANTOINE-LAURENT (1772–1838), French. Engravings based on his travels in Greece and Syria. Exhibited landscapes and ruins; distinguished art critic.

CHACATON, JEAN-NICOLAS-HENRI DE (1813–86), French. Pupil of Marilhat and of Ingres. Exhibited at the Salon from 1835 to 1857. History painter. Travelled in Syria, whence he brought back biblical landscapes.

CHAMPMARTIN, CHARLES-EMILE (CALLANDE DE) (1797–1883), French. Pupil of Guérin. History painter who went to Constantinople. Exhibited

at the Salon between 1819 and 1848.
Fig. p. 91

CHASSÉRIAU, THÉODORE (1819–56), French. Pupil of Ingres. All his work was coloured by his journey to Algeria. One of the stars of Orientalism.
Figs. pp. 49, 51, 93, 96, 105

CHATAUD, MARC-ALFRED (1833–1908), French. Noticed at the Salons of the Second Empire for his genre scenes. Lived in Marseilles and Algeria.

CHINNERY, GEORGE (1748–1847), Irish. He spent part of his life in India, and part in China, whence he sent genre scenes and landscapes, which were highly esteemed. Excellent draughtsman. Picturesque portraits of rajahs and mandarins.

CHLEBOWSKI, STANISLAS VON (1835–84), Polish. Lived in Constantinople and painted very brilliant genre paintings and some historical canvases.
Fig. p. 155

CLAIRIN, GEORGES-JULES-VICTOR (1843–1919), French. Pupil of Pils and friend of Regnault, whom he accompanied to Morocco. Stays in Algeria; official portraitist to Sarah Bernhardt. A theatrical and prolific Orientalist, he left fine watercolours and brilliant sketches.
Figs. pp. 129, 175

COLOMBARI, F., Colonel (first half of the nineteenth century), Italian. Military engineer who worked in Persia and recorded his surroundings.
Fig. p. 160

CONSTANT, JEAN-JOSEPH, known as Benjamin (1845–1902), French. Pupil of Cabanel. Travelled in Morocco in 1872 and brought back themes that were very successful at the Salon. Painter of Byzantine history and official portrait painter.
Fig. p. 87

CORRODI, HERMANN DAVID SALOMON (1844–1905), Swiss-Italian. Architectural and history painter, highly regarded in England and Germany.
Fig. p. 151

COTTET, CHARLES (1863–1924), French. Visited Algeria in 1892 and Egypt in 1896. Good technique and an excellent colourist.
Fig. p. 176

CRAPELET, LOUIS-AMABLE (1822–67), French. Pupil of Corot. Travelled in Egypt and Tunisia. Stay in Constantinople, whence he sent drawings to magazines. He also did stage sets. Between 1846 and 1866 exhibited views of Egypt.
Fig. p. 187

DADD, RICHARD (1819–87), English. A very meticulous painter, he went mad after a journey to the Holy Land. As an inmate of a mental hospital, he painted extremely elaborate watercolours of a fantastic East.
Fig. p. 99

DAGNAN-BOUVERET, PASCAL-ADOLPHE-JEAN (1852–1929), French. Pupil of Gérôme. Successful Salon painter specializing in Breton and Orientalist themes and portraits.

DANIELL, SAMUEL (1775–1811), English. Took part in expeditions to Africa and India. Watercolours of animals and plants, very popular at the time.

DANIELL, THOMAS (1749–1840), English. A landscape artist, he went to India in 1784. With his nephew William he published six volumes of Oriental scenes. Exhibited Indian subjects at the Royal Academy.

DANIELL, WILLIAM (1769–1837), English. Nephew of the above. Excellent topographic painter and engraver.

DAUZATS, ADRIEN (1804–68), French. One of the best Orientalists. Travelled through the whole of the Near East, then followed the Duc

d'Orléans to Algeria. A prolific artist, very successful at the Salons. His architectural paintings are very precise and his colouring very vivid. His watercolours are greatly sought after.
Fig. p. 145

DEBAT-PONSAN, EDOUARD-BERNARD (1847–1913), French. Pupil of Cabanel. Official portrait painter, he did studio Orientalist scenes.
Fig. p. 62

DECAMPS, GABRIEL-ALEXANDRE (1803–60), French. Left Abel de Pujol's studio to travel in Turkey. Very quickly became a star of the Salon. A splendid Orientalist, he longed to be a history painter. His landscapes have a genuine grandeur. Excellent lithographer. He had many imitators.
Figs. pp. 39, 57

DEHODENCQ, EDMÉ-ALEXIS-ALFRED (1822–82), French. Pupil of Cogniet. Long stays in Andalusia and Morocco. Greatly influenced by Delacroix, he painted scenes of violence. Splendid draughtsman. One of the best Orientalists of the middle of the century, he was consistently successful at the Salon.
Fig. p. 121

DELACROIX, AUGUSTE (1809–68), French. Travelled in Algeria, whence he brought back genre scenes.

DELACROIX, FERDINAND-VICTOR-EUGÈNE (1798–1863), French. Always attracted by Orientalist themes, he was so inspired by his journey to Morocco in 1832 that it left a mark on practically all his subsequent work.
Figs. pp. 46, 83, 119

DELAHOGUE, ALEXIS-AUGUSTE (1867–1936), French. He brought back landscapes and picturesque scenes from Algeria.

DENEUX, GABRIEL-CHARLES (born 1856), French. Pupil of Gérôme. Travelled in Algeria and Greece. Did decorative groupings.

DENON, DOMINIQUE-VIVANT, Baron (1747–1825), French. Curator of the Louvre. Excellent watercolours of Egypt.

DEUTSCH, LUDWIG (1855–1930), Austrian, naturalized French. A pupil of Jean-Paul Laurens, this Viennese painter was the typical Salon Orientalist of the end of the nineteenth century. His very precise and colourful – though sometimes rather fanciful – pictures enjoyed a great success.
Fig. p. 141

DEVEDEUX, LOUIS (1820–74), French. Pupil of Delaroche and Decamps. Appreciated at the Salon for his rather fanciful "Turqueries".

DEVILLY, LOUIS-THÉODORE (1818–86), French. History and genre painter; pupil of Maréchal and Delaroche. Fond of depicting battle scenes.

DIAZ DE LA PEÑA, NARCISSE VIRGILE (1807–76), French. The most charming of the Barbizon painters. Dreamed up a fantastic East, which

187

was extremely successful and was imitated by Ziem and Monticelli.
Figs. p. 58

DIBDIN, THOMAS COLMAN (1810–93), English. Travelled in India. Favoured buildings and landscapes.

DINET, ALPHONSE-ETIENNE (1861–1929), French. Pupil of Bouguereau. Discovered Algeria in 1882 and went back there every year. One of the last Orientalists; for forty years his sensuality earned him great success at the Salon. Converted to Islam.
Fig. p. 125

DJEMAL, ALI, Turkish. Painted in Constantinople c. 1900. A Turkish disciple of Gérôme, he excelled at architectural paintings.

DORÉ, PAUL-GUSTAVE-LOUIS-CHRISTOPHE (1832–83), French. Painter, sculptor and illustrator. A magnificent draughtsman, famous for the books he illustrated.

DUFEU, EDOUARD-JACQUES (1840–1900), French. A gifted painter, whose uncompromisingly forceful ideas were too often misunderstood, he was commissioned to decorate the Khedive's palace. He brought back landscapes and genre scenes from Egypt and Turkey. Also painted in Venice.

DUPRÉ, LOUIS (1789–1837), French. Neo-classical history painter. Travelled in Greece and Turkey, whence he returned with watercolours of costumes and buildings. Exhibited at the Salon from 1817 to 1837.

DUVENECK, FRANK (born 1848), American. Dynamic genre painter who sometimes chose Oriental subjects.
Fig. p. 94

DUVIEUX, HENRI (second half of the nineteenth century), French. Pupil of Marilhat. Views of Constantinople and Venice. Cameleers and gondoliers, somewhat in the manner of Ziem.

EDY-LEGRAND, EDOUARD-LÉON-LOUIS (born 1892), French. Painter,

engraver and illustrator. A brilliant draughtsman, he contributed to a renaissance in book illustration.

ERLANGER, RODOLPHE FRANÇOIS D' (1872–1930), French. Came from a family of bankers. Stayed for a long time in North Africa, especially at Tunis. Submitted genre scenes to the Salon.

ERNST, RUDOLPH (born 1854), Austrian. Pupil of Feuerbach. Exhibited in Vienna and Munich, then in Paris. Fascinated by the religious aspect of Islam.
Figs. pp. 70, 161

EVENEPOEL, HENRI-JACQUES-EDOUARD (1872–99), Belgian. Excellent pupil of Moreau; he went to Algeria and brought back scenes from the life of the common people and some very fine drawings.
Fig. p. 126

FABBI, FABIO (1861–1946), Italian. An official painter, he went to Egypt and sent genre scenes to Italian exhibitions.

FALÉRO, LUIS RICCARDO (1851–96), Spanish. A disciple of Fortuny, he painted odalisques and gipsies.

FARQUHARSON, JOSEPH (1846–1935), Scottish. A painter of the Scottish moors, he brought back some landscapes from a stay in Cairo.

FORBIN, LOUIS-NICOLAS-PHILIPPE-AUGUSTE, Comte de (1777–1841), French. Pupil of David. Officer in Napoleon's army, archaeologist in the East in 1818, director of the Louvre, painter of historical subjects and ruins. Published lithograph albums of his travels. Exhibited at the Salon between 1796 and 1840.

FORTUNY, MARIANO (1838–74), Spanish. Followed General Prim's expedition beyond Gibraltar. Greatly inspired by the province of Tangiers, which was conquered at the time. Took Regnault to Spain and Morocco.
Fig. p. 117

FRÈRE, CHARLES-THÉODORE (1814–88), French. Pupil of Roqueplan and Cogniet. One of the best Salon Orientalists, he exhibited from 1834 to 1882. Many stays in Algeria and Cairo. His numerous works, especially desert scenes and views of the Nile, are of a high quality. Had many imitators.
Figs. pp. 61, 140

FROMENTIN, EUGÈNE (1820–76), French. The most famous of the Orientalists. Numerous stays in Algeria; also went to Egypt with the Empress. His extensive work has always been rated highly. Splendid draughtsman. A well-known art critic and novelist.
Figs. pp. 52, 53

GE [GAY], NIKOLAI NIKOLAIEVICH (1831–94), Russian. Studied in Italy. Fond of Oriental settings. He was the favourite court painter in Russia in the second half of the nineteenth century.

GÉRÔME, JEAN-LÉON (1824–1904), French. Pupil of Delaroche. As a young man he travelled in Turkey and stayed frequently in Cairo. History painter, but was more inspired by the East. His photographic precision of execution sometimes clashes with the pretentiousness of the subjects. He finished his career as a sculptor. From the time he first submitted to the Salon in 1847, his work was extensively reproduced and imitated.
Figs. pp. 65, 103

GHYZIS, NICOLAS (first half of the nineteenth century), Greek. Battles, genre scenes.

GIRARDET, CHARLES (1813–71), Swiss. Pupil of Cogniet. History painter, greatly valued by Louis-Philippe. Travelled in Egypt and Spain. Prolific draughtsman.

GIRARDET, EUGÈNE-ALEXANDRE (1853–1907), French. Pupil of Gérôme. Numerous stays in Algeria, where he specialized in scenes of nomad life and desert views. Often imitated Guillaumet.
Fig. p. 130

GIRAUD, PIERRE-FRANÇOIS-EUGÈNE (1806–80), French. Engraver and painter who favoured Orientalist subjects after his travels with Alexandre Dumas in the Near East.

GIRODET DE ROUCY, ANNE-LOUIS, known as Girodet-Trioson (1767–1824), French. One of Napoleon's favourite painters, often attracted by exotic subjects. His *Revolt in Cairo* was the starting point of French Orientalism.
Fig. p. 27

GLEYRE, MARC-GABRIEL-CHARLES (1806–74), Swiss. Pupil of Hersent. Long stay in Upper Egypt in 1836. Returned by way of the Holy Land, whence he drew inspiration for biblical subjects. Very successful with *Evening or Lost Illusions* at the Salon of 1843. Became painter of historical subjects. Brought back numerous sketches and very fine drawings from the East.
Figs. pp. 85, 138

GOW, ANDREW GARRICK (1840–1920), English. History painter, very popular at the Royal Academy. After a stay in Cairo painted rather unoriginal Egyptian scenes.

GROS, ANTOINE-JEAN, Baron (1771–1835), French. Highly regarded by Bonaparte, he illustrated the Emperor's feats. His *Battle of Aboukir* heralds Orientalism.
Fig. p. 26

GUDIN, JEAN-ANTOINE-THÉODORE, Baron (1802–80), French. Pupil of Girodet. Seascape painter, he exhibited at the Salon and at the Royal Academy. Brought back battle scenes and harbour views from his travels in Greece and Algeria.

GUILLAUMET, GUSTAVE ACHILLE (1840–87), French. One of the best Orientalists of the mid-century. He lived for a long time in Algeria, where he painted without concessions to the picturesque. His desert landscapes have real grandeur. Distinguished writer.
Figs. pp. 69, 131

Carl Haag: The Camel, 1871. Watercolour, 52 × 36.8 cm. R. G. Searight Coll., London. – A little reminiscent of the naïve hero in Alphonse Daudet's novel, Les Aventures prodigieuses de Tartarin de Tarascon, *as he sets out on the lion-hunt.*

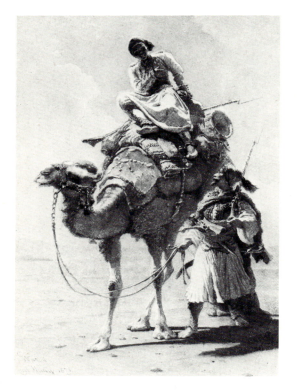

GUYS, CONSTANTIN (1802–92), French. A reporter with the army of Napoleon III, he brought back numerous wash tints from Constantinople and the Crimea; he favoured women, street scenes and battles as themes.
Fig. p. 171

HAAG, CARL (1820–1915), German. Settled in London. Travelled in Egypt and Syria. Fine watercolours. Excelled at architectural views and women's heads.
Fig. p. 190

HAMDY-BEY, OSMAN-EDHEM-PACHA-ZADEH (1842–1910), Turkish. Genre painter and archaeologist; pupil of Boulanger. He founded the Museum of Constantinople, of which he was named the first curator.

HESS, PETER HEINRICH LAMBERT VON (1792–1871), Bavarian. History painter; followed King Otto I to Greece and brought back heroic and picturesque scenes.

HILAIRE, JEAN-BAPTISTE (1753–1822), French. Accompanied Choiseul-Gouffier to Turkey in 1776; his elegant *"Turqueries"* enjoyed a great success at the Salons.

HUNT, WILLIAM HOLMAN (1827–1910), English. Pre-Raphaelite. Went to the Holy Land by way of Egypt to document biblical scenes, which were tremendously successful. Splendid draughtsman.
Figs. pp. 41, 44

INGRES, JEAN-AUGUSTE-DOMINIQUE (1780–1867), French. To him the East was an excuse to justify the most sensual nudes.
Figs. pp. 96, 97

IVANOV, ALEXANDER ANDREYEVICH (1806–58), Russian. Both mystic and realist, a painter who was highly regarded in Russia and went to the Holy Land to gather material.
Fig. p. 144

JANOVICH (end of the nineteenth century), Serb. Traditional folk scenes.

JOINVILLE, ANTOINE-VICTOR-EDOUARD-MADELEINE (1801–49), French. Pupil of Hersent. Stays in Algeria, exhibited landscapes between 1831 and 1848. Very fine drawings.

JONES, OWEN (1809–74), English. Architectural draughtsman, published a collection of coloured plates of the Alhambra. Travelled in the East and took part in the exhibition at the Crystal Palace.

JUNDT, GUSTAVE-ADOLPHE (1830–84), French. Sent drawings to magazines from Algeria.

KRAZEISEN, GENERAL KARL (1794–1878), Bavarian. Battle painter. Came to Greece in the retinue of King Otto; brought back watercolours of costumes.

Frederick Lord Leighton: Turk's Head. Charcoal, 17.8×14 cm. R.G. Searight Coll., London. – Souvenir of a journey in the East by a famous member of the Royal Academy.

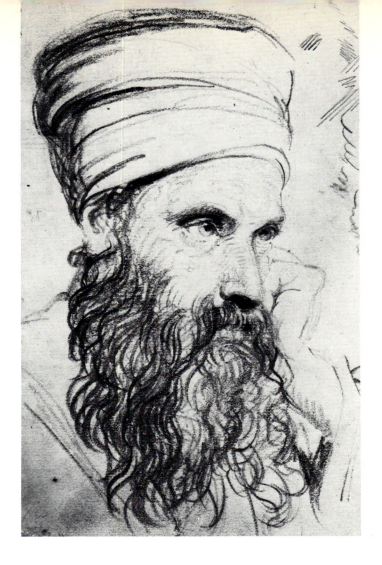

LABBÉ, EMILE-CHARLES (1820–85), French. Algerian subjects.
Fig. p. 157

LANDSEER, GEORGE (1834–78), English. A portrait painter, he went to India and Kashmir, where he painted maharajahs and did watercolours.

LANE, EDWARD WILLIAM (1801–76), English. Draughtsman, worked in Turkey and Syria.

LANZA, VINCENZO (1832–1910), Italian. Specialized in ruins and Greeks.

LAURENS, JULES-JOSEPH-AUGUSTIN (1825–1901), French. Excellent draughtsman; travelled in Turkey. His *"Turqueries"* had some success at the Salon. Long stays in Persia, whence he brought back numerous architectural and landscape paintings.
Fig. p. 159

LAURENS, PAUL-ALBERT (1870–1934), French. Son of Jean-Paul Laurens; pupil of Benjamin Constant. A portrait painter, he studied the common people in Tunisia.

LEAR, EDWARD (1812–88), English. Poet and great traveller, painted hundreds of watercolours, which were highly thought of in England.
Fig. p. 36

LEBLANC, THÉODORE (1800–37), French. Pupil of Charlet. A brilliant officer. Left interesting lithographs and good watercolours of his campaigns in Greece and Algeria.

LECOMTE DU NOÜY, JEAN-JULES-ANTOINE (1842–1923), French. Gérôme's favourite pupil, he went to Turkey and Egypt in 1875, and stayed in Rumania. From 1863, his – mainly Eastern and Byzantine – history paintings were very successful.
Figs. pp. 63, 66

LECOMTE-VERNET, CHARLES-EMILE-HIPPOLYTE (1821–1900), French. Pupil of his uncle, Horace Vernet and of Cogniet. History painter.
Fig. p. 135

LEIGHTON, FREDERICK, Lord (1830–96), English. The freest of the English academic painters, he went to the Holy Land. On his return, had a Moorish hall built in his house in Kensington.
Fig. p. 191

LELEUX, ADOLPHE-PIERRE (1812–91), French. History and genre painter and engraver. Painted Breton and Algerian subjects and views of the Pyrenees.

LEROY, PAUL-ALEXANDRE-ALFRED (1860–1942), French. Stays in Egypt and North Africa; his favourite subjects were horses and local colour.

LESSORE, EMILE-AUBERT (1805–76), French. Pupil of Ingres. Exhibited architectural views at the Salon between 1831 and 1869. Stays in Morocco.

LÉVY-DHURMER, LUCIEN (1865–1953), French. A Symbolist; travelled in Persia, Turkey, and Morocco after 1900. Brought back some very fine pastels, but was less successful in his genre scenes.
Figs. pp. 170, 177

LEWIS, FREDERICK CHRISTIAN (1813–75), English. Called "Indian Lewis" to distinguish him from his brother. During his travels in Persia and India, he drew costumes and ceremonies.
Fig. p. 163

LEWIS, JOHN FREDERICK (1805–76), English. The most famous of the English Orientalists; exhibited at the Royal Academy from 1821. In 1832 he went to Spain for two years. From 1842–51, long stay in Egypt. President of the Watercolour Society. His work, at first watercolours and then, above all, oils, was very sophisticated and has always been much sought after; because of its great attention to detail it has some-times been confused with Pre-Raphaelite works.
Figs. pp. 35, 68, 133

LOUBON, EMILE-CHARLES-JOSEPH (1809–1903), French. Pupil of Granet. After a trip to Algeria painted exotic landscapes. Went to Palestine.

LUNDGREN, EGON SILLIF (1815–75), Swedish. Travelled in India and Spain. Sent excellent drawings to magazines. Member of the Watercolour Society.

LUNOIS, ALEXANDRE (1863–1916), French. His extensive travels in Spain, Morocco, Turkey, and Asia influenced his works – lithographs, pastels and oil paintings – which were very popular during his lifetime.

LYTRAS, NICEPHORUS (1832–1904), Greek. Painted local scenes and *"Turqueries"*.

MACKEWAN, DAVID HALL (1817–73), English. Watercolourist very much influenced by William James Muller. Exhibited in London from 1836 to 1876. Travelled in the Middle East from 1840 to 1850.
Fig. p. 192

MAJORELLE, JACQUES (end of the nineteenth – beginning of the twentieth century), French. A painter who brought back picturesque scenes from his trips to Africa.

MAKART, HANS (1840–84), Austrian. Called "the Viennese Rubens". History painter with a vivid imagination and equally vivid palette. From his journey to Egypt, he derived the idea of a sumptuous Antiquity.
Fig. p. 71

MAKOVSKY, CONSTANTIN EGOROVICH (1839–1915), Russian. Romantic landscape painter and excellent topographic painter whose works were often reproduced in contemporary magazines. A stay in Egypt inspired some very colourful watercolours.
Fig. p. 76

MARILHAT, PROSPER-GEORGES-ANTOINE (1811–47), French. With Decamps, the best first-generation Orientalist. More accurate than Decamps, especially in architectural features and drawings. Long stay in Cairo and travels in Syria. Exhibited from 1831 to 1844.
Figs. pp. 139, 193

MARTIN, JOHN (born 1795), English. Landscape painter popular at the beginning of the nineteenth century.

MARZOCCHI DE BELLUCCI, NUMA (second half of the nineteenth century), French. Pupil of Cabanel. Stays in Algeria. Exhibited at the Salon from 1876. Genre scenes and horses were his favourite subjects.

MATOUT, LOUIS (1811–88), French. A history painter, sometimes a studio Orientalist. His Moorish women had a measure of success at the Salon.

MELLING, ANTOINE-IGNACE (1763–1830), French. Painter attached to the Ministry of Foreign Affairs. Stayed in Constantinople, where he became architect to Sultana Hadidge. Brought back precise and elegant drawings which were engraved in the *Voyage pittoresque de Constantinople et des rives du Bosphore.*

MEMPES, MORTIMER (1860–1938), English. Travelled through the whole of the Far East and in North Africa. Brought back watercolours that are more like picture postcards.

MERSON, LUC-OLIVIER (1846–1920), French. A history painter and pupil of Chassevent and of Pils. One of the great defenders of classicism; used Orientalist settings.
Fig. p. 67

MONTFORT, ANTOINE-ALPHONSE (1802–84), French. Travelled in Syria and Lebanon. Excellent at horses and architectural features.

MONTICELLI, ADOLPHE-JOSEPH (1824–86), French. The most delightful of the armchair Orientalists. His canvases always suggest a Second-Empire fancy-dress ball.
Fig. p. 81

MOREAU, GUSTAVE (1826–98), French. His poetical and mystic Orientalism was inspired by the works that his friends, like Fromentin, brought back from their travels in the East.
Fig. p. 84

MUCHA, ALPHONSE (1860–1939), Czech. Studied in Prague, Munich and Paris. Pupil of J.P. Laurens, Boulanger and Lefebvre. Famous for his posters, particularly of Sarah Bernhardt.

MÜLLER, CARL (first half of the nineteenth century), Swiss. Popular in England. From a journey to Turkey he brought back pictures of ruins, landscapes and scenes from the life of the common people. Very nice watercolours.

MÜLLER, LEOPOLD KARL (1834–92), Austrian. One of the best Austrian genre painters. From a long stay in Egypt brought back large picturesque scenes, which were very successful, particularly in England.
Figs. pp. 40, 73

MULLER, WILLIAM JAMES (1812–45), English. In 1838 travelled to Greece and Egypt; in 1841 joined Lycie's expedition, returning with many drawings and sketches. One of the best English Orientalists; his works were very popular.
Fig. p. 134

OYLY, SIR CHARLES D' (1781–1845), English. An architect, he did numerous paintings in India in the manner of Daniell.

PAGE, WILLIAM (first third of the nineteenth century), English. Topographic painter; brought back watercolours and landscapes from Turkey.

PARIS, REAR-ADMIRAL, French. During the Second Empire travelled in the Holy Land and brought back interesting lithographs.

PASINI, ALBERTO (1826–99), Italian. Very close to Fromentin. Travelled in Turkey, Persia, and Arabia.
Fig. p. 156

PAVIL, ELIE ANATOLE (1873–1948), Russian. Colonial painter; painted genre scenes, mainly in Morocco.

PENNEL, JOSEPH (1860–1926), American. Painter and etcher. Published sketches of Dalmatia.

PHILIPPOTEAUX, FÉLIX (1815–84), French. Pupil of Cogniet. Battle painter in Algeria. Good draughtsman.

PHILLIPS, JOHN (first half of the nineteenth century), Scottish. Famous illustrator around 1840.

POINT, ARMAND (1860(61?)–1932), French. Born in Algiers, his first subjects were Algerian. Later he tried to revive fifteenth- and sixteenth-century art in France on the Pre-Raphaelite model.

PORTER, SIR ROBERT KERR (1777–1842), English. A history painter who travelled extensively in Russia and the Orient, particularly in Persia.

PREZIOSI, AMADEO, Count (1816–82), Maltese. Fully accepted in Constantinople society after his marriage to a Greek woman. He painted graceful genre scenes, which were often reproduced in coloured lithographs. Second-Empire *"Turqueries"*.
Figs. pp. 95, 154

PROUVÉ, VICTOR EMILE (1858–1943), French. Pupil of Devilly and Cabanel. Attracted by Oriental subjects; his *Sardanapalus* is in the Museum of Algiers.

RAFFET, DENIS-AUGUSTE-MARIE (1804–60), French. Pupil of Gros. Famous artist of lithographs based on the campaigns of Napoleon and the Algerian campaigns, though he never went there. Travelled in the Crimea in 1837 and brought back an album of lithographs.

RAINALDI, FRANCESCO (1770–1805), Italian. An engraver who worked in Rome and Florence.
Fig. p. 29

RALLI, THÉODORE (1852–1909), Greek. One of the best Greek painters, specialized in religious scenes, but did excellent genre paintings in Constantinople.

REGNAULT, HENRI-ALEXANDRE-GEORGES (1843–71), French. A great painter, gave a new lease of life to Orientalism. Excelled in scenes of violence. Stays in Spain and Morocco. Influenced by the Spanish masters.
Figs. pp. 89, 120

Edouard Riou: Inauguration of the Suez Canal *(detail), 1869. Water-colour, 33×45 cm. Compagnie financière de Suez, Paris. – A striking portrayal of the invasion of the East by the West.*

David Roberts: Sketch of a Caravan at Tangiers *(detail), 1833. Drawing, 24.7×16.5 cm. R.G. Searight Coll., London. – All the Orientalists brought back sketchbooks which provided them with material for their full-scale paintings.*

REPIN, ILYA YEFIMOVICH (1844–1930), Russian. History painter. His *Cossacks Defying Sultan Mahmud IV* is a masterpiece of military Orientalism.
Fig. p. 160

RIOU, EDOUARD (1833–1900), French. Did excellent drawings for magazines, also painted landscapes and genre scenes during his trip to Egypt.
Fig. p. 195

ROBERTS, DAVID (1796–1864), Scottish. His precision in architectural painting and his romantic colouring make him one of the most interesting British Orientalists. He stayed for a long time in Spain, Morocco, and Egypt, and published some very fine lithograph albums based on his drawings.
Figs. pp. 115, 137, 195

ROCHEGROSSE, GEORGES ANTOINE (1859–1938), French. A gifted and prolific painter, but lacking taste. Had great success at the Salons with

pictures of historical Orientalism. He illustrated Flaubert's *Salammbô.* At the close of his life lived in Algiers, where he painted genre scenes.
Fig. p. 174

ROGIER, CAMILLE, French. A great friend of Théophile Gautier, he lived in Constantinople, where he entertained artists who were passing through. He painted gallant *"Turqueries"* exhibited at the Salon between 1839 and 1848.

ROTTMANN, CARL (1788–1850), Bavarian. Accompanied King Otto to Greece and brought back drawings of costumes and some landscapes.

ROUBAUD, BENJAMIN, known as Benjaim (1811–47), French. Genre painter and caricaturist. Successful at the Salon with Algerian subjects. Died in Algiers.

ROUSSEAU, HENRI EMILIEN (1875–1933), French. Pupil of Gérôme. A colonial painter, who concentrated on Algerian subjects, somewhat like Fromentin.

RYSSELBERGHE, THÉO VAN (1862–1926), Belgian. A Symbolist, went to Algeria to paint landscapes.

SCHMIED, FRANÇOIS LOUIS (1873–1941), Swiss. Pupil of Dampt. A colonial painter who worked mainly in Morocco. Very popular around 1925.

SCHOEFFT, AUGUST THEODOR (1809–88), Austro-Hungarian. Painter who travelled extensively in Europe and Asia, specializing in portraits.

SCHREYER, ADOLF (1828–99), German. Painter of fantasias.

SEDDON, THOMAS (1821–56), English. Painter of landscapes and Orientalist subjects. Accompanied Holman Hunt to the Orient in 1853–54. Died in Cairo during a later trip.

SERT Y BADIA, JOSÉ-MARIA (1876–1945), Spanish. Painter-decorator with a fine gift for colours. Lived in Paris for many years. Illustrated Gide's *Bathsheba*.

SIMON, LUCIEN (1861–1945), French. Landscape painter; Stays in Algeria. His Breton scenes were very popular.

SIMONI, GUSTAVO (second half of the nineteenth century), Italian. Influenced by Fortuny. A genre painter, travelled in Spain and Algeria. His watercolours were highly thought of.
Fig. p. 130

SMITH, ROBERT (1792–1882), Irish. Amateur painter who favoured Italian and Indian landscapes and portraits.

SOLOMON, SIMEON (1840–1905), English. Jewish artist influenced by Rossetti.
Fig. p. 143

SPITZWEG, CARL (1805–85), German. Influenced by Diaz de la Peña. Genre painter who treated pleasant themes.
Fig. p. 79

STUBBS, GEORGE (1724–1806), English. Famous animal painter specializing in horses. Drew the first Arabian horses from which today's thoroughbreds are descended.

SUREDA, ANDRÉ (1872–1930), French. A late Orientalist with a simplified style. Favoured Moroccan and Algerian scenes.

TIFFANY, LOUIS COMFORT (1848–1933), American. A great master of decorative Art Nouveau, painted landscapes in Algeria and Morocco.
Fig. p. 118

TISSOT, JAMES JACQUES JOSEPH (1836–1902), French. This sophisticated genre painter went to Palestine in 1890; he spent five years there and returned with hundreds of drawings to illustrate an extremely accurate background to the Life of Christ.
Fig. p. 146

TOURNEMINE, CHARLES EMILE DE (1812–72), French. Pupil of Isabey. Travelled in the Balkans, in Turkey, and in Egypt. His architectural paintings are lyrical and his landscapes accurate. An excellent painter, he later became curator of the Musée du Luxembourg.
Fig. p. 107

USSI, STEFANO (1822–1901), Italian. An official Italian painter; worked for the Khedive, then brought back canvases *à la* Fromentin from Morocco.

VARLEY, JOHN, the younger (second half of the nineteenth century), English. Exhibited Egyptian scenes at the Royal Academy from 1870 to 1895. His watercolours are sought after.

VERESHCHAGIN, VASILY VASILYEVICH (1842–1904), Russian. An architectural and battle painter; travelled in Central Asia and India, adding a metaphysical dimension to his vast picturesque canvases. Very famous in Russia.
Fig. p. 166

VERNET, CARLE (1758–1836), French. Famous history painter; at the time of the Restoration did lithographs of Arab horsemen.

VERNET, HORACE (1789–1863), French. A battle painter, he accompanied the army to Algeria. He travelled in Russia and the Near East. His canvases were immensely successful. His *Judith and Holofernes* is one of the best examples of academic Orientalism.
Figs. pp. 123, 128

VIBERT, JEHAN GEORGES (1840–1902), French. Very Parisian genre painter, sometimes tending towards Orientalism.

VINCENT, FRANÇOIS ANDRÉ (1746–1816), French. A history painter; pupil of Vien. A rival of David's, he was considered a great artist by his contemporaries.

VOLERI, SILVESTRO (1814–1902), Italian. Genre painter influenced by Fortuny.

VRYZAKIS, THEODORE (1814–78), Greek. Trained in Munich with Peter von Hess; his Greek and Turkish genre scenes were very successful in Germany.

WALLIS, HENRY (1830–1916), English. Watercolourist; did excellent architectural pictures in Cairo.
Fig. p. 78

WALTON, ELIJAH (1832–80), English. Landscape painter, went to Egypt and Turkey.

WASNETZOV, VICTOR M. (1848–1919), Russian. A history painter and portraitist who added Orientalist touches to his works.

WERNER, CARL FRIEDRICH HEINRICH (1808–94), German. Travelled in Spain and the Holy Land. His landscapes and architectural paintings are highly regarded in Germany.
Fig. p. 142

WILKIE, SIR DAVID (1785–1841), Scottish. One of the most famous painters of his generation. Went to the Holy Land, and to Constanti-

nople, where he did the Sultan's portrait. His death at sea inspired one of Turner's masterpieces.

WITSEN, WILHELM (1860–1923), Dutch. Engraver; travelled in India.

WITTMER, JOHANN MICHAEL (1802–80), German. Accompanied the Crown Prince of Bavaria to Greece, Asia Minor, and Sicily, whence he brought back portraits and landscapes.
Fig. p. 150

WYLD, WILLIAM (1806–89), English. Disciple of Horace Vernet, a friend of Bonington and Delacroix. Long stays in Algeria; successfully exhibited genre scenes at the Salon and the Royal Academy.
Fig. p. 127

YRIARTE, CHARLES (1832–98), French. An architectural painter and author who illustrated his works with Oriental scenes.

ZIEM, FÉLIX (1821–1911), French. Of Croat origin. Travelled in Russia when he was very young, then stayed in Constantinople and Venice. His work is very colourful and interesting. He painted hundreds of more or less Eastern seascapes.
Figs. pp. 59, 60

ZOFFANY, JOHN (1733–1810), German. Settled in England and travelled to India from 1783 to 1789. He painted portraits and genre scenes.

ZONARO, FAUSTO (1854–1929), Italian. Landscapes and Turkish scenes.

General Works and Travel Books

Alazard, Jean. *L'Orient et la Peinture française au XIX^e siècle: De Delacroix à Renoir*. Paris, 1930.

Allard, Dr Camille. *Souvenirs d'Orient: Les Echelles du Levant*. Paris, 1864.

Ampère, Jean-Jacques. *Voyage en Egypte et en Nubie*. Paris, 1868. (excerpt from *La Revue des Deux-Mondes*, vols. 15 and 16, 1846).

Arberry, A.J. *The Legacy of Persia*. London, 1930.

– *British Orientalists*, London, 1943.

Barth, H. *Les Villes d'art célèbres: Constantinople*. Paris, 1906.

Barthélemy Saint-Hilaire, J. *Lettres sur l'Egypte*. Paris, 1857.

Baudelaire, Charles. *Curiosités esthétiques*. Lausanne, 1956.

Bénézit, Emmanuel. *Dictionnaire critique et documentaire des Peintres, Sculpteurs, Dessinateurs et Graveurs*. 8 vols. New, revised edition. Paris, 1966.

Besnard, Albert. *L'Homme en rose*. Paris, 1910.

Bezombes, Roger. *L'Exotisme dans l'Art et la Pensée*. Paris, 1953.

Blondel, Edouard. *Deux ans en Syrie et en Palestine (1838–1839)*. Paris, 1840.

Blunt, W.S. *My Diaries: Being a Personal Narrative of Events, 1888–1914*. London, 1919, 1920.

Boppe, A. *Les Peintres du Bosphore au XVIII^e siècle*. Paris, 1911.

Bouillier, Eugène. *Lettre d'un pèlerin de Jérusalem: Journal d'un voyage en Orient*. Laval, 1854.

Brindesi, Jean. *Musée des Anciens Costumes turcs de Constantinople*. Paris, n.d.

– *Souvenir de Constantinople*. Paris, c. 1855.

Bruin, Cornelis de. *Travels in Moscovy, Persia and the East Indies....* London, 1737.

– *Voyage au Levant....* (translated from the Flemish) Delft, 1700.

Burchell, S.C. and Chassigneux, André. *Le Canal de Suez*. Paris, 1967.

Burton, Isabel. *The Inner Life of Syria, Palestine and the Holy Land*. 2 vols. London, 1875.

Burton, Sir Richard. *A Plain and Literal Translation of the Arabian Nights Entertainment...* 16 vols. Benares, 1885–88.

Byron, George Gordon Noel, Lord. *The Corsair*. In *Byron: Poetical Works*. Reprinted. London, 1967.

– *The Giaour*. In *Byron: Poetical Works*. Reprinted. London, 1967.

– *Childe Harold's Pilgrimage*. In *Byron: Poetical Works*. Reprinted. London, 1967.

Cadavalne, Edmond de and Breuvery, J. de. *L'Egypte et la Turquie de 1829 à 1836*. 4 vols.; *Egypte et Nubie*. vols. 1,2. Paris, 1836.

Carré, Jean-Marie. *Voyageurs et Ecrivains français en Egypte*. Cairo, 1932.

Celebonovic, Aleksa. *The Heyday of Salon Painting*. London, 1974.

Chateaubriand, F. R. de. *L'Itinéraire de Paris à Jérusalem*. Paris, 1811.

– *Les Aventures du dernier Abencérage*. Paris, 1807; London, 1826.

Chew, Samuel. *The Crescent and the Rose*. London, 1937.

Choiseul-Gouffier, Marie Gabriel Florent Auguste. *Voyage pittoresque de la Grèce*. 3 vols. Paris, 1780–1824.

Cornille, Henri. *Souvenirs d'Orient: Constantinople, Grèce, Jérusalem, Egypte, 1831, 1832, 1833*. Paris, 1833.

Corrant, A. *The Oriental Tale in England*. London, n.d.

Davis, Ralph. *Aleppo and Devonshire Square*. London, 1967.

Delacroix, Eugène. *Journal*. 3 vols. Paris, 1893–95.

– *Lettres*, Published by P. Burty, Paris, 1878.

Denon, Dominique-Vivant. *Voyage dans la Basse et la Haute-Egypte pendant les Campagnes du général Bonaparte*. Paris, 1802.

– *Description de l'Egypte*. Paris, 1808–25.

Du Camp, Maxime. *Egypte, Nubie, Palestine et Syrie: Dessins photographiques recueillis pendant les années 1849, 1850 et 1851, accompagnés d'un texte explicatif et précédés d'une introduction*. 2 vols. Paris, 1852.

– *Souvenirs et Paysages d'Orient: Smyrne, Ephèse, Magnésie, Constantinople, Scio*. Paris, 1848.

Duckett, William Alexander. *La Turquie pittoresque: Histoire, mœurs, description*. Preface by T. Gautier. Paris, 1855.

Dugat, Gustave. *Histoire des Orientalistes de l'Europe: Du XII^e au XIX^e siècle*. 2 vols. Paris, 1868–70.

Dumas, Alexandre, *père*. *Le Véloce, ou Tanger, Alger et Tunis; Ouvrage entièrement inédit*. 4 vols. Paris, 1848–51.

– and Dauzats, Adrien, *Quinze jours au Sinaï*. Paris, 1841.

Durakan, Zeynep M. *The Harem of the Topkapi Palace*. Istanbul, 1973.

Essad, Djelah. *Constantinople de Byzance à Stamboul*. Paris, 1909.

Estailleur-Chanteraine, P. d'. *Abd-el-Kader*. Paris, 1931.

FitzGerald, Edward. *The Rubáiyát of Omar Khayyám*. London, 1859.

Flaubert, Gustave. *Lettres d'Egypte de Gustave Flaubert, d'après les manuscrits autographes*. Edited by Antoine Youssef Naaman. Paris, 1965.

– *Voyage en Orient*. Edited by René Dumesnil. In *Œuvres complètes de Flaubert: Voyages*. vol. 2. Paris, 1948.

Forster, E. M. *Alexandria*. Alexandria, 1922.

Fromentin, Eugène. *Sahara et Sahel (Un Eté dans le Sahara et Une Année dans le Sahel)*. Paris, 1887.

Gail, Marzia. *Persia and the Victorians*. London, 1951.

Gautier, Judith. *Le Dragon impérial*. Paris, 1896.

– *L'Inde éblouie*. Paris, 1900.

Gautier, Théophile. *Fra Las Montes: Voyage en Espagne*. Paris, 1845.

– *Voyages pittoresques en Algérie*. n.p. 1845. Reprinted: Geneva, 1973.

– *Emaux et Camées*. Paris, 1852.

– *Constantinople*. New edition. Paris, 1856.

– *Abécédaire du Salon de 1861, etc*. Paris, 1861.

– *Les Dieux et Demi-Dieux de la Peinture*. Paris, 1864.

Gobineau, comte Joseph Arthur de. *Trois Ans en Asie, de 1855 à 1858*. Paris, 1859.

– *Nouvelles asiatiques*. n.p., 1876; Paris, 1913.

Goupil, Frédéric Auguste Antoine. *Voyage d'Horace Vernet en Orient, rédigé par M. Goupil-Fesquet*. Paris, 1843.

Hammer-Purgstall, Joseph von. *Die Staatsverfassung des Osman-Reiches*. 2 vols. Vienna, 1814.

– *Diwan des Hafis*. n.p. 1813.

Hearn, Lafcadio. *Out of the East*. Boston and New York, 1895.

– *Gleanings in Buddha-Fields*. London, New York, Boston, 1898.

Heine, Heinrich. *Reisebilder*. 4 parts. Hamburg, 1826–34.

– *Romanzero*. In *Heinrich Heine's Sämtliche Werke*. 10 vols. Hamburg, 1851.

– *Almansor*. In *Heinrich Heine: Sämtliche Werke*. 4 vols. Edited by F. Lachmann. Leipzig, n.d.

Hugo, Victor. *Les Orientales*. Paris, 1829.

Iorga, N. *Les Voyageurs français dans l'Orient européen*. Paris, 1928.

Jourda, Pierre. *L'Exotisme dans la Littérature française depuis Chateaubriand*. 2 vols. Paris, 1938. [1956]

Kinglake, A.W. *Eōthen*. London, 1844.

Lamartine, Alphonse de. *Souvenirs, Impressions, Pensées et Paysages pendant un Voyage en Orient (1832–1833)*. 2 vols. Paris, 1835.

Lear, Edward. *Letters of Edward Lear to Chichester Fortescue, Lord Carlingford and Frances Countess Waldegrave*. Edited by Lady Strachey of Sutton Court. London, 1907.

– *Later Letters*. Preface by Hubert Congreve. London, 1911.

Lewis, B.D. *The Middle East and the West*. London, 1964.

Loti, Pierre. *Aziyadé*. Paris, 1879.

– *Roman d'un Spahi*. Paris, 1881.

– *Fantôme d'Orient*. Paris, 1892.

– *Le Désert*. Paris, 1895.

– *La Galilée*. Paris, 1896.

– *L'Inde sans les Anglais*. Paris, 1903.

– *Vers Ispahan*. Paris, 1904.

Macaulay, Rose. *The Pleasure of Ruins*. London, 1951.

Malcolm, Sir John. *Sketches of Persia from the Journals of a Traveller in the East*. 2 vols. London, 1827.

Mamboury, E. *Istamboul touristique*. Istanbul, 1951.

Marcellus, comte de. *Souvenirs de l'Orient*. 2 vols. Paris, 1839.

Mardrus, J.C., Doctor. *Les Mille et Une Nuits*. 16 vols. Paris, 1898–1904.

Mariette, F.A.F. *Itinéraire des invités aux fêtes d'inauguration du canal de Suez*. 3rd revised edition. Cairo and Paris, 1880.

– *Itinéraire de la Haute-Egypte, comprenant une description des monuments antiques des rives du Nil entre le Caire et la première cataracte*. Alexandria, 1872.

Marmier, Xavier. *Du Rhin au Nil: Tyrol, Hongrie, Provinces danubiennes, Syrie, Palestine, Egypte. Souvenirs de voyage*. Paris, 1847.

Meester, Marie de. "*Oriental Influences in the English Literature of the Nineteenth Century*." In *Anglistische Forschungen*. Edited by J. Hoops. Heidelberg, 1915.

Meryan, Dr Charles Lewis. *Travels of Lady Hester Stanhope: Forming the Completion of her Memoirs, Narrated by her Physician [C.L. Meryan]*. 3 vols. 1846.

Montagu, Lady Mary Wortley. *Letters*. n.p. 1727.

Moore, Thomas. *Lalla Rookh: An Oriental Romance*. London, 1817.

Morier, James J. *A Journey through Persia, Armenia, and Asia Minor, to Constantinople, in the Years 1808 and 1809: In Which Is Included Some Account of the Proceedings of his Majesty's Mission under Sir Harford Jones, Bart., to the Court of the King of Persia*. London, 1812.

– *The Adventures of Hajji Baba, of Ispahan*. 3 vols. Paris, 1824.

Musset, Alfred de. *Namouna*. Paris, 1833.

Nerval, Gérard de. *Voyage en Orient: Turquie*. vol. 2 Reprinted. Paris, 1964.

Nouty, Hassan. *Le Proche-Orient dans la Littérature française*. Cairo, 1958.

Pardieu, comte de. *Excursion en Orient: Egypte, le mont Sinaï, l'Arabie, la Palestine, la Syrie, le Liban*. Paris, 1851.

Penrose, Boies. *Urbane Travelers: 1591–1635*. Philadelphia, 1942.

Pococke, Richard. *A Description of the East and Some Other Countries*. 2 vols. London, 1743–45.

Poujade, Eugène. *Le Liban et la Syrie (1845–1860)*. Paris, 1860.

Preziosi, Count Amadeo. *Stamboul: Souvenir d'Orient*. Paris, 1858.

Prisse d'Avennes, E. *Miroir de l'Orient*. Paris, 1852.

Pückler-Muskau, Hermann Ludwig Heinrich von. *Semilisso in Afrika*. Stuttgart, 1836.

– *Aus Mehemed Alis Reich*. n.p., 1844.

Reclus, Elisée. *Voyage au Caire et dans la Haute-Egypte*. Versailles, 1870.

Rhone, Arthur. *L'Egypte à Petites Journées: Le Caire d'autrefois*. Paris, 1910.

Roberts, David. *Egypt and Nubia*. 3 vols. London, 1846–49.

Rogier, Camille. *La Turquie, Mœurs et Usages des Orientaux au XIX^e siècle, etc. dessinés d'après nature, par C. Rogier, avec une introduction par Th. Gautier, et un texte descriptif*. Paris, 1847.

Russell, William. *Diary in the East*. London, 1869.

St Clair, Alexandrine. *The Image of the Turk in Europe*. New York, 1973.

Saulcy, Louis-Félicien Joseph Caignart de. *Carnets de voyage en Orient (1845–1869)*. Paris, 1955.

Searight, Sarah. *The British in the Middle East*. London, 1969.

Soustiel, Jean and Thornton, Lynne. "L'Influence des miniatures orientales sur les peintres français au début du XX^e siècle". In *Art et Curiosité*. Paris, 1974.

Taylor, Baron and Reybaud, Louis. *La Syrie, l'Egypte, la Palestine et la Judée considérées sous leur aspect historique, archéologique, descriptif et pittoresque*. 2 vols. Paris, 1839.

Teynard, Félix. *Egypte et Nubie: Sites et monuments les plus intéressants pour l'étude de l'art et de l'histoire. Atlas photographié accompagné de plans et d'une table explicative servant de complément à la grande description de l'Egypte par F. Teynard*. 2 parts. Paris, 1858.

Thackeray, W.M. *From Cornhill to Cairo*. London, 1865.

Tharaud, Jérôme and Jean. *Rabat ou les Heures marocaines*. Paris, 1921.

Tourett, F. Gilles de la. *L'Orient et les Peintres de Venise*. Paris, 1924.

Urquhart, David. *The Lebanon (Mount Souria): A History and a Diary*. 2 vols. London, 1860.

Valon, vicomte Alexis de. *Une Année dans le Levant*. Paris, 1846.

Vogüé, Eugène-Melchior de. *Syrie, Palestine, Mont Athos: Voyage aux Pays du Passé*. Paris, 1876.

Volney, Constantin François de. *Les Ruines*. Paris, 1799.

Weber, S.H. *Voyages and Travels in the Near East in the Nineteenth Century*. Princeton, 1952.

Wilson, A. *Bibliography of Persia*. London, 1930.

Wood, A.C. *History of the Levant Company*. London, 1964.

Monographs on Orientalist Painters

JULES-ROBERT AUGUSTE, known as "Monsieur Auguste":

Saunier, C. "Un Artiste romantique oublié, M. Auguste". In *Gazette des Beaux-Arts*. vols. 1 and 2. 1910.

LÉON-ADOLPHE-AUGUSTE BELLY:

Mandach, Conrad de. "Léon Belly". In *Gazette des Beaux-Arts*. 1913.

ALEXANDRE BIDA:

Paris, Gaston. "Souvenirs sur Bida". In *Gazette des Beaux-Arts*. 1895.

CARLO BOSSOLI:

Peyrot, Ada. *Carlo Bossoli*. 2 vols. Turin, 1974.

CHARLES-EMILE (CALLANDE DE) CHAMPMARTIN:

Guillemot. "Champmartin". In *Gazette des Beaux-Arts*. 1919.

THÉODORE CHASSÉRIAU:

Bénédite, Léonce. *Théodore Chassériau: Sa vie et son œuvre*. 2 vols. Paris, 1931.

Escholier, Raymond. "L'Orientalisme de Chassériau". In *Gazette des Beaux-Arts*. 1921.

Sandoz, Marc. *Chassériau: Catalogue raisonné des peintures et estampes*. Paris, 1974.

ADRIEN DAUZATS:

Jouin, Henri. *Adrien Dauzats: Peintre et écrivain*. Paris, 1897.

GABRIEL-ALEXANDRE DECAMPS:

Colombier, P. du. *Decamps* (In *Les Maîtres de l'Art moderne* series). Paris, 1928.

EDMÉ-ALEXIS-ALFRED DEHODENCQ:

Seailles, Gabriel. *Alfred Dehodencq: Histoire d'un coloriste*. Paris, 1885.

– *Alfred Dehodencq: L'Homme et l'artiste*. Paris, 1910.

EUGÈNE DELACROIX:

Burty, P. "Eugène Delacroix au Maroc". In *Gazette des Beaux-Arts*. 1865.

Guiffrey, J. *Le Voyage d'Eugène Delacroix au Maroc*. 2 vols. Paris, 1909.

Joubin, André. *Lettres de E. Delacroix écrites du Maroc en 1832*. Paris, 1930.

Robaut, A. and Chesneau, E. *L'Œuvre complet de Eugène Delacroix*. Paris, 1858.

Eugène Fromentin:

Dorbec, Prosper. *Eugène Fromentin* (In *Les Grands Artistes* series). Paris, 1926.

Gonse, Louis. *Eugène Fromentin: Peintre et écrivain*. Paris, 1881.

Lagrange, Andrée. *L'Art de Fromentin*. Paris, 1952.

Marcos, Fouad. *Fromentin et l'Afrique*. Sherbrok, 1974.

Jean-Léon Gérôme:

Moreau-Vauthier, C. *Gérôme, peintre et sculpteur, l'homme et l'artiste*. Paris, 1906.

Marc-Gabriel-Charles Gleyre:

Charles Gleyre ou les illusions perdues. Catalogue of the travelling exhibition 1974–1975. By Ursula Stürzinger, Dr Hans Lüthy, Dr Rudolf Koella. A publication of l'Institut suisse pour l'Etude de l'Art. Zurich, 1974.

Gustave Guillaumet:

Badin, A. "G. Guillaumet". In *L'Art*. 1888.

Bénédite, Léonce. "La Peinture orientaliste et G. Guillaumet". In *Nouvelle Revue*. 1888.

Durand-Greville. "G. Guillaumet". In *L'Artiste*. 1887.

Guillaumet, Gustave. *Tableaux algériens*. Paris, 1886.

Renan, Ary. "Gustave Guillaumet". In *Gazette des Beaux-Arts*. 1887.

Constantin Guys:

Geffroy, G. *Constantin Guys: L'Historien du Second Empire*. Paris, 1904.

William Holman Hunt:

Hunt, William Holman. *Pre-Raphaelitism and the Pre-Raphaelite Brotherhood*. 2 vols. London. 1905.

Jules-Joseph-Auguste Laurens:

Labande, A. *Jules Laurens*. Paris, 1910.

Emile-Charles-Joseph Loubon:

Brahic-Guiral, P. *Loubon*. Marseilles. 1974.

Prosper Marilhat:

Gomot, H. *Marilhat et son Œuvre*. Clermont-Ferrand, 1884.

Henri Regnault:

Cazalis, Henri. *Henri Regnault: Sa vie et son œuvre*. Paris, 1872.

Marx, Roger. *Henri Regnault*. Paris, 1876.

Regnault, Henri. *Correspondance*. Compiled and annotated by Arthur Duparc. Paris, 1872.

David Roberts:

Ballantine, James. *The Life of David Roberts*. Edinburgh, 1866.

Jean Seignemartin:

Faure, C. and Stengelin, A. *Jean Seignemartin*. Lyons, 1905.

Horace Vernet:

Durande, Amédée. *Joseph, Carle et Horace Vernet: Correspondance et Biographies*. Paris, 1864(?)

Henry Wallis:

Huish, Marcus B. *Henry Wallis, R.S.W.* London, 1904.

Félix Ziem:

Anonymous. *Les Maîtres illustres: F. Ziem*. Series director: Henri Rougon. Paris, n.d.

202

207

The publisher wishes to thank all the museums and collectors mentioned below for the use of their photographs. With the exception of collectors who asked to remain anonymous, the owners of the works are given in the captions; the dimensions, technique, and date of the work are also indicated there, insofar as these data were made available to us. The numbers refer to the page on which the work is reproduced. The photographs in this book are from the following sources:

Bayonne, Musée Basque: 170

Berne, Gottfried Keller Stiftung: 185 right (photo: Schweizerisches Institut für Kunstwissenschaft, Zurich)

Bristol, The City Art Gallery: 134

Brussels, Musées royaux des Beaux-Arts de Belgique: 126 (photo: A.C.L., Brussels)

Carpentras, Musée Duplessis: 159 (photo: Hans Hinz, Basle)

Cassel, Staatliche Kunstsammlungen: 71

Collections:

—— Bernard Haim: 58 bottom (photo: Hans Hinz, Basle)

—— Manoukian: 67 (photo: Studio Contact, Paris)

—— R. G. Searight: 36, 80, 115, 117, 130 bottom, 133, 142, 147, 154, 183, 190, 191, 192, 195 right (photos: Courtauld Institute, London)

—— Other collections: 52 (photo: Musées Nationaux, Paris); 60 (photo: Hans Hinz, Basle); 29, 162, 163 (photos: Hartnoll & Eyre, Ltd., London); 166 (photo: Georg Schäfer, Schweinfurt)

Geneva, Musée d'Art et d'Histoire: 25

Hamburg, Kunsthalle: 43 (photo: Ralph Kleinhempel, Hamburg)

Lausanne, Musée cantonal des Beaux-Arts: 85 (photo: Institut suisse pour l'étude de l'art, Zurich); 138 (photo: André Held, Ecublens)

Leningrad, Russian Museum: 160 right (photo: APN, Paris)

London, National Portrait Gallery: 34

—— The Tate Gallery: 35 (photo: John Webb)

—— Wallace Collection: 32, 128

Marseilles, Musée des Beaux-Arts: 81, 158 (photos: Hans Hinz, Basle); 173 (photo: Atelier municipal de Reprographie, Marseilles)

—— Musée Grobet-Labadié: 120 (photo: Luc Joubert, *L'Œil,* Paris)

Montpellier, Musée Fabre: 193

Moscow, Tretiakov Gallery: 144 (photo: APN, Paris)

Munich, Bayerische Staatsgemäldesammlungen: 79, 150

Nantes, Musée des Beaux-Arts: 63 (photo: Studio Madec, Nantes); 65, 103 (photos: Hans Hinz, Basle)

New York, The Metropolitan Museum of Art: 118 bottom, 156

Orléans, Musée des Beaux-Arts: 98

Oxford, Ashmolean Museum: 99

Paris, Musée du Louvre: 18, 19, 21, 23, 39, 46, 49, 53, 57, 83, 84, 89, 96, 104, 114, 145, 187 (photos: Musées Nationaux, Paris); 101, 107, 139, 171 (photos: Hans Hinz, Basle); 69 (photo: Luc Joubert, L'Œil, Paris)

—— Ancien Musée du Luxembourg: 66, 87, 118 top, 131, 165 (photos: Archives photographiques, Paris)

—— Bibliothèque nationale: 37

—— Compagnie Financière de Suez: 140 top, 195 left (photos: Hans Hinz, Basle)

—— Galerie Tanagra: 56, 174; 92 (photos: J. Guillot, Connaissance des Arts, Paris); 135, 161, 172 (photos: Studio Contact, Paris)

—— Musée des Arts africains et océaniens: 178 (photo: Musées Nationaux, Paris)

—— Musée National d'Art Moderne: 179 (photo: Musées Nationaux, Paris)

Périgueux, Musée du Périgord: 157

Philadelphia, The Pennsylvania Academy of the Fine Arts: 94

Reims, Musée: 121, 125 (photos: Dumont-Babinot, Paris)

Rochefort-sur-Mer, Musée municipal: 91 (photo: Studio Blain, Rochefort)

Southampton, The Southampton Art Gallery: 41, 143

Strasbourg, Musée des Beaux-Arts: 176

Toulouse, Musée des Augustins: 62 (photo: Jean Dieuzade, Toulouse)

Versailles, Musée: 22, 26, 27, 51 (photos: Musées Nationaux, Paris)

Vienna, Österreichische Galerie: 40, 73 (photos: Fotostudio Otto, Vienna)

Washington, D. C., National Gallery of Art: 124

Various Sources:

70, 76, 78, 95, 123, 127, 129, 137, 140 bottom, 141, 151, 153, 155, 177, 185 left (photos: Jean Soustiel, Paris)

30, 44, 54, 59, 74, 109, 110, 146 (photos: G. Routhier, Studio Lourmel, Paris)

93, 97, 105, 119 (Photos taken from *L'Aquarelle Française au XIX^e siècle* by François Daulte)

68, 130 top (Photos graciously made available by Sotheby's, Paris)

This book was printed in March, 1977 by Imprimerie Hertig + Co. S.A., Bienne
The photolithographs were done by Atesa Argraf, Geneva
The binding is the work of Schumacher S. A., Schmitten-Berne
Editorial: Barbara J. Perroud
Production: Suzanne Meister
Documentalist: Ingrid de Kalbermatten
Designer: Studio S + T, Lausanne.

Printed in Switzerland